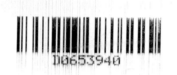

Catching the moment

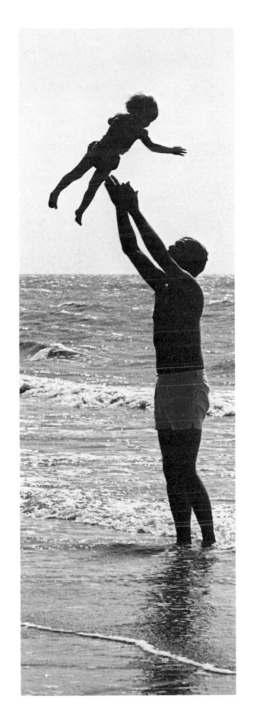

Camilla Jessel

Catching the moment

Photograph your child

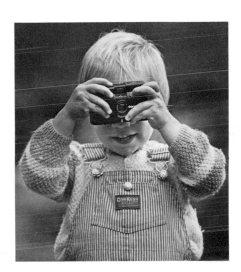

The Herbert Press

For Andrzej, Roxanna
and Jeremy

Copyright © 1985 by Camilla Jessel
Copyright © 1985 drawings by Jeremy Panufnik
Copyright under the Berne Convention

Published in Great Britain 1985 by
The Herbert Press Limited,
46 Northchurch Road, London N1 4EJ

Designed by Pauline Harrison
House editor Erica Hunningher

Printed and bound in Great Britain by
Butler & Tanner Ltd, Frome and London.

British Library Cataloguing in
Publication Data

Jessel, Camilla
 Catching the moment:
 photograph your child.
 1. Photography of children
 I. Title
 778.9′25 TR681.C5

ISBN 0-906969-46-8

Contents

Introduction

The photography of babies and children involves more than technical know-how, much more than the choice of an ideal camera or flash-gun. To me, the photography of children is about capturing the beautiful and interesting shapes their bodies make in action; their sparkle, intelligence and creativity; the individuality behind the appealing eyes.

Our children grow and change so fast that only a photograph can freeze them in time, bring back the tender memories of their transient ages and stages. The camera offers us the privilege of retaining images of these passing moments. Too many family albums and framed portraits show only the glossy side of childhood: all dressed up for a birthday party, hair immaculate for a formal portrait. Is it not more touching as the years pass, for the children themselves as well as parents, to remember and treasure the day-to-day normalities of family life?

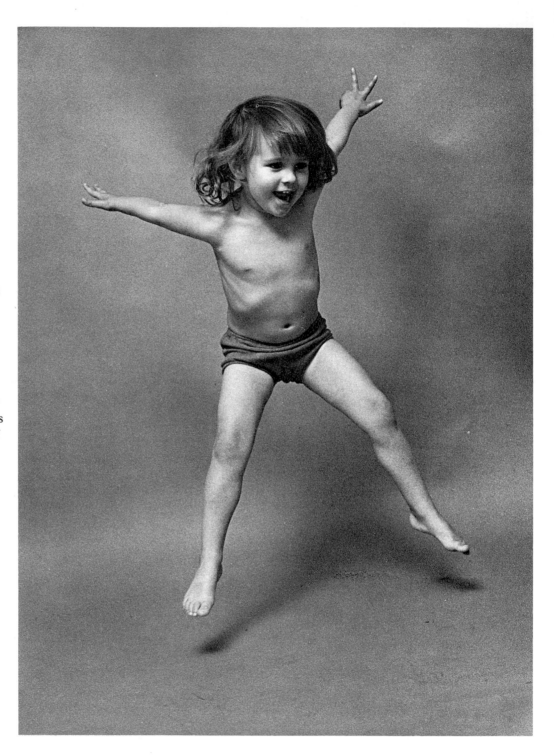

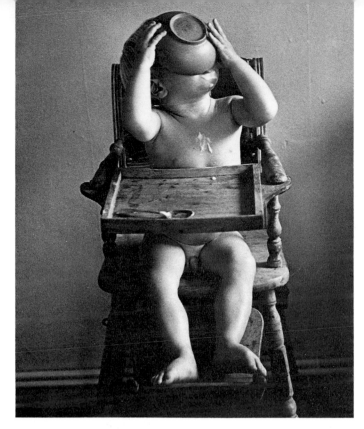

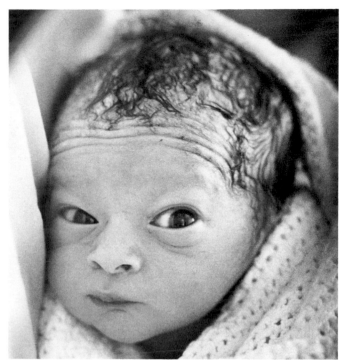

Real children are gloriously imperfect: in retrospect, disasters are often funnier and more appealing than moments of glory.

For this reason, it is essential always to have a camera loaded and at hand, ready for anything amusing or unusual that the rich imagination of the child invents. Given time and space, children will create more interesting pictures than anything we might impose. We owe it to them to record them as the rugged, imaginative individuals they truly are, rather than setting them up as unnaturally tidy, falsely smiling dolls.

The first photographic challenge arises within minutes of birth: to depict the newborn already as a personality rather than just a blob inside a bundle of clothing (p. 86).

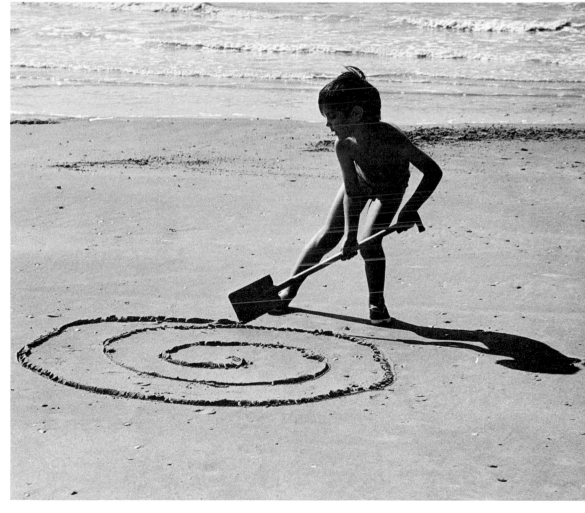

The convention that a child should always smile at a camera is a travesty. Smiles are wonderful. We cannot have too many of them, provided they are genuine and spontaneous. Perhaps we owe it to ourselves also to be aware of our children lovingly reaching out to us, showing that we need each other and that not every moment is gilded with laughter.

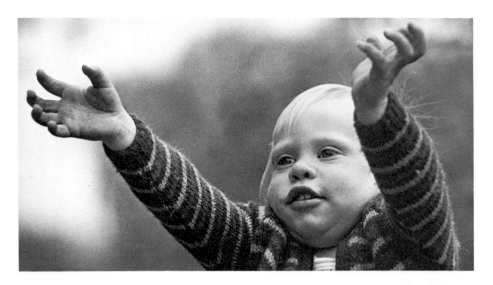

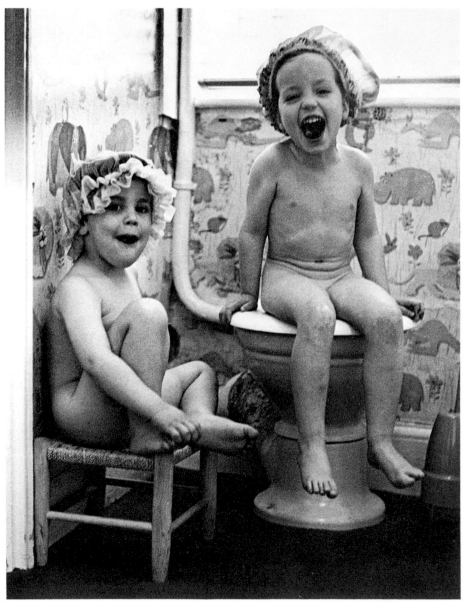

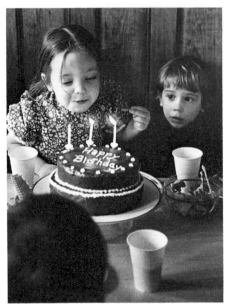

Photographic truth lies not just with the happy birthday girl: real life includes the boy beside her aching with envy because he has three long months to wait till he is five.

Is it really preferable years later to have retained only a polite image of our children posing in the cardboard elegance of the portrait photographer's studio rather than being their true selves later that evening at home?

Over the years, which picture will more vividly recall the determined toddler: yet another manufactured smile aimed straight at the photographer? Or that moment when he packed himself to make sure that he would not be left behind when the family moved house?

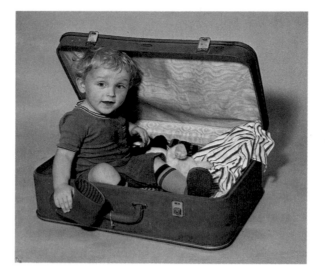

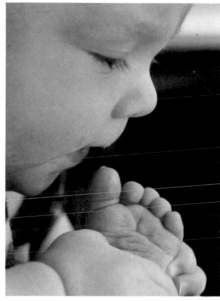

Every milestone in a baby's development is a potentially entertaining item for the family album. Whether it is her toe or, a few months later, a spoonful of cornflakes she is struggling to get into her mouth, she deserves a camera present, ready to record her latest achievement.

The technical quality of such pictures may vary with the type of equipment used. But better a slight blur and spontaneity than technical perfection and a dull, self-conscious baby in the photograph. The parent who knows the child may produce far more memorable pictures than a fussy professional who spends a hot half hour arranging the lights.

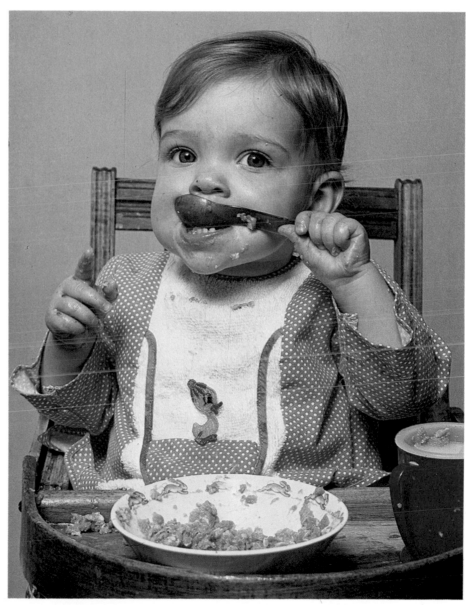

Everyone loves colour. Unfortunately, in practical terms, it may not possess the same lasting qualities as black and white: dyes fade, the colours become more muted as the years pass. However, even faded colours may be better than none: the tactile, silken quality of a baby's flesh, a sparkle of blue eyes, or a blaze of red hair.

Colour film is irresistible, and for many people it has taken over completely from black and white.

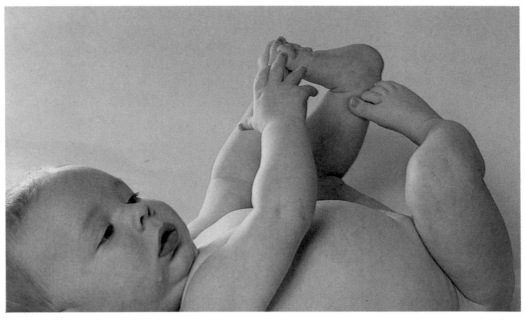

The aesthetics of colour photography are subtly different from black and white. Inevitably, emphasis falls more on colour content, less on character and human qualities. Though the child's pride in her new possession still shows through, the stripy umbrella dominates the picture.

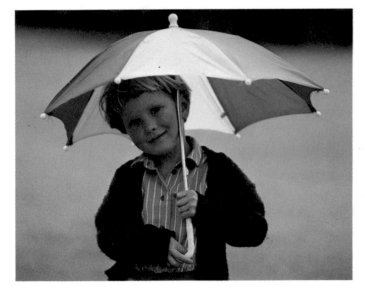

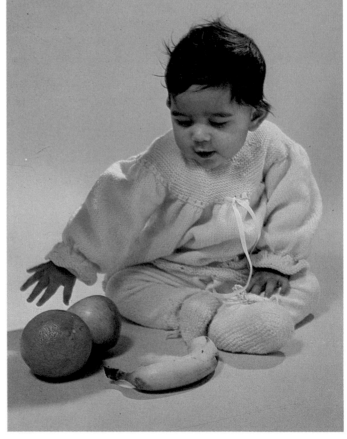

Prettiness takes over and the personalities pay. The intentional starkness of black and white serves to highlight character and movement, while in colour, what the child is wearing becomes a crucial part of the composition.

The colour of clothing is so important, it is possible to render the child totally abstract and still have a satisfactory colour picture.

While celebrating the richness of colour available, however, it is worth sometimes keeping the tones intentionally close to monochrome, choosing softer shades of clothing, just to reduce the dominance of primary colours and let the child's character shine through.

Choice of camera

Many parents rush to a camera shop just before their baby is born, submitting to the pressure of advertisements or eager salesmen, without rationally considering which kind of camera will bring them lasting pleasure and satisfaction.

A panic decision to buy an easy-to-use camera may later be regretted when its limitations are discovered.

The purchase of a more advanced camera may equally be regretted if you are not prepared to give time to understanding it. A technically complex camera can get in the way of straightforward, heartwarming, spontaneous shots unless the photographer is willing to practise, like a pianist, constantly keeping up speed and technique. The camera is only a machine which will become an obstacle rather than a friend if its owner cannot master it.

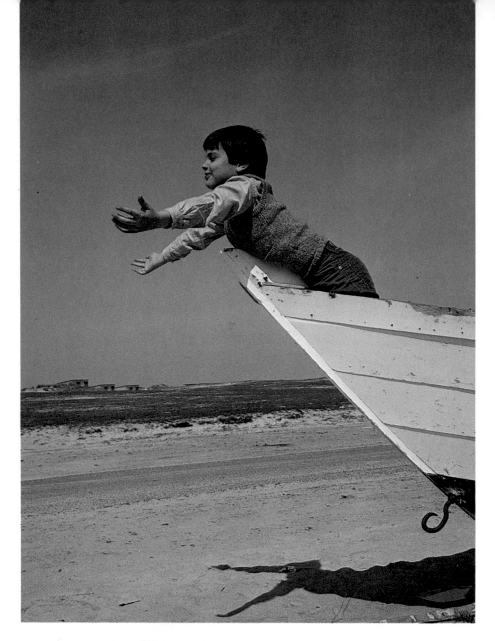

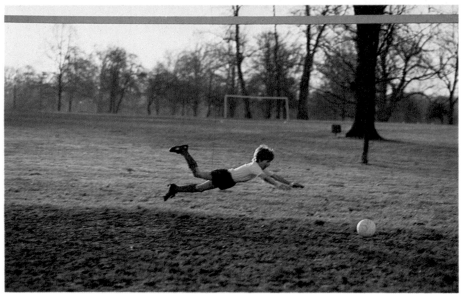

Whether simple or complex, a camera needs to become like a third eye, sufficiently part of its owner to be used almost without thought.

Price is a factor which usually has to be considered; but the most expensive camera on the market is not necessarily going to achieve the best photographs. It is the photographer's eye behind the viewfinder, not the camera itself, which produces the lively, well-composed picture.

Price apart, the basic choice is between a compact camera with one fixed lens and a camera system with interchangeable lenses.

Most compact automatic cameras virtually think for the photographer, and the better ones can produce pictures up to professional standards. But they are manufactured not so much for parents as for tourists; the one fixed lens with its wide angle view can encompass not just a baby, not just a family group, but also a castle, a vast landscape stretching into space. This all-embracing wide angle lens rules out flattering full-frame head and shoulder portraits or acceptable close-ups.

With an interchangeable lens camera, a wide angle lens may be used for groups or castles, but a telephoto lens, ideal for child portraits, can be snapped into position in an instant.

This difference is best understood by testing the wide angle and tele lens views with your own hands:

Same child, same place, different cameras:

A camera with an (interchangeable) telephoto lens gives a truer rendering of facial proportion and throws the background out of focus.

Olympus OM1 SLR with interchangeable 100mm lens at f 2.8 focused on eyes

A camera with a fixed lens: when the child's head and shoulders are near enough to fill the negative, they are too close to be in focus; facial features are distorted by the close viewpoint with wide angle optics, and the background shows disturbing detail.

Chinon Autofocus Compact Camera with fixed 35mm wide angle lens

It is possible to buy little auxiliary telephoto lenses which fit in front of compact or disc camera lenses. However, considerable sharpness and quality will be lost; it is cheaper and more satisfactory to stand back and take the photograph from further away to avoid blur or distortion, then to crop it in the darkroom (p. 144), or to trim the edges of a ready-printed enlargement.

Easy-to-use, fixed lens cameras

Besides its fixed wide angle lens, the easy-to-use, compact camera usually has other major drawbacks: a direct, unsubtle flashgun (pp. 24-5); inadequacy when shooting against light (pp. 38-9); and inability to take filters (pp. 138-40, 150-1).

However, when it comes to rapid handling for spontaneous shots, the easy-to-use camera has an edge over the complex systems. It is also lighter in weight, and streamlined in design, living up to the designation of 'compact', so can be kept at the ready in pocket or handbag.

At the cheapest end of the market, almost any camera sold today is adequate for family snapshots. Many (though not all) of the subjects and aspects of child photography illustrated in this book can be achieved with the lowest price cameras. Technical quality may be lacking (the poor definition due to cheap lenses is compounded by the tiny negative size in 110 and disc film). But even these most basic cameras will produce agreeable photographs for amusement and happy memories, which after all is the main purpose of photographing your child.

At the top of the price range, the lens will be excellent, so that the pictures will be sharp and well contrasted; and the sophisticated automatic control of aperture and shutter speed will produce accurately exposed negatives and slides in most circumstances. On some models, a motor drive winds on the film ready for the next shot, and rewinds at the touch of button, so the next film can be quickly loaded. (However, for spontaneous shots where the photographer is trying to work silently and not be noticed, the squawk of the autowind may be a handicap.)

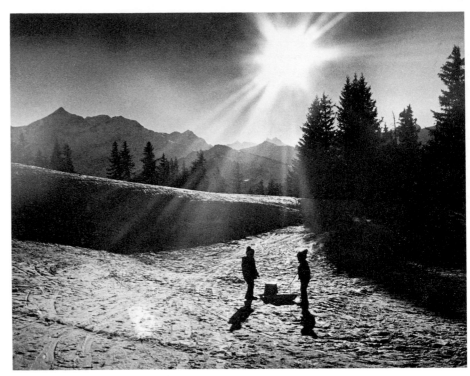

Shooting against the light (p. 38) is tricky with most compact cameras.
Leica CL (manual setting) 90mm lens with yellow filter f 8 1/125 sec. Plus-X film

Chinon Autofocus (with automatic speed and aperture setting) Tri-X film
The total automation of this typical autofocus compact camera allows instant shooting without thought.

Autofocus cameras

Autofocus cameras preempt the need for manual setting of focus. An infra-red beam informs the camera of the exact distance from film surface to subject as the photograph is taken.

A child is running towards you. His plane of focus changes constantly. With an ordinary camera, the photographer needs prejudgement (p. 63) and extremely rapid reflexes to keep the subject sharp. With an automatic camera it is a question of just pointing and firing, a great asset for spontaneous photography. Though the user is still stuck with the fixed wide angle lens, this matters less with action shots because inclusion of surroundings tends to pleasingly accentuate speed. (At a price, autofocus is also available on some cameras with interchangeable lenses.)

Autofocus cameras do have minor pitfalls, particularly that, since the infra-red beam measures from the centre of the photograph, the photographer cannot choose, for compositional effect, to have a side area sharp and to throw the centre of the picture out of focus. This can be awkward, if, for example, two children are sitting on the grass, and the centre spot is a distant clump of trees: the trees will be in focus, not the children.

Also, black and dark colours upset the accuracy of the infra-red beam, as do mirrors or windows between camera and subject.

Despite these limitations, for anyone who cannot face thinking about technicalities, my advice is to enjoy yourself with the most automated, autofocus camera you can afford. But, before making this decision, it is worth finding out how easy it is after all to master a more complicated-looking camera, and how much more satisfactory some of the photographic effects will be.

Chinon Autofocus Tri-X film

Photographs taken in the mirror are risky with an autofocus camera, which may take the reading from the glass, not the reflection.
Olympus OM2 50mm lens f 2.8 1/125 sec. Tri-X film

Camera systems with interchangeable lenses

Cameras with interchangeable lenses are not nearly so hard to use as some people imagine. Lenses can be changed with just a twist and a click. Some models are as fully automatic in their light metering and exposure setting as the compact fixed lens cameras, so that it is possible to have all the advantages of alternative lenses without having to worry about shutter speeds or depth of field.

However, many 35mm camera bodies offer both automatic and manual control. This combination is ideal because the automatic setting can be used when there is no time to think, while the manual setting is available for specific effects.

Totally automatic cameras allow no control over shutter speed or aperture, which can become frustrating. The shutter dictates the length of time that light is allowed to land on the film (1/125th second allows through twice as much light as 1/250th second). The higher the fraction, the faster the shutter speed, so that 1/1000th second can stop almost any movement. The slower the shutter speed, the more any movement in the picture will be blurred, sometimes artistically an advantage, other times to be avoided (p. 66). Low shutter speeds also introduce the risk of camera shake, according to how steady your hand is, so it is an advantage to be able to choose the speed which suits you, rather than leaving everything to the automatic camera.

Behind every lens in most reasonable quality cameras, whether fully automatic or manually controlled, is an aperture ring. Lens apertures work like your eyes: in bright sunlight, the aperture is closed down to its minimum size (eyes narrow and the pupils contract): in low light the

aperture is opened to its full size (eyes widen and the pupils dilate).

The amount that the aperture is opened or closed is indicated by f settings. Just as each different shutter setting halves or doubles the amount of light reaching the film, in balance,

Aperture opened wide for low light (f 1.4 or f 2)

Average opening for average light (f 5.6 or f 8)

Minimum opening for bright light (f 16, f 22 or f 32)

each f stop doubles or halves the amount of light getting through the aperture in the lens, so f2.8 allows through twice as much light as f4.

Automatic camera control of aperture avoids any worry for beginners. However, manual control is essential if you want to manipulate depth of field, which alters emphasis in photographs and can make them much more interesting. In identical lighting conditions, it is possible to decide whether to open the aperture to its maximum so that only a narrow plane of the photograph is in focus; or to set a minimal aperture resulting in maximum depth of field so that both foreground and background are sharp.

A wide angle lens (used for the view) offers greater depth of field at wider apertures than a tele lens (used for the close-up portrait).

The interchangeable 35mm lenses are almost always superior in quality and produce sharper pictures with better contrast and colour than the lenses in inexpensive compact cameras.

Superbly designed sub-miniature cameras with interchangeable lens systems are tempting because they are so easy to carry around, but the tiny size of the film (110), with negatives of only 13 × 17mm, means that, though enprints are acceptable, enlargements are less satisfactory than with 35mm (24 × 36mm) film.

The larger format cameras which use 120 or 220 film, with negatives of 60mm square or even larger, produce photographs of brilliant quality. Although popular for studio use, they are cumbersome for high-speed, spontaneous work: 35mm is the ideal format for unobtrusive child photography.

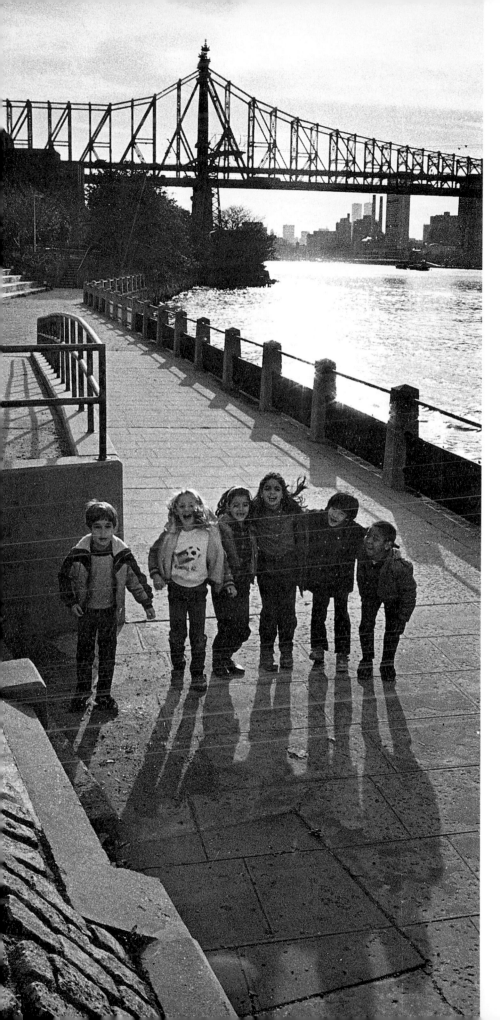

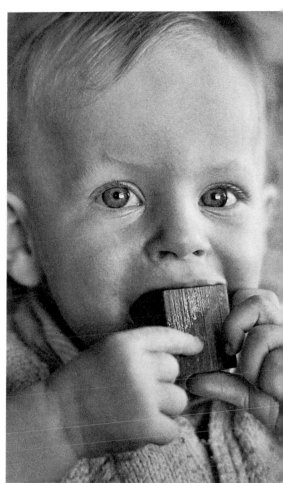

Shallow depth of field is useful for emphasizing character in the eyes, or any other feature the photographer would like to dominate the picture, because it throws everything else out of focus, even nose and hair.

*Leica R4 90mm lens f 2 1/125 sec.
Tri-X film*

Extensive depth of field has obvious advantages when view, perspective and people in the foreground are all important aspects of the picture.

*Leica R4 35mm lens f 16 1/125 sec.
Tri-X film*

Choice of lenses

Only one or two lenses are essential for the beginner, but, once you have gained confidence, you are likely to want to explore further possibilities. Lenses determine the angle of view, and therefore the area included in the photograph: the shorter the focal length of the lens, the greater its angle of view (p. 13).

50mm standard lens

A 35mm camera body is normally sold with a standard 50mm lens: with most makes it is cheaper to buy one as part of the basic package.

The standard lens is useful in the greatest number of situations. Its view is not wide enough to embrace a whole room, nor narrow enough to be ideal for head and shoulder portraits. But it will get you by in most circumstances. It is lightweight and has a large aperture (probably f1.8 or f2), so that it can be used in low light without a flash, a must for spontaneous indoor child photography.

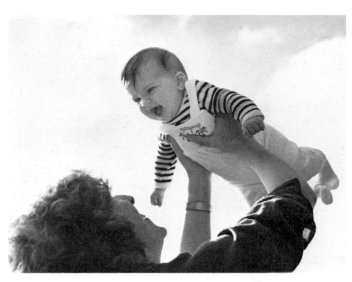

Leica R4 50mm lens f8 1/125 sec. Tri-X film

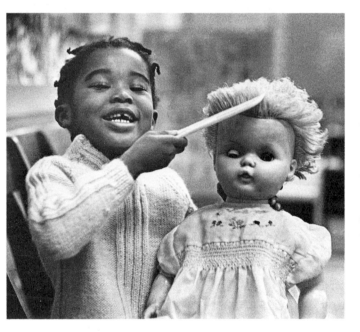

Leica M2 50mm lens f2 1/125 sec. Tri-X film pushed 1 stop

90mm or 100mm lenses

Until you become more experienced and ambitious, I would suggest buying only one alternative lens, a 90 or 100mm (they are much the same: Japanese cameras usually offer 100mm, and German cameras 90mm). Some people would recommend instead a telephoto zoom, which in some ways allows more flexibility, but is heavier, more difficult to hold steady and can only be used in bright lighting conditions (p. 23).

The 90 or 100mm lenses are normally quite compact and lightweight. Some have apertures as large as the 50mm standard, so can be used in poor light. Their main advantage is that they bring you closer in to the action without having physically to move nearer – essential for shots of imaginative play, where any adult intrusion will make children self-conscious.

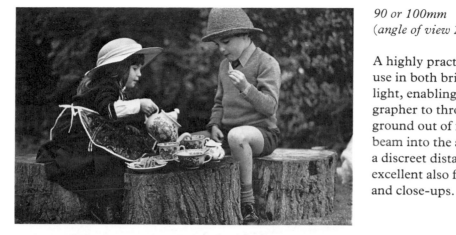

Comparative lenses

These four photographs were all taken a good 6 metres (20 ft) from the subject:

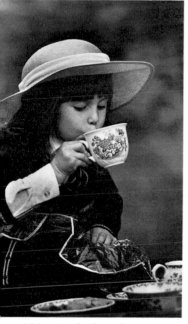

180mm telephoto lens
(angle of view 14°)

Superb for getting in really close without crowding the child. However, this lens is considerably heavier and longer than a 100mm, and has a less wide maximum aperture, usually f2.8 or f4, presenting risk of camera shake unless the light is excellent and an exposure time of at least 1/250 second is possible.

90 or 100mm
(angle of view 24°)

A highly practical lens for use in both bright and poor light, enabling the photographer to throw the background out of focus and beam into the action from a discreet distance. It is excellent also for portraits and close-ups.

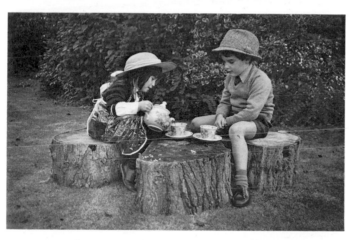

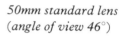

50mm standard lens
(angle of view 46°)

A wider view. A good general lens, but close-ups of the two children would have been impossible without coming in so near that their concentration would have been shattered.

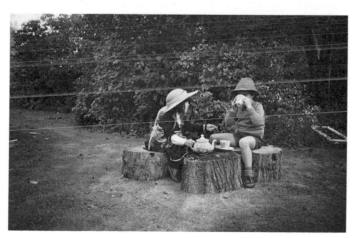

35mm wide angle lens
(angle of view 62°)

Also light and compact, excellent in both poor and bright light. Unsuitable for 'spying' on imaginative games because of the wide area it covers, but its positive uses are manifold (pp. 20–21). It is a likely third lens for the collection.

Wide angle lenses

Wide angle lenses are indispensable indoors, allowing you to include two or more children at work or play, even in a small room or in a crowded situation where it is impossible to stand back and use a telephoto.

Leica M2 35mm lens f 2.8 1/125 sec. Tri-X film

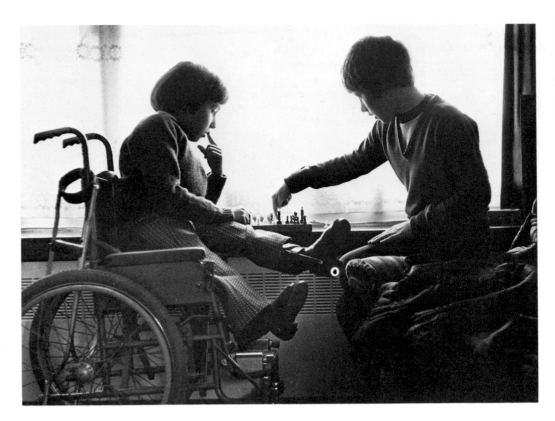

The 35mm is the least expensive in the range of wide angle lenses, and the most likely to have a wide aperture (probably f2), for indoor use in poor light. Some photographers prefer to invest in a more extreme wide angle, a 28mm or 25mm, which allows the inclusion of even wider areas. However, care has to be taken: due to the increased width of view and, perhaps, a close viewpoint, the edges of the photograph, whether human face or architectural detail, can easily become distorted. Here the converging parallels create a sense of height. They were emphasized by tilting the camera.

Leica R4 28mm lens f 16 1/125 sec. Tri-X film, orange filter to bring out the clouds and render the boys as silhouettes

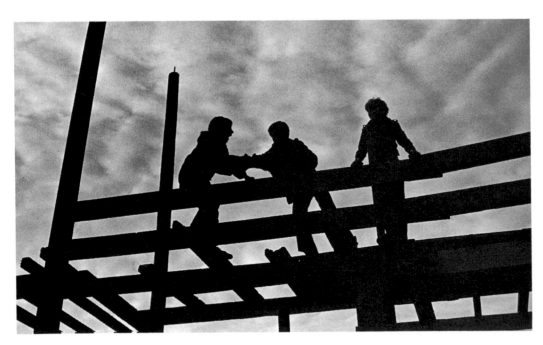

Because of the much greater depth of field in focus, wide angle lenses can be extremely useful when both background and foreground are of equal importance.

Another advantage of the exaggerated perspective created by the wide angle lens is that people in the foreground appear larger and dominate the photograph, while buildings are optically reduced to a smaller size, so can be seen complete.

Leica R4 35mm lens f 8 1/125 sec. Tri-X film

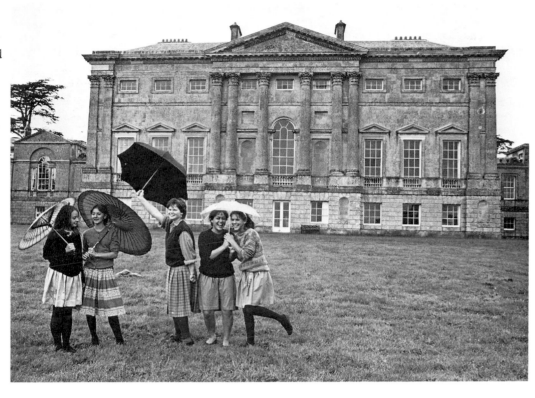

The widest of all lenses, the much vaunted 'fisheye' lens, hugely expensive and hefty to carry around, has little application in child photography. Its character-istic circular image anyway becomes boring and repeti-tive after the initial pleasure of experimentation.

The semi-fisheye, the 16mm wide angle, is well worth considering for some special effects (pp. 51, 52 and 60). Though distortion is inevitable, this can be exploited to dramatize both silhouette and speed. Architectural parallels slant and curve, especially if the viewpoint is from above (p. 52). It is an expensive extra and not to be used in too many circumstances, but it has very special creative possibilities, and can, in a tight squeeze, save a situation.

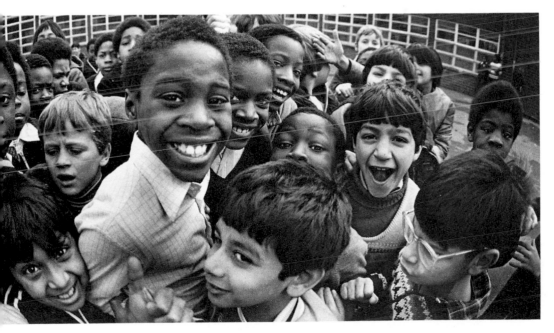

'Take my photo, Miss!' Mobbed in a playground, the children pressing against me, the deep focus of the semi-fisheye (from half a metre to infinity) enabled me to include everyone. The rather zany distortion seems to reflect the mutual enjoyment of our impromptu session.

Olympus OM1 16mm lens f 11 1/125 sec. Tri-X film

Longer telephoto lenses

Telephoto lenses are desirable not only for getting in close on sport or children's imaginative games but also for close-ups and portraits. It is helpful to compare what happens with different lenses if the full frame of the negative is used for the face:

16mm wide angle

35mm wide angle

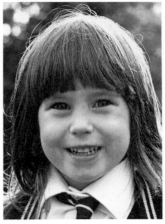
90mm telephoto

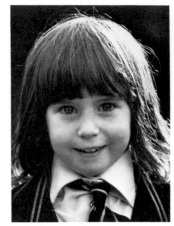
180mm telephoto

The wide angle lenses are obviously unsuitable for head and shoulder portraiture. Even the ever-useful 90mm does not give such true facial proportions as the 180mm.

However, these longer length telephoto lenses are an extra weight to carry around, and they have the further disadvantage of needing brighter lighting conditions. They absorb more light because of their longer length; they almost invariably have smaller maximum apertures, and, because of their extra length and weight, there is a risk of camera shake if they are used at less than 1/250 second. As so often in photography, a technical advantage gained means a practical advantage lost: with telephoto (and telezoom) lenses, the lightness and wide apertures

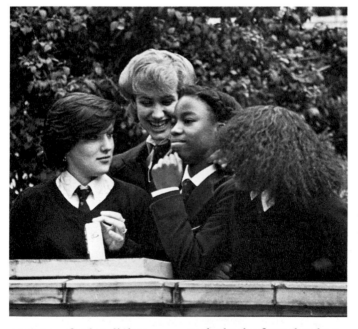

necessary for low light spontaneous photography.

One way to avoid carrying the extra weight of a longer tele lens is to use a tele-converter. This is a small, lightweight auxiliary lens which can be bayonetted on to the back of another lens, doubling its focal length, so that the 50mm becomes a 100mm, the 90mm becomes a 180mm. Its extra length loses the photographer two whole f stops, a nuisance in poor light. Also, this results in a dimmer viewfinder image with some consequent difficulty in focusing, which does not occur with the equivalent telephoto lens. However, the converter's light weight makes it preferable to the telelenses if you also have to carry a toddler and his toys. The converter is equally useful when working out of doors in rough-and-tumble situations with children all around; say in a school playground, where it is impractical to carry a heavy gadget bag. The converter can be fitted comfortably into a pocket and slipped on quickly when needed, for instance to catch a group of girls hatching a plot on the other side of the playground.

Leica R4 90mm lens with teleconverter f 4 1/125 sec. Tri-X film

Zoom lenses

Zoom lenses allow you to vary the focal length, and therefore the angle of view, without having to change lenses: you can select at a touch the right framing for the subject, or achieve two versions within seconds.

Wide angle zoom lenses give a choice of focal lengths from 35mm to 70mm, or 28mm to 80mm. Where the photographer has little space to manoeuvre, these combinations allow a wide angle view, say, of two children at play, then the possibility to zoom in on the activity of one of them without having to move closer.

Telephoto zoom lenses, incorporating focal lengths from 75mm to 200mm, or 70mm to 210mm, are invaluable for children at play outside. The main disadvantage is that the widest aperture on most telephoto zoom lenses is f3.5 or f4.5, and the extra weight makes slow shutter speeds impracticable, so their use is limited in less than bright light.

Leica R4 75–200 zoom lens at 75mm then 200mm f5.6 1/250 sec. Tri-X film

Some zoom lenses also offer macro close-up possibilities, which would make them seem an excellent buy. However, the need for bright natural light or special macro flash equipment is a disadvantage; and the sharpness of some cheaper zoom lenses is questionable, especially at full aperture.

Zoom lenses have other interesting uses: for example the zoom burst shot, where you shoot at a slow speed, zooming the lens from far to close as the shutter is pressed.

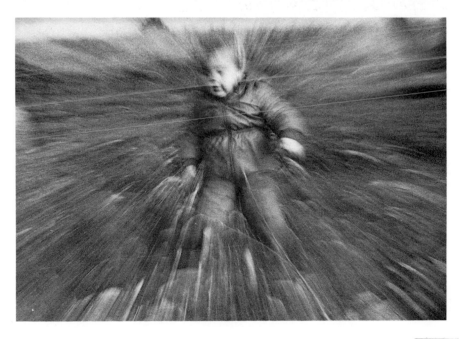

Leica R4 75–200mm zoom lens f16 1/15 sec. zoom setting moved from 200 to 75mm while firing

Lighting with flash

Comparative methods

The ideal way to light indoor photographs where there is not enough available light from windows is to use a flashgun with a tilting head and bounce the flash off the ceiling. A lightweight, portable computer flashgun which calculates the correct exposure at the moment of firing allows you to move around freely after the child. The light that reaches the subject is of a diffused, gentle quality, giving excellent moulding to facial features, hands, clothes and toys. No hard shadows are cast on the surface behind the subject.

Direct flash straight from the camera is the least satisfactory, though the easiest method. The blast of white light coming straight from the camera flattens out facial features and casts ugly shadows. No subtle effects are possible. Regrettably, most fixed-lens cameras have their own built-in direct flashguns rather than a 'hot-shoe' for connection to a separate flashgun.

Electronic studio flash units – one or more flashheads on tripods, with the different reflectors and snoots available – can produce delicate, varied lighting. However, they are cumbersome and have no sensor to measure light from a moving target. For the mobile child, bounce flash from the camera is more practical.

Direct flash on camera
Advantages: easy to use, needs little thought.
Disadvantages: flattens facial features, casts ugly shadows, no subtle effects possible.

Bounce flash
Advantages: diffused reflected light, can be moved as child moves.
Disadvantages: needs thought and planning, more inbuilt power – so more expensive.

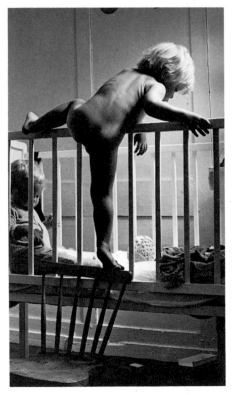

Electronic studio flash
Advantages: power, quality of light, controllability for artistic effects, extremely rapid recycling.
Disadvantages: static, on tripod so unsuitable for active toddlers.

Problems of direct flash

There is no way round using direct flash from most compact, disc and 110 cameras, but ways can be found to lessen the more disastrous effects.

The worst problem is red-eye: direct flash passes straight through the translucent eyeball, bringing out the colour of the blood vessels. It is less likely to occur if the child is not looking straight at you. (The oblique lighting of bounce flash eliminates the problem.)

Another frequent misfortune is bleaching out, the almost white photograph, overexposed because of the proximity of flash to subject. Cheaper flashguns are usually geared to provide correct exposure when standing back for, say, a family group. For a close-up of baby or child, reduce the effect of the light blast by fixing some light-absorbent diffusing material over the flashhead: two or three layers of beige nylon

tights, or honeycombed transparent plastic insulating material, or a pale pink or mushroom coloured hand-kerchief. (Care must be taken that these home-made light diffusers do not cover any light-reading sensor, only the flash itself.)

Also hideous are the black shadows cast by a direct blast of light from the front. It helps to be slightly higher than the subject so that the shadow is thrown downwards: from below, a shadow can loom mountainous. If practicable, subjects should be moved well away from a back surface such as a wall or high-backed chair, so that the shadow has nowhere to fall.

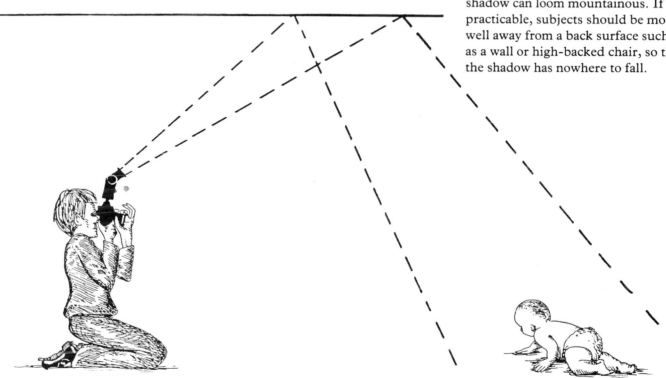

Bounce flash

The ideal flashgun for bounce flash should have the following features: accurate computing of the light on the subject; a twisting, tilting head; high power and rapid recycling.

Some modern computer guns are 'dedicated' so that they link in with the computer in a given make of camera to ensure that exactly the right amount of light reaches the film at the moment of firing. For non 'dedicated' flash, a sensor in the flashgun (which has been set with the same ISO film setting as the camera) calculates the correct amount of light as it is reflected back to the camera from the subject.

The better quality flashguns have tilting heads so that light can easily be bounced off the ceiling, but most of these can be used only for horizontal format photographs. Ideally, a flashgun should have both a tilting and a twisting head, so that vertical bounced photographs also are possible.

Some flashguns have separate light sensors; the flashhead can be removed and pointed in any direction to bounce the light, while the sensor, mounted on the camera, takes the light reading from the same level as the film. Another useful accessory is an auxiliary reflector attached to the flashhead.

One of the essentials for bounce flash, whether colour (p. 31) or black and white, is that the ceiling or other bounce surface is of a pale colour. Dark tones absorb too much light: the subject will be underlit. If the ceiling is unsuitable, sometimes the flashhead can be twisted to obtain horizontal flash off a white door; or a reflector umbrella can be held over the shoulder. These contortions usually mean that the camera must be operated with the right hand only, leaving the left free for the flash.

Vivitar 4600 flash (twisted head for upright photo) bounced off white ceiling Olympus OM1 35mm lens f4 Tri-X film

Power is another vital factor, partly because of the extra distance the light has to travel, but also because the flashgun must recycle rapidly after use. In spontaneous, true-to-life photography, if the first photograph is taken an instant too soon, the particular expression or grimace may have faded before the ready light comes on again. Always have spare batteries at hand, and never try to economize by making them last.

Braun professional flashgun with rechargeable power pack, flash bounced off white ceiling Leica M2 50mm lens f 4

When the ceiling is very high, or when the photographer is close to the subject, too much light falls on the top of the subject's head, and the face may be underlit. The lens aperture should be opened an extra half stop. Then the hair will be slightly haloed and the skin tones of the face correct. This varies with different flashguns and with the circumstances, but, so long as you know your own equipment, with practice, the adjustment becomes a matter of instinct.

Two Vivitar 4600 flashguns, one bounced off ceiling and one with slave-fired module behind subject's head

If there is time to arrange secondary lighting, it can greatly improve effects to have a second (even a third) flashgun providing backlighting or fill-in effects. It means buying a second or third flashgun of the same make, with a special 'slave' fired module, which is set off simultaneously as the main flash is activated from the camera.

Electronic studio flash

Studio flash units, though large and cumbersome, have several technical advantages over battery-operated portable flashguns, particularly their greater power, and the fact that they have auxiliary tungsten lighting built in to the flashhead, enabling you to see exactly how the child is lit and how the shadows will fall before the flash is fired. With studio flash units it is much easier to set up rim or backlighting.

Power is from the domestic electricity supply. Exposure is measured by a flashmeter which is held close to the subject and pointed at the main light source (or averaged off several lights). The quality of light is superb, most noticeably with colour. The extra power means that extra-high quality 'slow' films with fine grain (pp. 32–5) can be used, resulting in exquisite skin textures and delicate colours.

Though designed for use in the studio, electronic flash units are portable enough to instal anywhere in the house, say in the child's bedroom, or near the highchair. A gentle light can be achieved by reflection from a special silver-gold umbrella. In small rooms these umbrellas are cumbersome, and a diffusing snoot may be used; otherwise the light can be reflected off wall or ceiling, as in bounce flash. (Care must be taken not to introduce ugly colour reflections, p. 31.)

Unfortunately, with ambulant children, if they move a mere two feet closer or further from the light source, the light reaching them alters in strength: the flashmeter has to be consulted each time the child moves, and the camera adjusted accordingly. Ways and means have to be found to persuade or gently trap the child into the circle of light already prepared by the photographer (pp. 75 and 109–11).

Another great advantage with studio flash is that it takes less time than a battery-operated flash to recycle. It is therefore preferable to hand-held flash for rapid sequential shots.

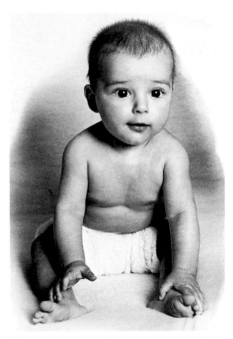 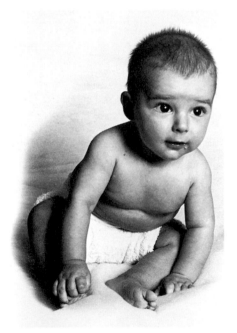 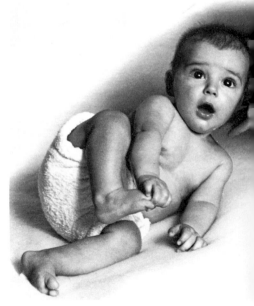

This baby is perfectly demonstrating the developmental stage where he believes he can stay upright by holding on to his toe. With a hand-held battery-operated portable flashgun, the second and third shots would have been lost while the flash was recycling (see also p. 93).

Olympus OM1 100mm lens f 8 one Bowens Monolite with umbrella reflector

Studio flash units are reliable, a great luxury to use, but for true spontaneous photography, obviously the portable flashgun is the first requirement, the studio flash an extra for occasional, well-planned use.

Because electronic flash stops move-
ment, the child in the studio does not
have to stay frozen to a seat. How-
ever, since the exposure would alter
nearer or further from the lights, he
can be encouraged to move only
vertically, remaining equidistant
from the main light source.

*3 Bowens Monolites, two of equal
strength either side of the camera,
reflected from umbrellas, a third back-
lighting the head and shoulders of
the leaping child
Leica R4 35mm lens f8
Ektachrome 64 film*

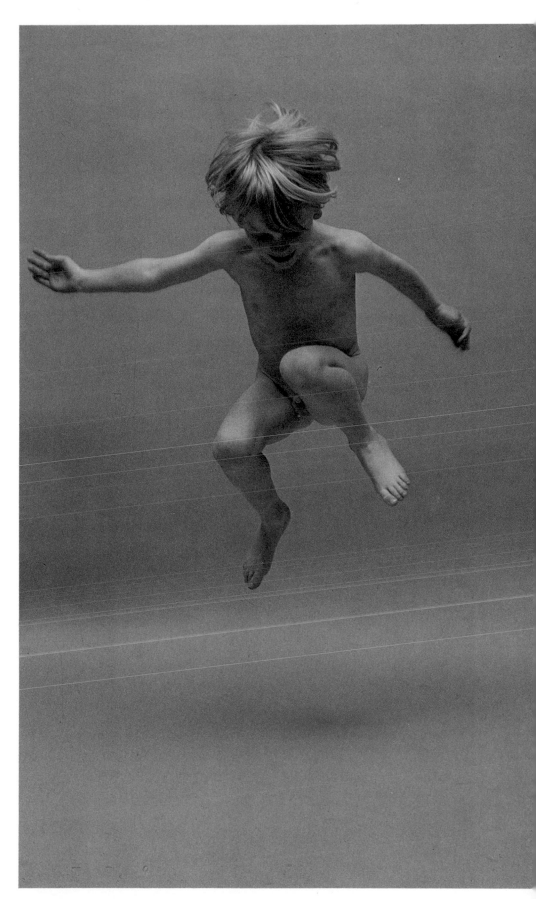

Fill-in flash

A flashgun is useful out of doors when shooting against the light, to fill in detail which would otherwise be in shadow.

The flashgun should be 'cheated' so that it lights the subject slightly below the normal exposure: this is done by doubling the ISO number (p. 33) of the film set on the flashgun, therefore cutting the light emitted (for example, ISO 100/21° film would be set as normal on the camera, but as ISO 200/24° on the flashgun). Shooting out of doors, remember to adjust the shutter speed for flash photography.

Olympus OM1 f 5.6 1/60 sec.
Vivitar 4600 flashgun
Kodachrome 64 film set at
ISO 64/19° on the camera and 125/22°
on the flashgun

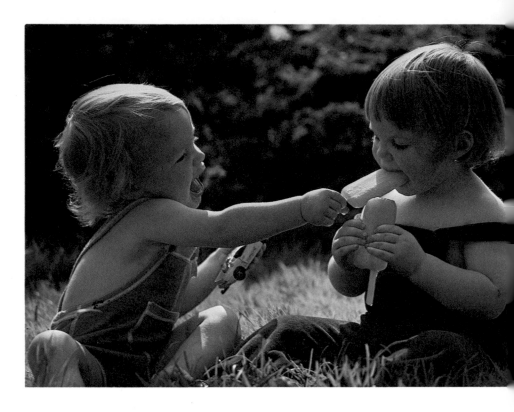

Fill-in flash can also be used indoors, in conjunction with directional light from a window. With indoor (bounced) fill-in flash, the setting on the flashgun should be normal, not 'cheated'. The directional window lighting here is just strong enough in comparison with the flash to backlight the children's heads (*below left*).

Directional light from a window without flash tends to produce heavy frontal shadow (*below right*).

Leica R4 35mm lens f 5.6 1/30 sec. Ektachrome 64 film.
Braun F910 Professional flashgun, ISO setting normal,
bounced off ceiling

Leica R4 35mm lens f 2.8 1/125 sec. Ektachrome 200 film

Reflected colour

To prevent unexpected tinges and taints in colour photographs, new awareness needs to be cultivated: unnoticed colours from nearby seem to leap on to the film and pervade what we *think* we have seen.

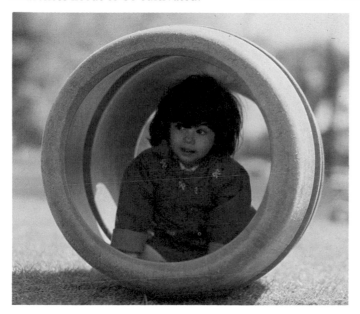

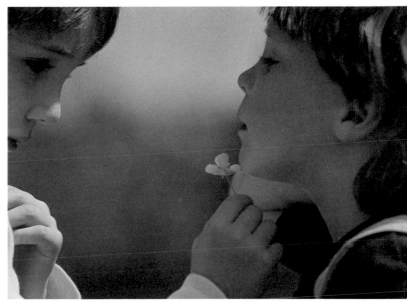

Colours reflect from all sorts of unexpected sources, sometimes to pictorial advantage, sometimes wrecking a picture which at the moment of shooting seemed perfect.

Bounce flash, though a boon for natural-looking lighting indoors, may disastrously scatter unwanted colour around if any reflecting surface close by is brighter than white or the faintest pastel shades.

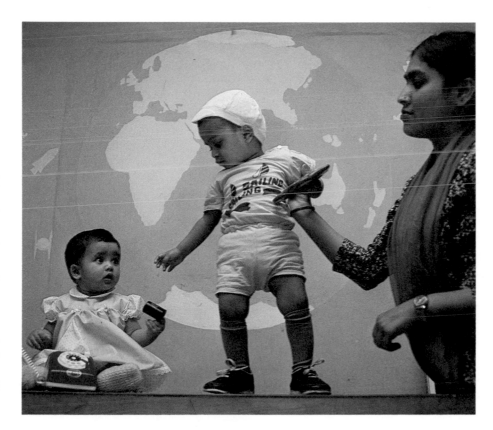

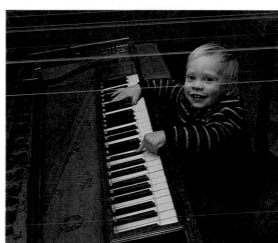

Bounce flash off white ceiling; acid green wall

Bounce flash off pale cream ceiling, no other strong colours around

Choice of film

Different types of colour film

Colour reversal film produces transparencies, colour negative film is used to make positive prints. A selection has to be made from a variety of film types within these categories: the correct choice of colour film vitally affects the end product. Different lighting conditions require different speeds of film: 'fast' for use in poor light, 'slow' for use in bright light. Some are balanced for daylight, others for tungsten lighting.

DAYLIGHT FILM

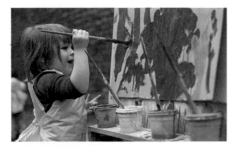

Slow film balanced for use on normal bright days.

Ektachrome 64 film (ISO 64/19°)

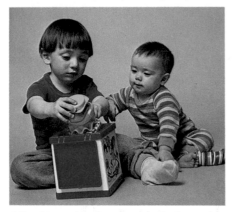

Also for use indoors with flash.

Ektachrome 64 film (ISO 64/19°)

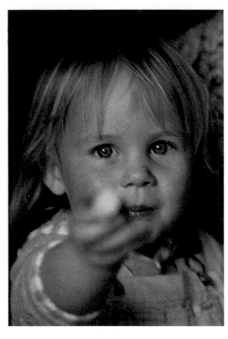

Outdoors when the light is bad, or for flash when more light is needed, faster daylight films can be used. The colours are more muted than with slower daylight films.

Ektachrome 400 film (ISO 400/27°)

In normal tungsten lighting, daylight film picks up the orange light shed by the filaments of a tungsten bulb. If required, this can be countered by a blue filter.

Ektachrome 200 film (ISO 200/24°)

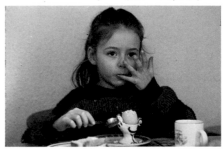

In extremely poor available light, even faster films are used. They are grainier and even more muted in effect.

Ektachrome P800/1600 film (can be exposed at ISO 800 or 1600).

TUNGSTEN FILM

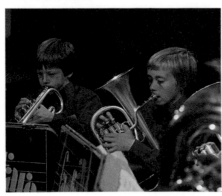

Special tungsten film can be used without flash in television or photographic studios with floodlights.

Ektachrome 160-Tungsten film (ISO 160/23°)

Faster tungsten film is required for use without flash under most ordinary household tungsten lights, or for a floodlit stage (pp. 130–31).

3M 640-Tungsten film (ISO 640/29°)

Film speeds

Three different speed markings are printed on film boxes:

ASA stands for American Standards Association.
DIN stands for Deutsche Industrie Norm.
ISO stands for International Standards Organization, and is the result of attempts to produce a world-wide standard. The ISO rating gives both the ASA and DIN numbers.

On many camera and flashgun setting dials, the DIN factor is ignored, and ISO and ASA are marked as identical. Whichever is used, it indicates the degree of the film's sensitivity to light, whether colour or black and white.

Each time a different kind of film is loaded, the corresponding number must be set on the camera dial.

FAST FILM (ISO 400/27° = 400 ASA = 27 DIN) is mainly for use in low light.
SLOW FILM (ISO 25/15° to 160/23°) is essentially for use in bright light or with flash.

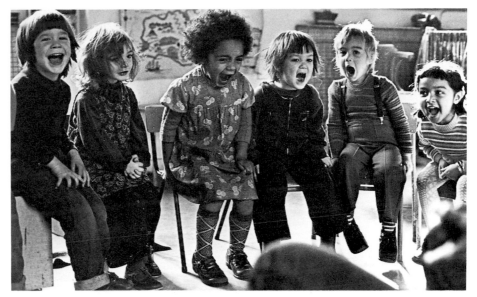

Leica M5 50mm lens f 2.8 1/60 sec. Tri-X ISO 400/27° (fast) film

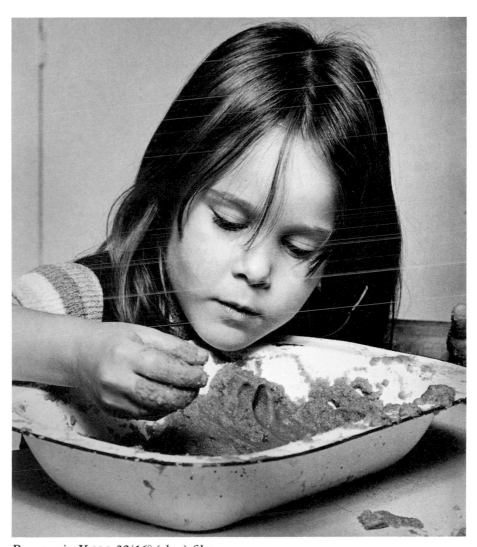

Panatomic-X ISO 32/16° (slow) film

Graininess

Fast films for use in poorer light are much grainier than slow films. Graininess can occasionally spoil a picture, but more often it introduces a warm, gentle effect which can be most appealing.

Normal fast ISO 400/27° film, when only slightly enlarged, shows very little grain indeed.

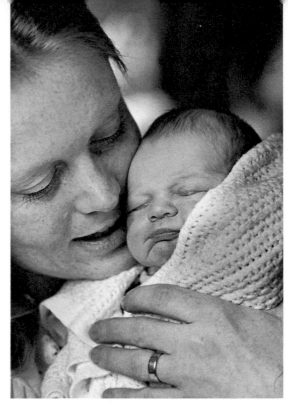

The grain becomes much more apparent in a huge enlargement:

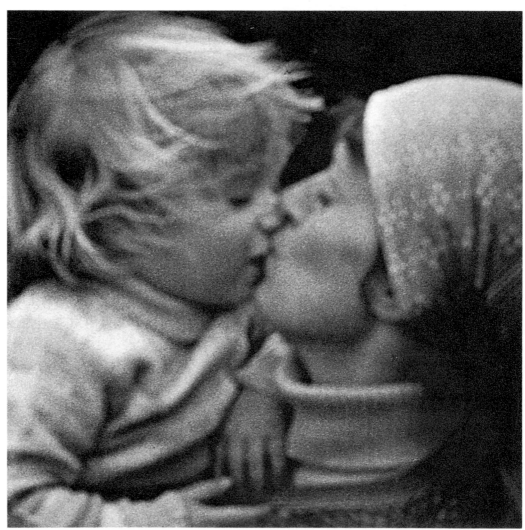

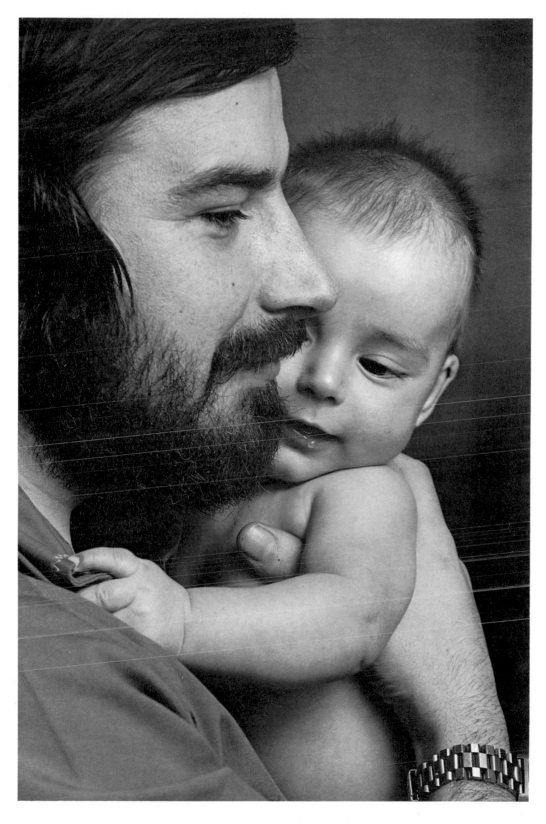

Less grainy, slower film demands more light which can be inconvenient in spontaneous child photography. But the almost tactile skin textures attainable in colour or black and white make the trouble well worthwhile.

One Bowens electronic flash studio light. Panatomic-X film ISO 32/16°

Manipulating natural light

The three basic elements of good photography are content (what is in the picture), composition (the way it fills the frame), and lighting (the calculated use of light to enhance and strengthen the image).

Unlike painting, where the artist can control colours or contrasts, photography is a mechanical and chemical process with numerous danger factors, such as wrong exposure, unsuitable film or errors in development, all of which can alter or threaten the end product. When the camera shutter opens and shuts, it is admitting a pattern of light on to the sensitized emulsion of the film, creating a latent image which only becomes a negative or transparency when processed in the requisite chemicals.

Though adjustments can sometimes be made while printing in the darkroom, emulsion is far less tolerant than the artist's paint, which he can continue to make brighter or paler at will while brushing it on to a canvas.

This is why accurate light metering is vital for photography in available light. It is why flashguns or floodlights are needed for poor light. It is why careful choice from the wide variety of film types on the market can make such a difference to the quality of the final photograph. Our eyes will adjust to various brightnesses of light, and even to near-darkness. An emulsion will not. The technical process of taking an image through a lens and imprinting it on to emulsion means that there must be not only enough light, but exactly the correct amount of light to obtain maximum quality from the film being used or to produce the special effect required.

Leica M2 f 2.8 1/125 sec.
Tri-X film

The accurate control of light reaching the film has to be mastered – an easy matter nowadays due to the advanced light meters built in to modern cameras, which, on many models can be set to fully automatic, taking over control of speed and aperture.

Then, to achieve really exciting and interesting photographs, there is a whole new world to be explored with the ways that light can be manipulated. The great difference between an adequate photograph or an artistically dramatic one is often quite simply the interesting use of light.

It is worth looking at the use of light in this photograph (*opposite*). To emphasize the tranquillity of these very young ballerinas stitching their pointe shoes, the bench has been turned about until the sun not only highlights their traditional dancers' hairstyles, but also picks out the darning thread and the autumn leaves. The light is manipulated here for both artistic and atmospheric effect.

Olympus OM1 f 5.6 1/500 sec.
Tri-X film

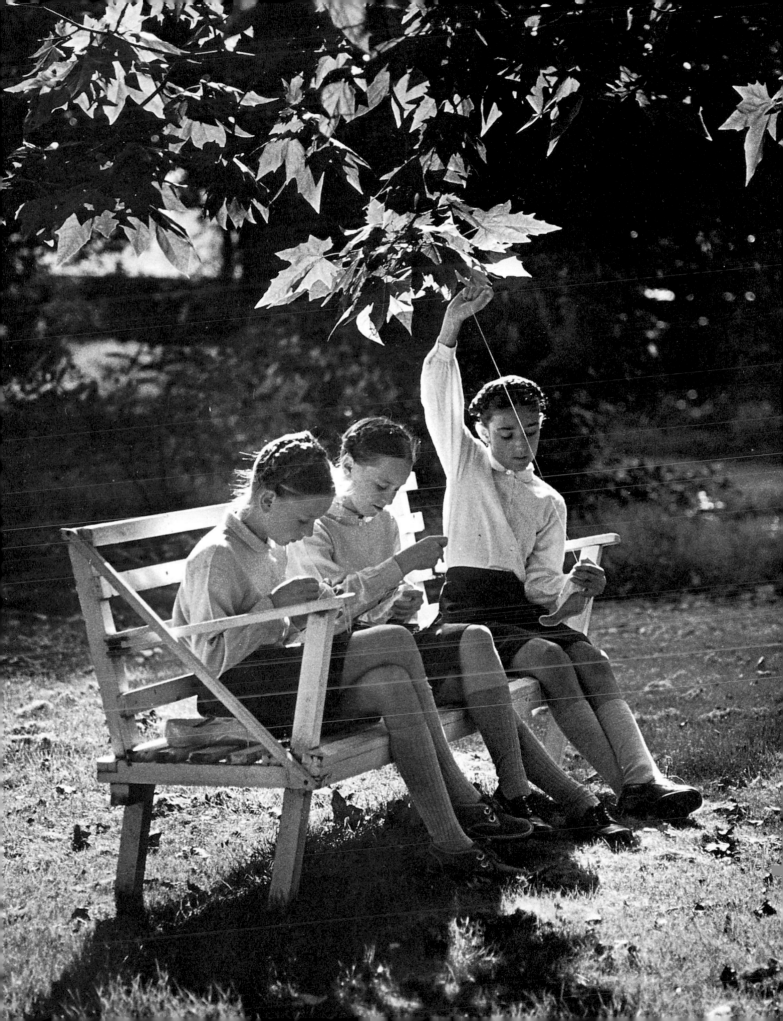

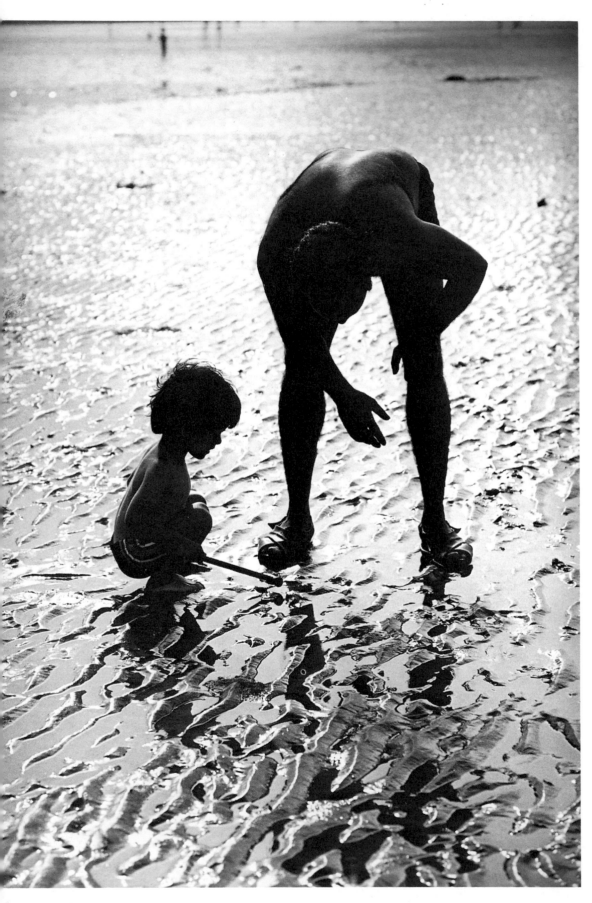

Backlighting

The best effects are usually achieved by backlighting (*contre-jour*), whether from carefully arranged studio lights, or an indoor window or outdoor sun.

Backlighting not only offers opportunities for exciting silhouettes, it lights up textures, gives a glitter to a photograph that can never be achieved with frontal lighting.

One danger with most fixed lens cameras is that lenses are built flat into the front of the camera, and no lens hoods are available to shield them from extraneous sunrays, which may enter and wreck the picture. A hand or a piece of card can be held above to shield the lens, but backlighting is much safer on the more advanced cameras due to the use of a lens hood, the higher quality coating on the better lenses, the more selective light metering, and the possibility of controlling exposure (see also p. 138).

Leica CL f4 1/1000 sec. Plus-X film orange filter to cut glare and add contrast

In the days of the primitive box cameras, photographers were always advised to stand with the sun falling over one shoulder directly on to the subject's face. Sun, though a gift to the skilful photographer, can ruin pictures. Too high in the sky, and the tops of heads will be overlit, while the shadows on the face will be ugly, the eye sockets black and empty (unless the photographer wants to bother with fill-in flash, p. 30). Worse still, the effect of sun dappled through trees on to a human face will be patchy, sometimes almost diseased-looking.

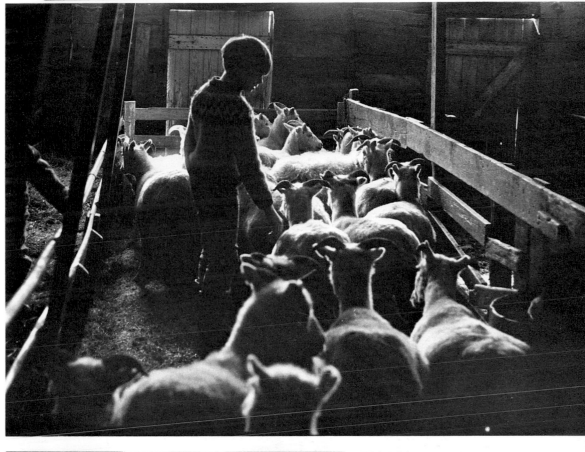

Often sun over the shoulder is the only solution. However, more beautiful effects are possible shooting against the sun, especially in the so-called magic hours, early mornings and late afternoons, when it is low in the sky, back-lighting hair like a halo.

Leica R4 135mm lens f4 1/250 sec. Tri-X film

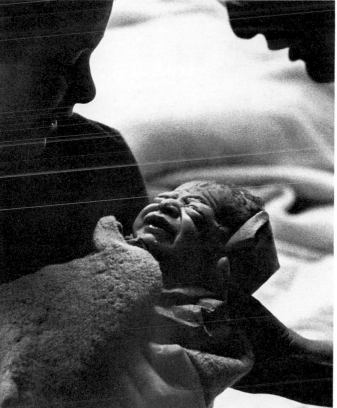

Trickling through a narrow window, sunlight can be used to create magical rim lighting.

Leica R4 50mm lens f2.8 1/60 sec. Tri-X film pushed 2½ stops

To a landscape photographer the differences of directional lighting are obvious; but they are equally important to the photographer of human beings. The way the face is lit, how the nose- and eye-shadows fall, the emphasis on the contours can change a tiny human face, just as they can visually alter the contours of a mountain or valley scene.

Olympus OM2 35mm lens f2.8 1/16 sec. Tri-X film pushed 2 stops

39

Grey days

Grey days are comfortable and easy for black and white photography. They present no problems of dark shadows or overbright highlights, though they offer no opportunities either for dramatic backlighting or effects.

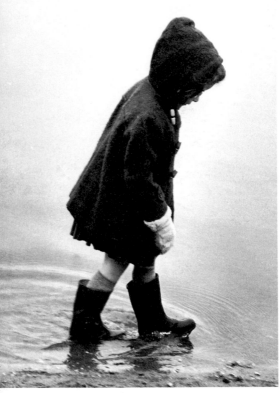

On a misty day, the background usefully neutralized, all emphasis is on the small girl trying out her new boots in a puddle.

Leica M2 90mm lens f 5.6 1/125 sec. Tri-X film

The lack of contrast afforded by the even lighting can be compensated for in the darkroom by printing on harder than average paper (p. 146).

Leica M2 50mm lens f 8 1/125 sec. Tri-X film printed on grade 3 paper

Colour temperature

Grey days are trickier when it comes to colour film. The human eye, though acutely sensitive to extremes of brightness and darkness, seems less perceptive towards changing colour temperatures. It is necessary to build up a new consciousness.

On grey days, blue predominates. Shadows are bluish – not black as the mind is preconditioned to believe – clouds too.

Sunlight has a strong yellow bias (especially in winter when the blue in the sky is not creating a counter-balance).

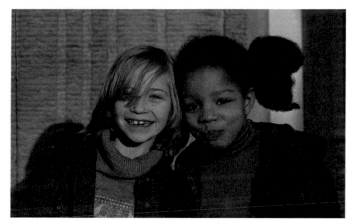

Even a pale sunset paints faces orange.

These colour biases show up more strongly in transparencies than in colour prints, which are optically colour corrected at the printing stage. (The more accurate the negative, however, the better the final print.)

Colour biases can be at least partially corrected with filters. The text book solution is that a blue filter counters an excess of yellow, and a light yellow filter an excess of blue.

However, flesh colours are better served by warming filters such as the pinkish brown 81B for dull days, the 81C for grimly grey-blue days, and the rosier 81A to improve skin colour in yellow light.

Leica R4 50mm lens f 5.6 1/125 sec. Ektachrome 64 film Hoya 81A filter to correct flesh tints without spoiling the yellow of the trees

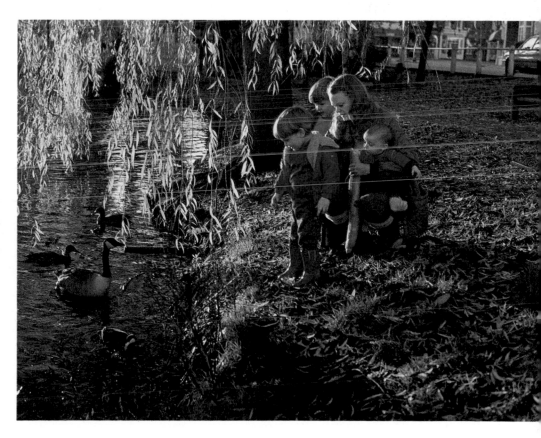

Indoor available light for colour

With light from a window, the colour temperature varies as much as it would if the photograph had been taken outdoors. On a grey day, this photograph would have come out dismally blue. Sun outside provided clear, cheerful lighting inside.

Olympus OM2 50mm lens
f5.6 1/125 sec.
Ektachrome 400 film

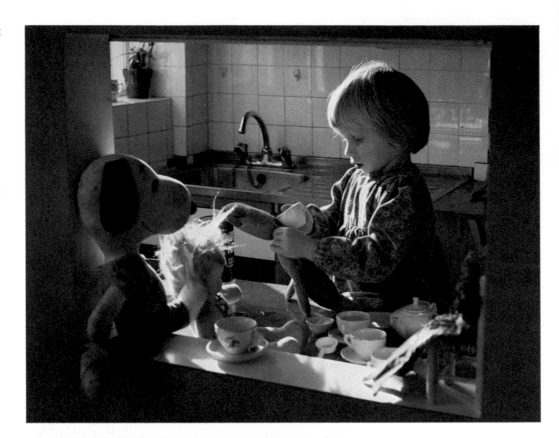

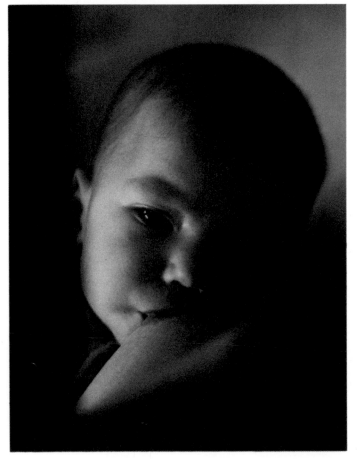

Mixed lighting can be effective. Window light here was combined with an ordinary overhead tungsten light. Though tungsten usually looks orange on daylight film, combined with daylight it creates pleasingly warm flesh tones.

Leica R4 60mm macro lens
f3.5 1/60 sec.
Ektachrome 200 film

42

Directional light from a window

In colder countries throughout autumn, winter and spring, children outdoors are bundled up to the ears. To show the person inside the anorak, the pictures have to be taken indoors.

Bounce flash (p. 26) is one solution for natural-looking lighting. Directional light from a window is frequently more interesting.

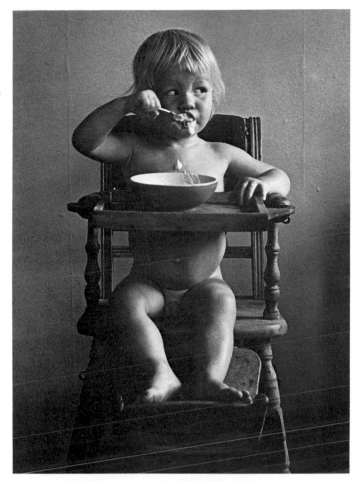

Light from a window at the side gives an almost three-dimensional effect to the baby in the high-chair.

Olympus OM2 35mm lens f 2.8 1/125 sec. Tri-X film

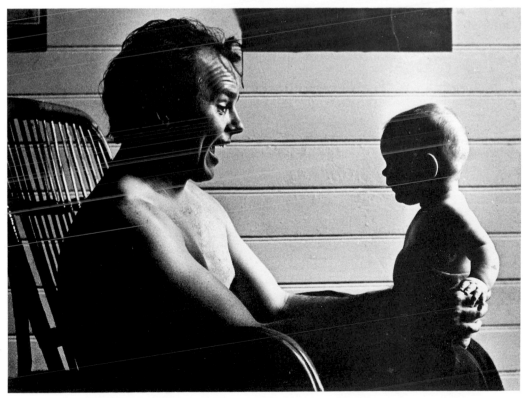

Again from the side, the strongly directional light through a full length french window is almost as dramatic as backlighting.

Olympus OM2 50mm lens f 2.8 1/125 sec. Tri-X film

43

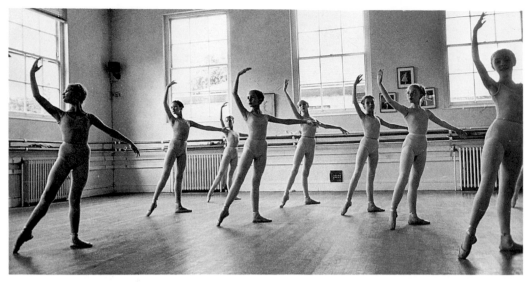

A multiplicity of windows brings the advantage of sculptural back- and side-lighting. It also introduces the hazards of a slightly busy background, but it is more interesting to see these thirteen-year-old dancers at the Royal Ballet School in their daily work surroundings than with the same effect created by artificial light against the artificial background of paper in a studio. Here the low viewpoint of the camera helps to maximize the framing qualities of the windows.

Leica M2 35mm lens f 2.8 1/125 sec. Tri-X film

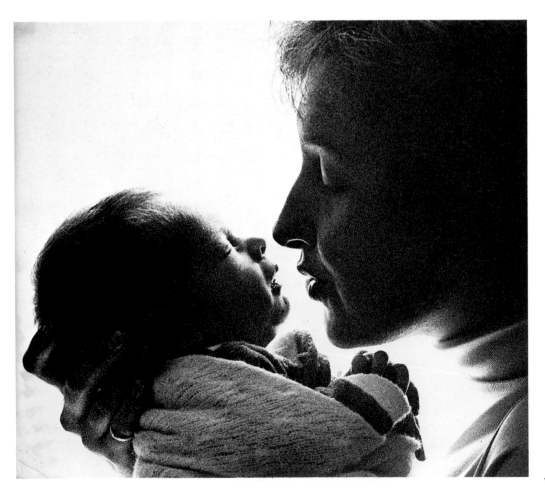

A plain wide contemporary window, with no complicated panes or patterns, not only provides interesting backlighting but also an uncluttered background, in this case giving maximum effect to the symbiotic match-mix – the profiles of mother and baby coming together like two pieces of a jigsaw puzzle.

Olympus OM1 50mm lens f 2 1/125 sec. Tri-X film

Extreme low light

Only a faint vent of light illuminates the excitement of these Icelandic farm boys as they enter the dark barn where their father's sheep winter, to discover the first lamb of the season. In the dark-roofed, ancient building, bounce flash would have been impossible; direct flash would have startled the lamb and eliminated the faint yet beautiful lighting.

The ISO 400 film was uprated to ISO 1600, the slowest possible shutter speed set (and great care taken to avoid camera shake). At home in the darkroom, the film was 'cooked' in special developer. The result is

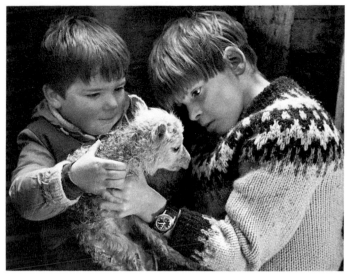

grainy, but the atmosphere of the moment is captured.

Shooting at 1/30 second, or even 1/60, presents a risk of camera shake. Practice is needed even for those with the steadiest hands. It is important to squeeze rather than press the shutter release and to hold the camera steady against the face. Tripods are too cumbersome for spontaneous photography.

Leica R4 50mm lens f 2 1/30 sec. Tri-X film uprated 2 stops, developed in Diafine (p. 143)

If there is light, there is a photograph. The greatest extent to which I have pushed my camera and the steadiness of my hands was at a 'Leboyer-style' home birth. The parents had decided that their baby should be born in virtual silence and darkness so that her coming into the world would not be too much of a shock to her. All I was allowed was a small, shaded lamp 18 feet across the darkened room. I used a Leica M series camera, with one of the quietest shutters in the world, and I did not bother even to look at a light-meter, but shot at the widest possible aperture at the slowest speed I dared, relying on yet another very special chemical stew in the darkroom. Nothing venture, nothing gain! These pictures have been published world-wide.

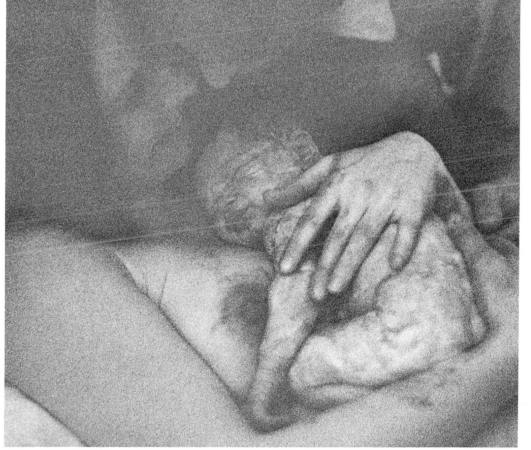

Leica M5 50mm lens f 1.4 1/15 sec. Tri-X film uprated indefinitely, Acuspeed developer used for triple the recommended time

45

Composition and content

Rules of all sorts exist about composition: about the 'classical apex', the 'golden proportions'. The main subject, according to the old dictates, should occupy two-thirds of the picture area, leaving one-third as a balancing background. This formula may of course produce aesthetically satisfying work; however, a photograph that breaks all conventions could have equal or greater impact. Some element of compositional harmony should be sought, but, as in music, sometimes an unexpected discord refreshes, excites.

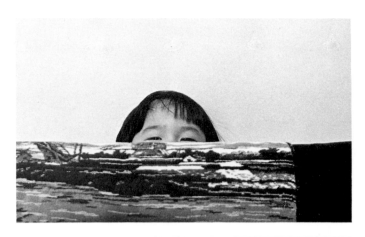

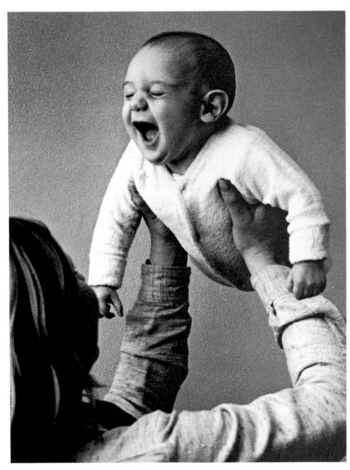

It is interesting, nevertheless, to experiment with the old theories about composition and shape: diagonals are said to be restful, while an S shape is thought to be disturbing. Any formula repeated too often will become boring, but it is worth bearing in mind the classical idea that the subject should form a triangle or apex within the rectangle.

Though it might just as well form a diamond . . .

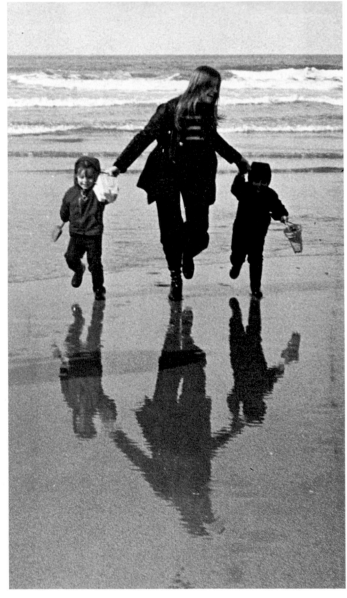

. . . or an X.

I was not thinking in terms of geometric shapes, however, when I took this photograph: I was intent on the contrasting expressions of the Irish sisters. I only noticed the X shape later in the darkroom.

Positioning of the subject within the format is a matter of instinct, an instinct which grows with experience. With children in action, the photographer has to rely on this instinct. There will rarely be time to plan.

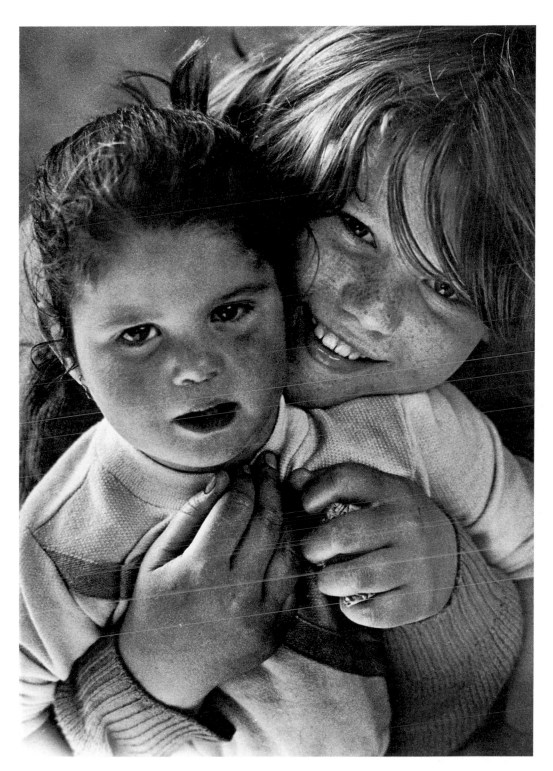

Format and focus

Another preconception to challenge is that a photograph always has to be rectangular. It could be square or circular or oval (p. 144).

The convention of photographing head and shoulders in an upright rectangle is so established that editors often ask photographers for a 'portrait' shaped picture, meaning a vertical one. This photograph (*right*) in official editorial language is a 'landscape'!

Equally absurd, this scenic picture would editorially be described as a 'portrait'.

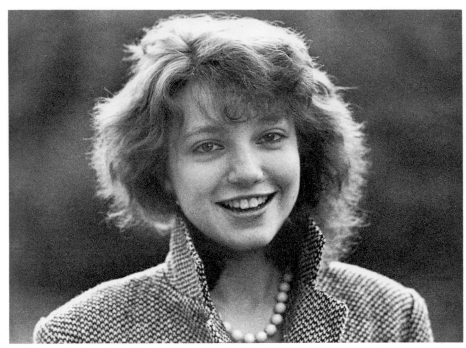

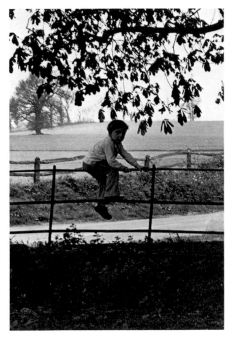

There is much to be said in favour of the horizontal head and shoulder shot. If the portrait had been vertical so that more of this teenager's coat had been included, its strong pattern would have taken the eye down and away from her challenging expression. With horizontal framing, the background can be thrown right out of focus leaving the image to emerge with greater clarity.

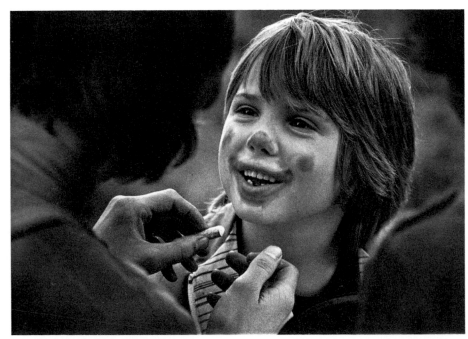

Selective focus is an important aspect of composition. While not wanting for dramatic reasons to leave out a second character in a situation, yet wishing all the emphasis to be on the chief protaganist, a half-focused hint of the other presence is enough; a sort of funnel through which all the attention is drawn to the emotional centre of the picture.

. . . or an X.

I was not thinking in terms of geometric shapes, however, when I took this photograph: I was intent on the contrasting expressions of the Irish sisters. I only noticed the X shape later in the darkroom.

Positioning of the subject within the format is a matter of instinct, an instinct which grows with experience. With children in action, the photographer has to rely on this instinct. There will rarely be time to plan.

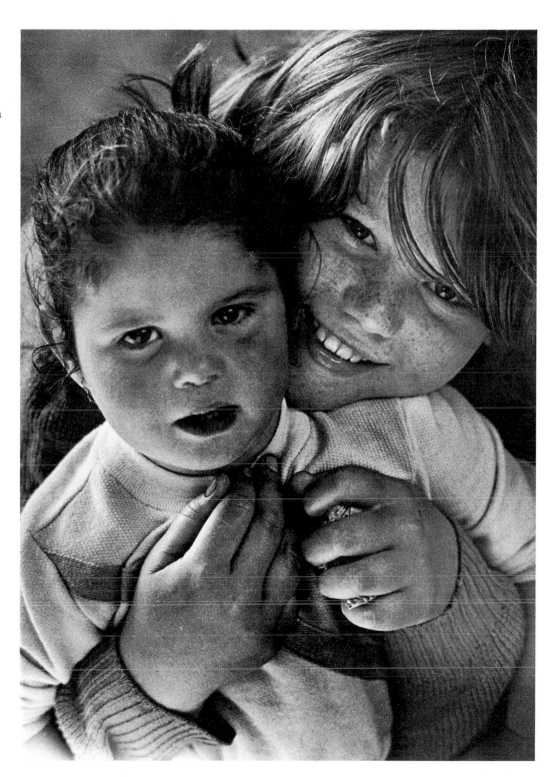

Format and focus

Another preconception to challenge is that a photograph always has to be rectangular. It could be square or circular or oval (p. 144).

The convention of photographing head and shoulders in an upright rectangle is so established that editors often ask photographers for a 'portrait' shaped picture, meaning a vertical one. This photograph (*right*) in official editorial language is a 'landscape'!

Equally absurd, this scenic picture would editorially be described as a 'portrait'.

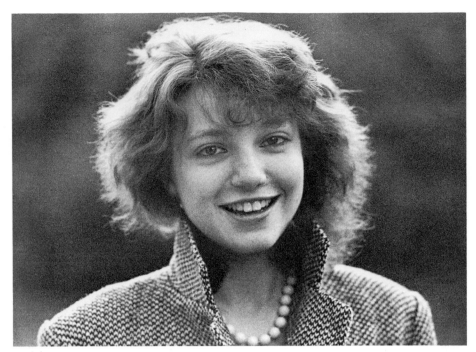

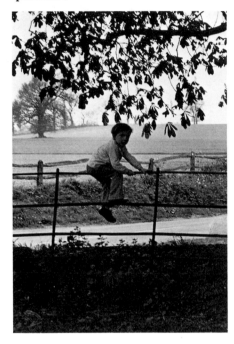

There is much to be said in favour of the horizontal head and shoulder shot. If the portrait had been vertical so that more of this teenager's coat had been included, its strong pattern would have taken the eye down and away from her challenging expression. With horizontal framing, the background can be thrown right out of focus leaving the image to emerge with greater clarity.

Selective focus is an important aspect of composition. While not wanting for dramatic reasons to leave out a second character in a situation, yet wishing all the emphasis to be on the chief protaganist, a half-focused hint of the other presence is enough; a sort of funnel through which all the attention is drawn to the emotional centre of the picture.

Backgrounds

The essence of the picture should dominate, the surroundings decorate as well as draw the eye inwards to the core of what is happening.

Ideally shapes in a normal home background can be exploited to lead the eye inward towards the subject. In this way the environment is used to enhance rather than hinder the overall composition.

An easy way out of compositional difficulties, however, is to have an absolutely plain background.

This baby, who has only just learnt to sit alone, has been placed on a dark brown carpet in front of a dark brown sofa. The humour of the picture, her colossal effort to stay upright, reinforced by her mistaken belief that by gripping her toe she is actually supporting herself, is brought out by the neutral surround.

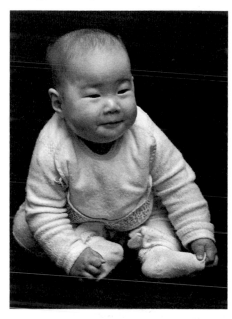

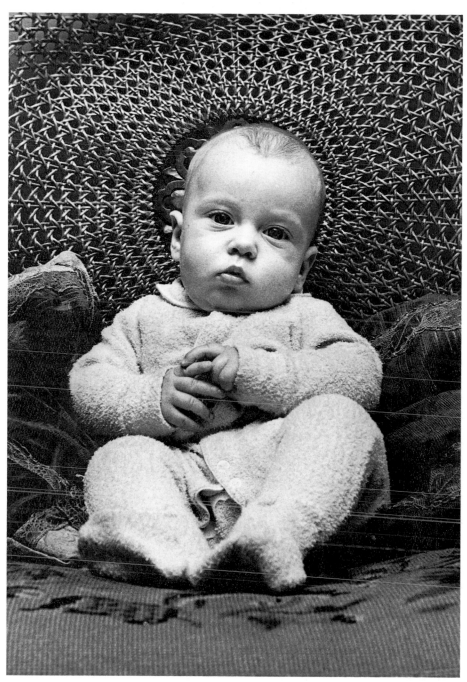

Spontaneity or studied composition?

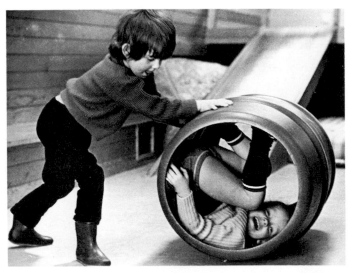

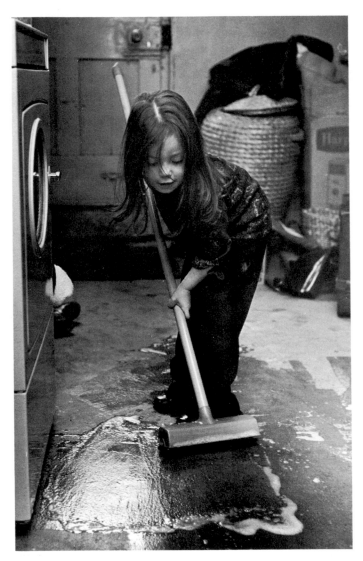

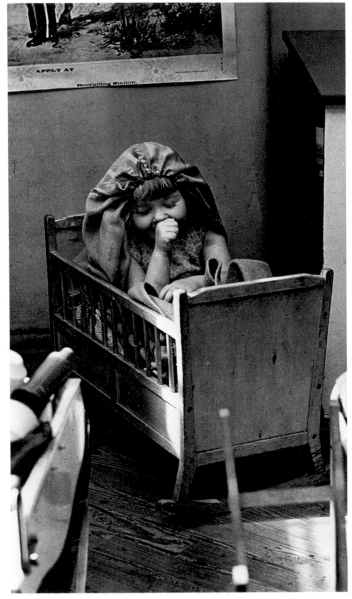

In child photography it is more important to achieve life and spontaneity than to produce pictures with perfect composition.

Though each of these three pictures would have been artistically better with uncluttered backgrounds, it was right to shoot first – catching the moment – then attempt to improve the back-ground. Possibly greater photographic impact would have been achieved by better framing and angle. However, in each case, to have moved the children against a more desirable background would have interrupted their absorption and concentration upon their activities – like a light going out – and subsequent photographs would have been dull and pointless.

Sometimes it is possible to take the spontaneous picture first, then work quietly on improving the pictorial quality without disturbing the child's enjoyment.

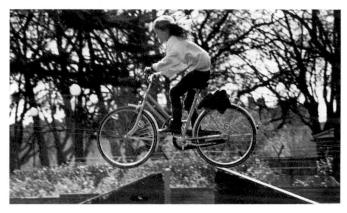

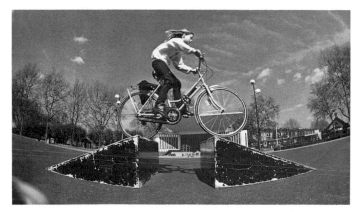

A girl is seen across a playground, circling, again and again making her cycle leap. She might get bored and go at any time. So first it is worth grabbing an instant shot with whatever lens is on the camera.

Leica R4 90mm f8 1/250 sec. Plus-X film (against the sun)

Fortunately she is so wrapped up in the excitement of her daring leaps that it is possible not to spoil her fun by coming in close, asking her permission and continuing to shoot: a different angle, a different lens, a different photograph.

Low angle viewpoint with sun over shoulder, 16mm lens with yellow filter to accentuate clouds

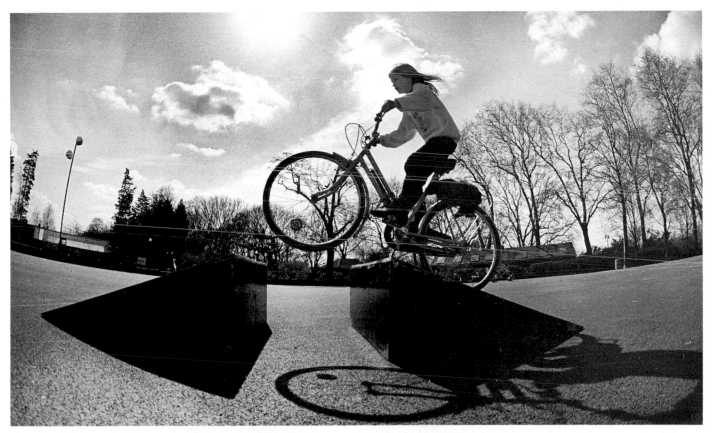

While the action is still there, perhaps an even better picture can be found? Returning to the *contre-jour* side, retaining the extremely wide angle lens, and getting in really close to the subject, it is possible to achieve something nearer to the girl's own sensation virtually of flying.

Low angle very close to subject and against the sun, also 16mm lens with yellow filter

51

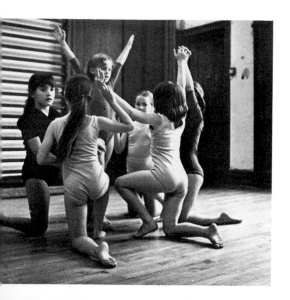

High angles/low angles

Fresh viewpoints lead to fresh interpretations of everyday subjects, and you may arrive at a more interesting framing or a plainer background.

It was dangerous hanging from the top of the wall bars, with only one hand to aim the Leica, but worth the risk: instead of school noticeboards intruding just behind the heads of the young dancers, their silhouettes were cleanly framed in the angle of the floor.

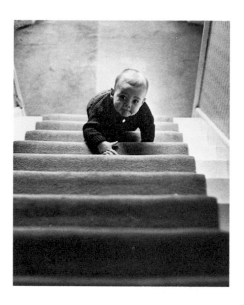

From above, perspective consecutively reduces the width of the more distant stairs, producing inward-leading lines which draw the viewer's eye towards the baby, while the plain patch of carpet on the floor behind leaves his head clearly outlined. The distant rather than close-up view produces a sense of the height he has yet to climb.

The view from below exaggerates the depth of each stair and indicates the triumph of his achievement.

Leica M2 35mm lens f4 1/125 sec. Tri-X film pushed one stop

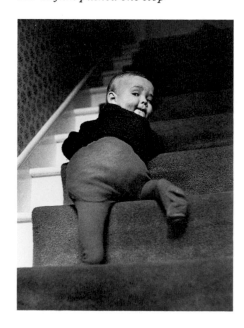

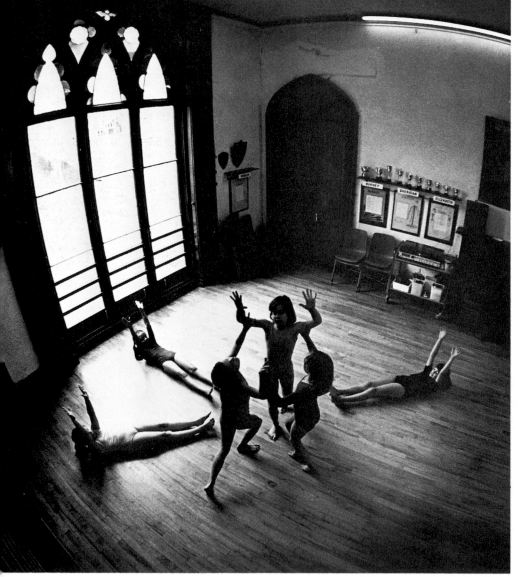

Leica R4 16mm lens f4 1/60 sec. Tri-X film

The boy on the swing was photo-
graphed first from a standing position,
then, only a second later, almost
from ground level. The lower view-
point not only adds to the drama and
sense of height, but also illustrates
the value of an uncluttered back-
ground.

Leica R4 50mm lens f8 1/250 sec.
Tri-X film

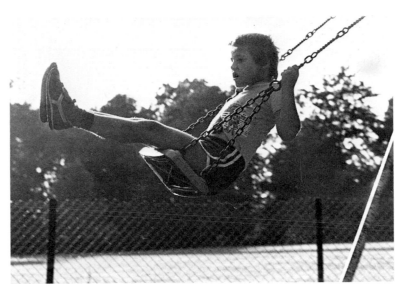

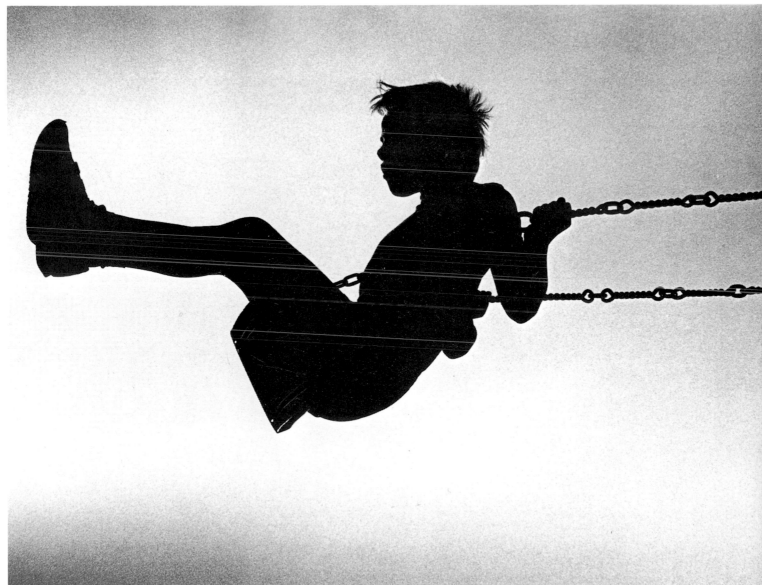

High key/low key

Another dimension and mood can be introduced by thinking in terms of high key and low key photography, both with colour and black and white.

The delicacy of high key at first seems more suitable than low key for babies.

Olympus OM1 50mm lens
f 5.6 bounce flash
Plus-X film

Leica M2 50 mm lens f4
1/125 secs. Tri-X film

Light toned subjects on pale or vignetted backgrounds (p. 146) with even, clear unshadowy lighting, help to achieve high key effects.

Leica R4 60mm macro lens
f 3.5 1/125 sec. Tri-X film
vignetted in darkroom

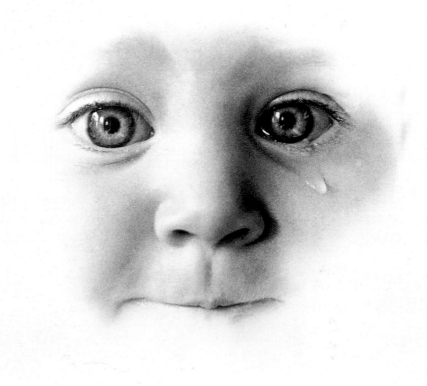

54

It is equally worthwhile to try to perceive in terms of low key, with its dark areas and warm tones. Though less conventional for babies, it brings variety, often drama to the pages of an album.

Leica M5 50mm lens f 8 studio flash Plus-X film

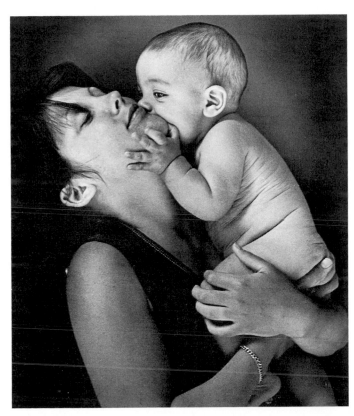

Directional light (p. 43) and darkish backgrounds are helpful in producing low key effects.

Olympus OM2 50mm lens f 2.8 1/125 sec. Tri-X film

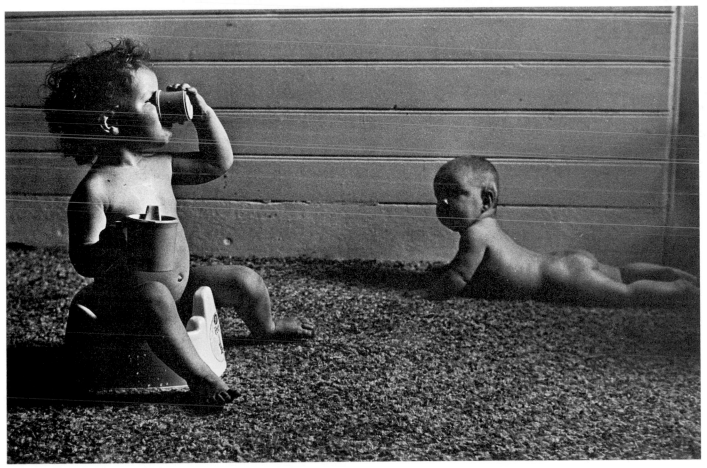

Framing the subject

Surroundings can be decorative as well as fulfilling their function of drawing the eye inward.

Framing the subject can be achieved in many different ways by a creative photographer. For a learner who is trying to improve the artistic quality of photographs, a valuable exercise would be to go out and about for several days, putting every single shot into some sort of a frame.

The frame may be on the same plane as the subject, as a sort of halo behind, or in the foreground. Sometimes a frontal plane frame will have to be out of focus; however, with care, this can serve to further emphasize the main subject.

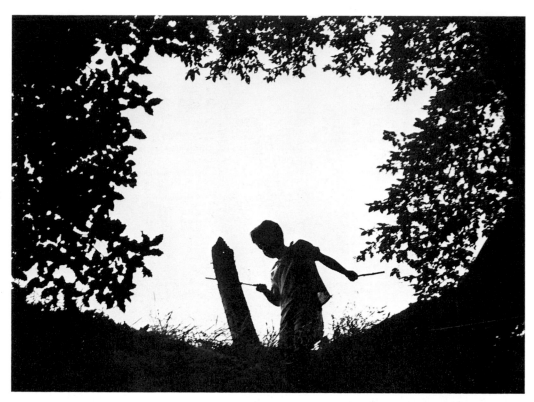

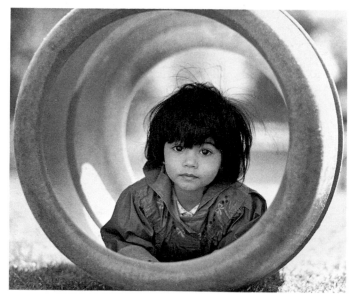

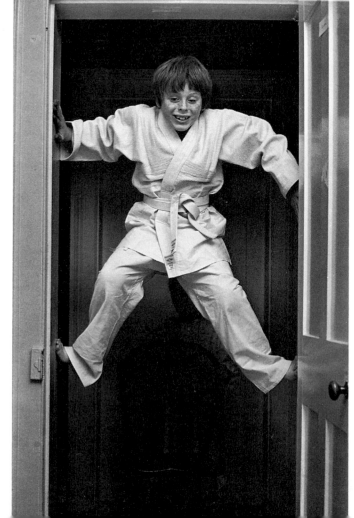

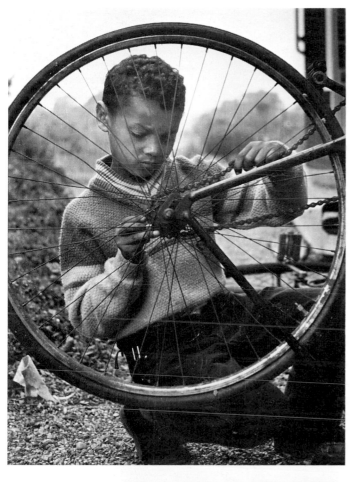

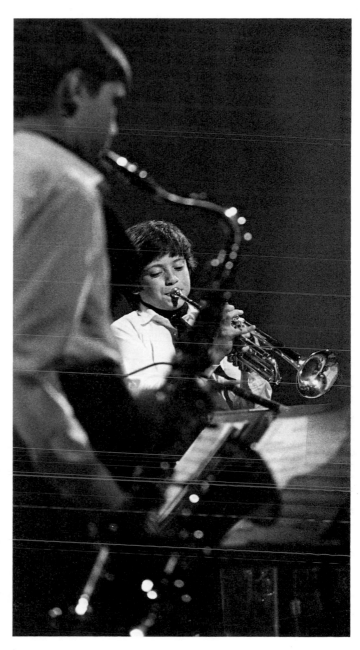

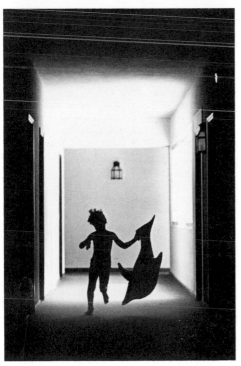

Reflections

Reflections are another inexhaustible area of compositional interest. Mirrors are not the only source. The perceptive eye will find them in all sorts of strange places.

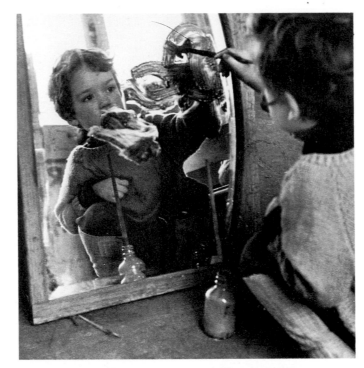

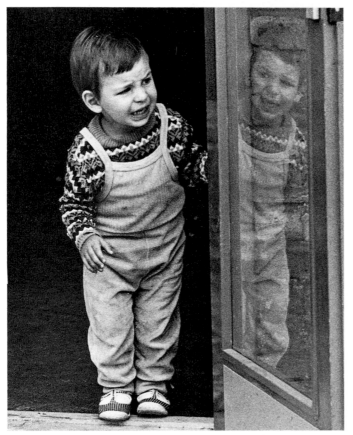

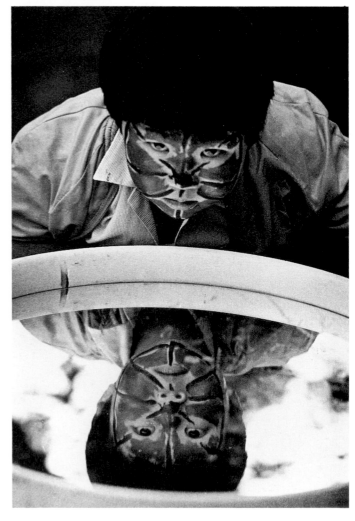

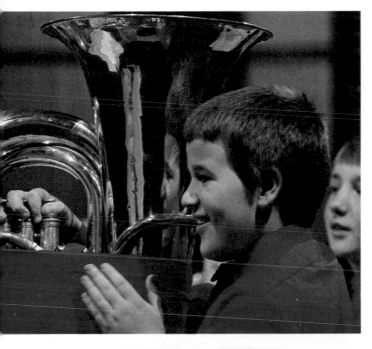

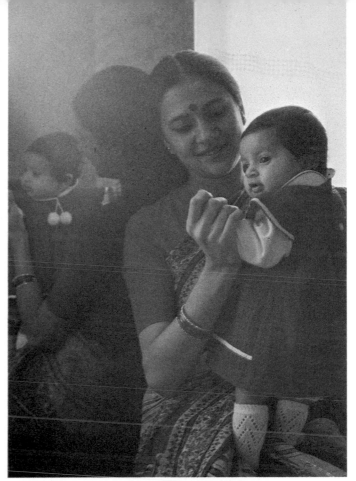

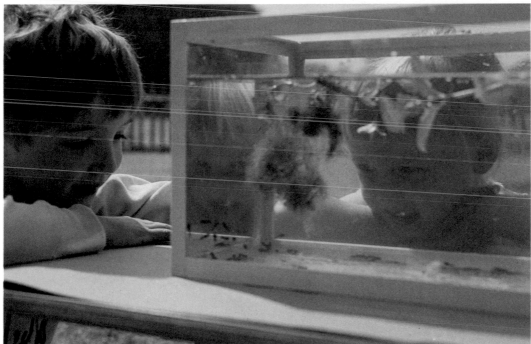

Children in action

Action photography tends to conjure up an image of fast horizontal movement. However, it is often visually more exciting to catch a child mid-air than mid-sprint; to see him reaching new heights on a trampoline, testing out his nerve in a courageous leap. Or simply jumping for joy.

This air-born tendency in children is often best depicted in silhouette by shooting from a low angle against sea or sky.

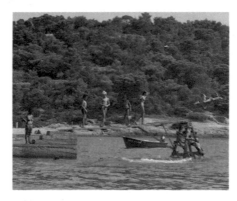

A busy background tends to minimize the drama. When I first saw these leaping children, the sun was over my shoulder.

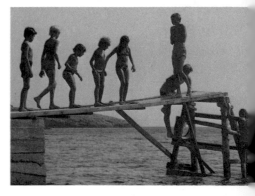

Closer, from a lower viewpoint, even partially silhouetted against the sky, the effect was less dramatic than true *contre-jour*.

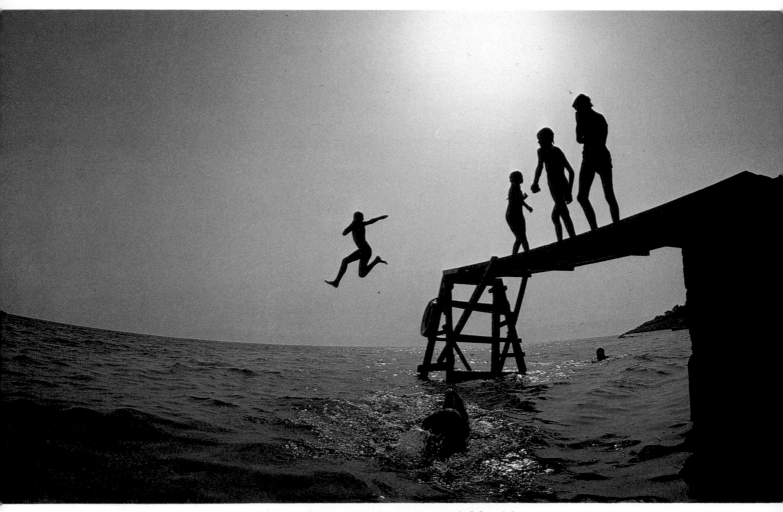

Olympus OM2 16mm (semi-fisheye) lens
f16 1/1000 sec. Kodachrome-X film

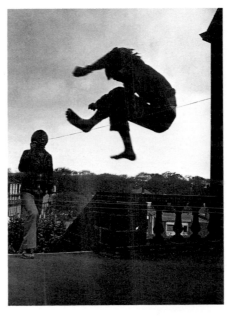

Silhouettes in action express not only speed and movement: they can be as indicative of personality as facial features. The one-time sufferer of the Vietnamese boat exodus, now at school in the West, demonstrates all the natural grace and angular movement of a Chinese classical dancer.

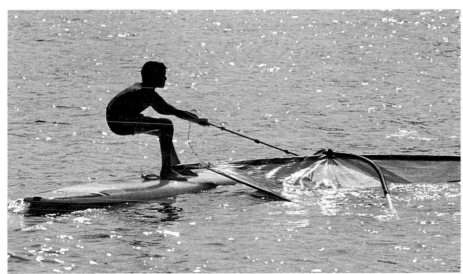

Humour at sporting failure may also be more strikingly stated through body language than by expression of eyes and mouth.

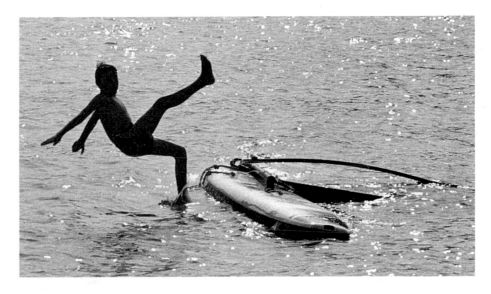

Planning and judging focus

The photographer needs more speed than the subject.

Just as a driver in a moment of emergency knows her own car well enough to react on 'automatic pilot', equally, in photography, each opportunity for a fast action shot needs emergency adrenalin and instant perception and judgement. This can only be achieved through a great deal of practice, leading to rapid reflexes and an intimate knowledge of how your own camera and flash equipment responds in different working situations.

It is possible sometimes to preconceive likely effects. The children had been playing their jumping game for some minutes before I managed to catch one of them mid-window-frame.

Leica M2 35mm lens f4
1/125 sec. Tri-X film

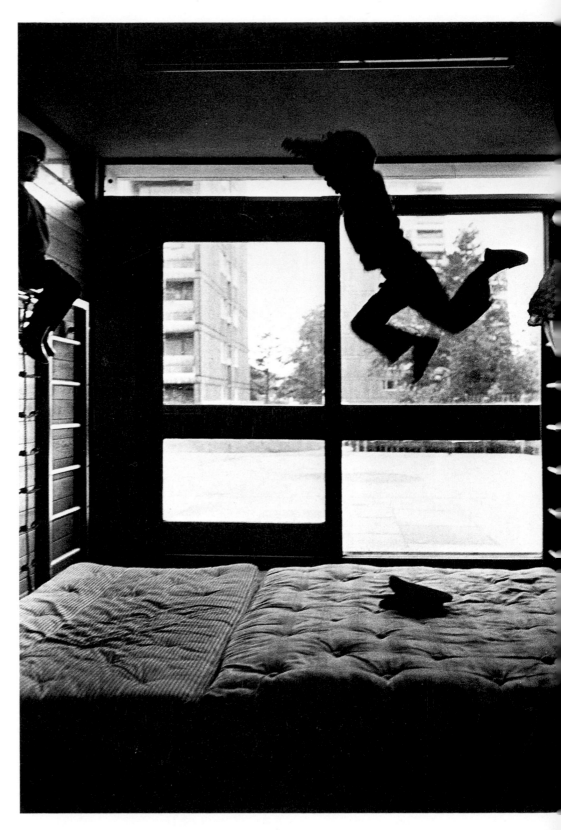

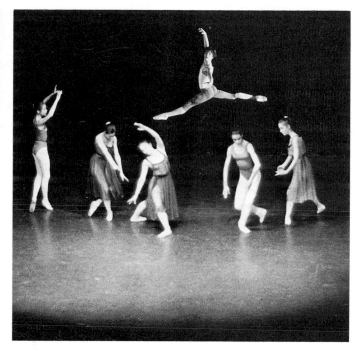

In photographing a ballet rehearsal, some experience is required to be able to anticipate and catch the young dancer just as he flattens out at the top of his leap.

Olympus OM1 100mm lens f2.8. 1/125 sec. Tri-X film

It is more difficult to focus when the subject is moving directly towards the camera than if the speeding object is passing in a parallel line or arc across the photographer's vision. If a child is hurtling towards you, the focus point is altering every fragment of a second. An autofocus camera could be a solution, but only when one main subject is central in the viewfinder (p.15). An autofocus infra-red sensor beam might have missed all four of these leaping boys, leaving all of them blurred but the wall perfectly in focus. To achieve focus with a manually controlled camera, it was necessary to pre-plan, to ask the boys to rehearse the jump two or three times, in order to assess the precise area on which to focus.

Leica M2 f5.6 bounce flash off ceiling Tri-X film

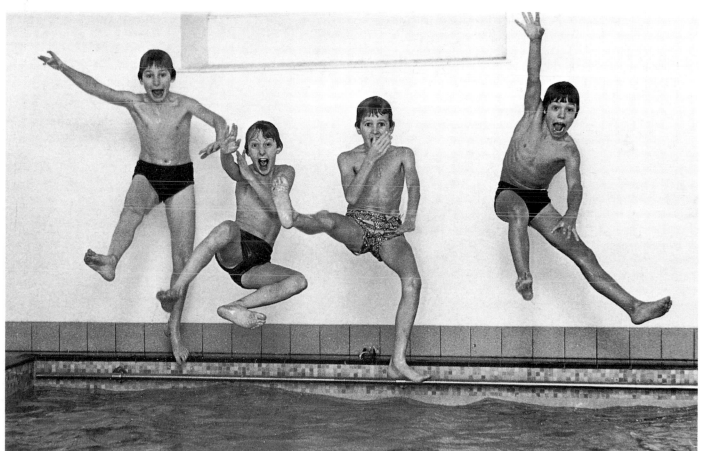

How fast is action?

Action photography is normally associated with sport or speed. However, just as much skill and fast reaction is needed to obtain photographs of rapidly changing expressions, say a baby's face as it is crumpling up ready to cry.

Olympus OM2 100mm lens f2.8 1/125 sec. Tri-X film

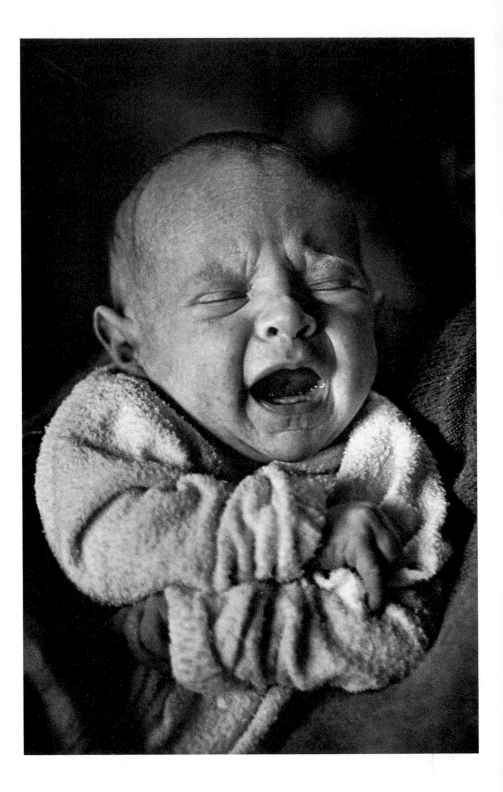

Almost every photograph in this book could be described in some ways as an action photograph.

It is harder to catch the way that a tottering toddler tilts as he lifts one foot in front of the other than it is to catch a ballet dancer in mid-air (p.63).

Olympus OM1 50mm lens f 5.6 bounce flash

Moments like these need planning, patience, luck, and the acceptance that it is impossible to win every time.

Autowind or motor drive?

With the minute and subtle movements of babies, as with sport and more obvious action, an autowinder can be extremely useful.

Motor drive or autowind attachments are available for most advanced camera systems.

I prefer the lighter-weight autowind to a motor drive. Though its action is not usually continuous or as fast as a motor, it conveniently winds on one frame at a time as soon as the photograph has been taken, so that the camera never has to be taken from the eye while the action is on.

The motor drive blasts off film at the rate of six or ten frames a second. Possibly one of those frames will contain the desired dynamism and excitement the photographer is trying to catch. However, a 36-frame film can be used up this way so quickly that the film runs out just before the best moment arrives. With judgement this danger can be overcome, but the tendency to use too much film too soon is almost overwhelming.

(Some makers offer special camera backs which hold giant film rolls of 250 frames, but a motor drive already is a heavy extra; the wider camera back is a further encumbrance.)

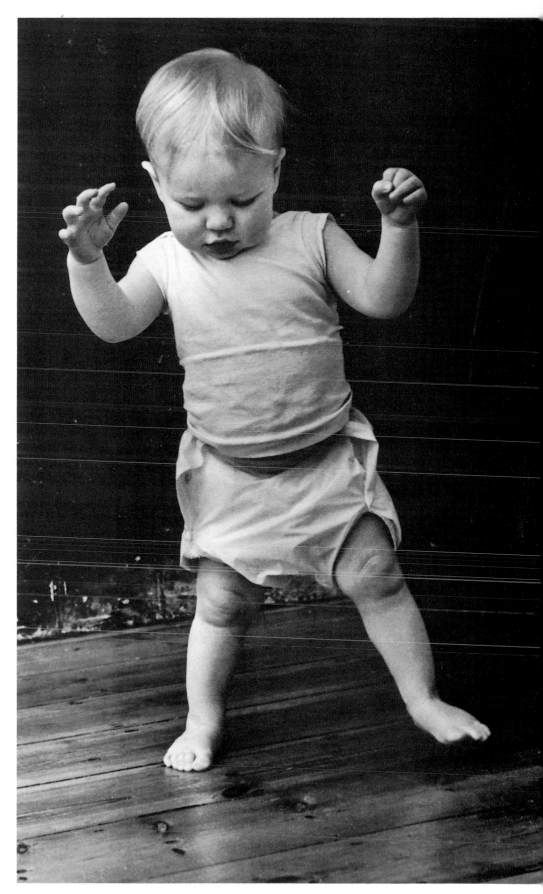

Stopping movement or intentional blur

Depending on subject matter, high speed is sometimes better expressed by freezing the movement, sometimes by allowing a certain amount of blur.

One way to freeze movement is with a flashgun, which in most cases goes on and off in 1/1000th of a second or less.

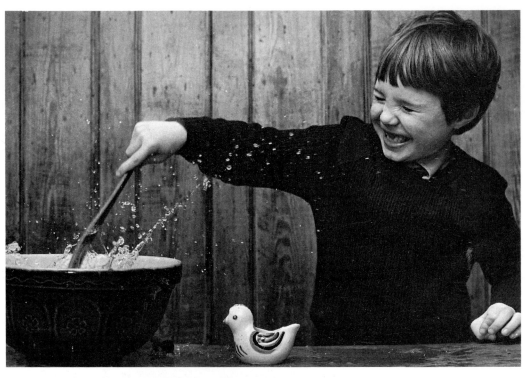

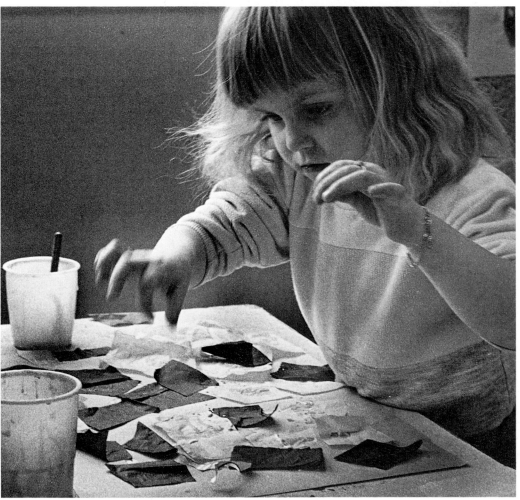

Another way is to use the highest shutter speeds: 1/250 second stops the movement enough to catch hair standing on end in shock – a dramatic rehearsal moment (*opposite*).

A slower speed of 1/60th second renders this busy young artist quite sharp but shows the intensity and the speed of her work on her collage by the blurred movement of her hand.

Movement towards the camera produces less blur than horizontal movements along one plane in front of the camera.

66

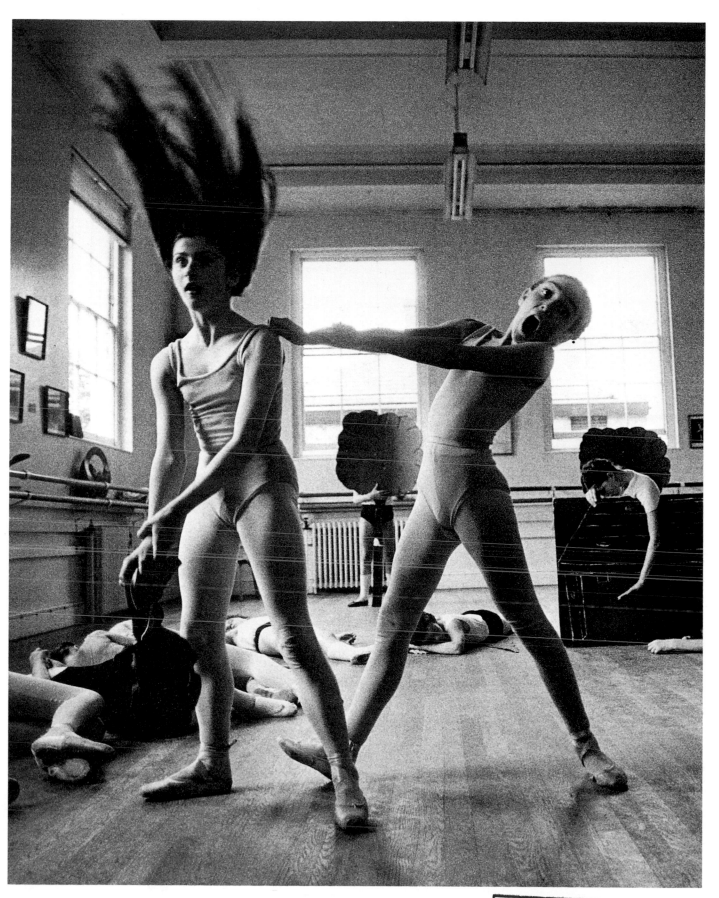

Panning

Probably the most effective way of expressing speed is panning.

The shutter speed for panning should be between 1/8 and 1/30 second. Panning unfortunately is almost impossible on fully automatic cameras, except by using very slow film (say ISO 32 or 64) in very poor light, or dark (neutral density) filters so that the automatic speed selector will choose a lower speed.

With automatic cameras where the aperture can be controlled, however, the aperture should be set probably to f16, even f22, whichever produces the appropriate shutter speed. With manual cameras, the speed is set at 1/15th second and the aperture altered accordingly.

The subject needs to be passing the photographer at speed.

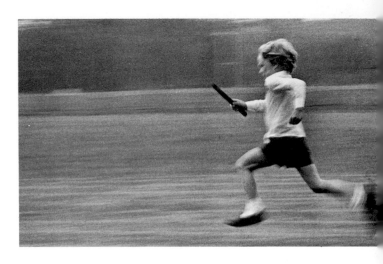

As this young runner approached from the side, I focused on him, moving the camera exactly at his pace. As he passed me, I released the shutter, following through, always keeping a steady movement precisely with the runner. Because the camera is moving at exactly the same rate, the subject comes out sharp, and the background shows the pronounced blur of the 1/15th second slow exposure.

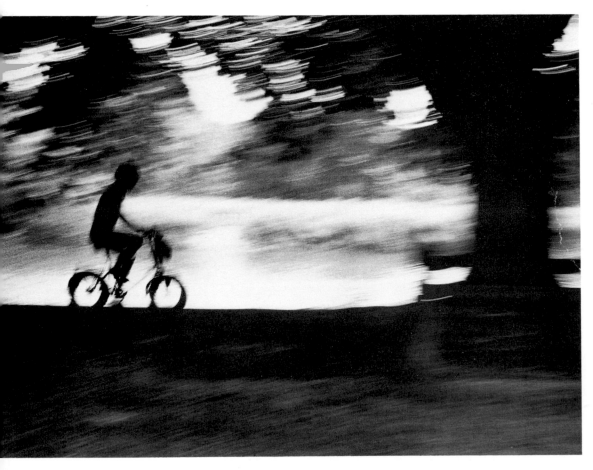

Once the long slow movement at the same speed as the subject is mastered, it is worth trying a shorter sharper burst of equal speed, as it sometimes produces a more interesting background effect.

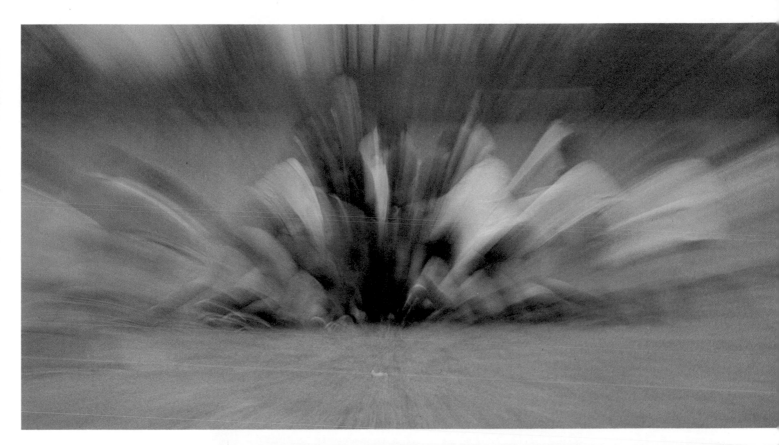

Zoom burst shots of moving subjects create unpredictable and often interesting abstracts.

Leica R4
75–200mm zoom lens
f11 1/15 sec.
Ektachrome 64 film

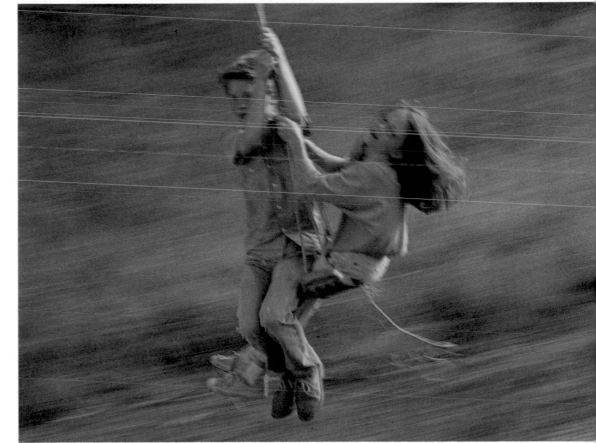

Panning can be even more effective in colour.

Leica R4 90mm lens
f16 1/15 sec.
Ektachrome 64 film

What is a portrait?

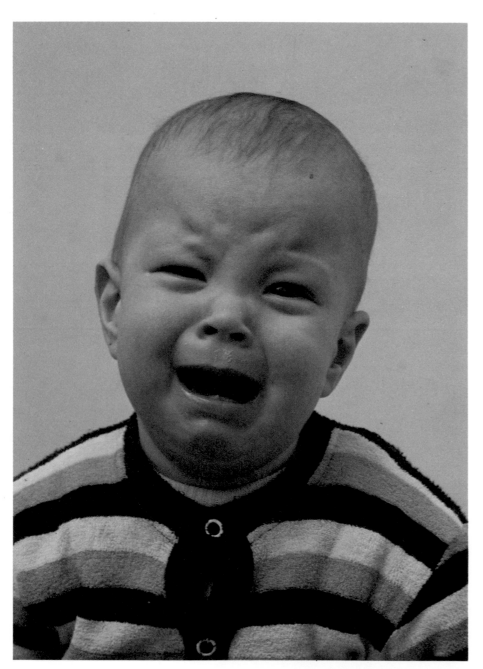

Does it have to be happy?

Does the child have to be beautifully dressed?

Do the features have to show clearly?

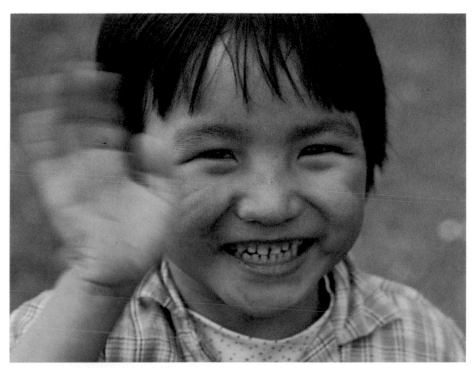

Does the 'sitter' have to stay still?

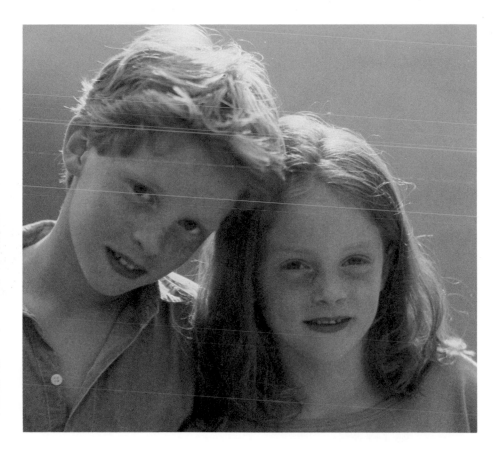

Does it have to be in a studio?

Background: coloured paper hung from washing line
Lighting: evening sunlight from behind the subjects
Toning: sepia filter, Cokin no. 005

Convention seems to demand a studio
picture of an immaculately clothed,
static child: but will this be a portrait?
Or a travesty of a real person trapped
inside an imposed image?

Of course characteristic portraits can be achieved in studios.

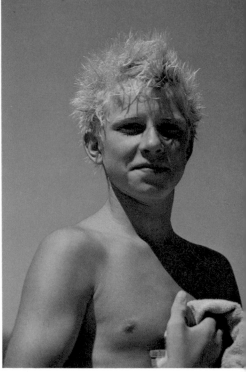

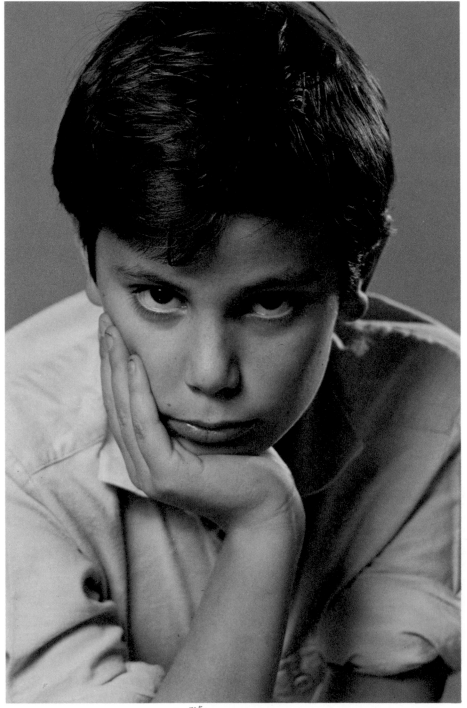

But, if the purpose is to convey what
the person is like, rather than where
his parents buy his clothes, the scene
can equally well be the beach.

A true portrait should be as much
about the character of the subject as
his or her features. For the parent,
it will be a moment preserved: the
fast growing, ever-changing child as
he was when deliciously small – or
perhaps the teenager before she
becomes a woman. Sometimes a
child portrait can give a surprising
hint of the future adult.

Unfortunately, many so-called portraits fail to express any sign of character. Fearing the opinions of neighbours or mother-in-law, parents tend to set the scene for an unnatural, idealized version of the child, with clean face, tidy hair, stiff new clothes, constrained to sit still. No wonder so few commercial portraits show the individuality of the imprisoned sitter, glued to a studio seat, attempting grimly to cooperate and provide the obligatory smile.

It is worth trying to imagine this truculent yet sensitive country child, her face scrubbed, hair immaculate, trapped in a studio being told to say cheese. Which picture would better represent her true character?

Eyes are even more important than smiles. The spirit of the child needs to shine out. Eyes are the windows on the soul.

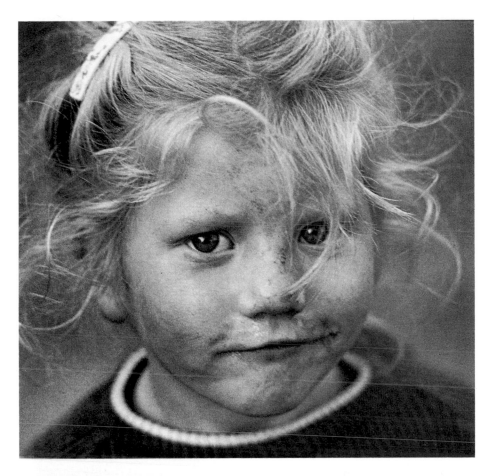

A portrait should do more than define a person's character. It needs also to be a picture of quality, which, when framed, continues to please, does not grate upon the eye. Therefore composition and pictorial elements are vital.

A certain amount of clutter in the background of action pictures is acceptable in the family album for the sake of spontaneity, but could become irritating if seen daily in a prominently displayed frame.

So the demand to be made of a good child portraitist is to choose a plain, uncluttered or very attractive background, then spark the subject into showing his personality, be it sensitive and serious or extrovert and smiling.

Indoor portraits

Because of the need to worry about lighting, it is harder to take really natural portraits indoors.

Often the best results will come from catching the child unawares, making use of available light from a window or reading lamp.

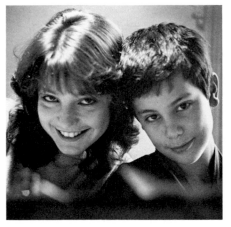

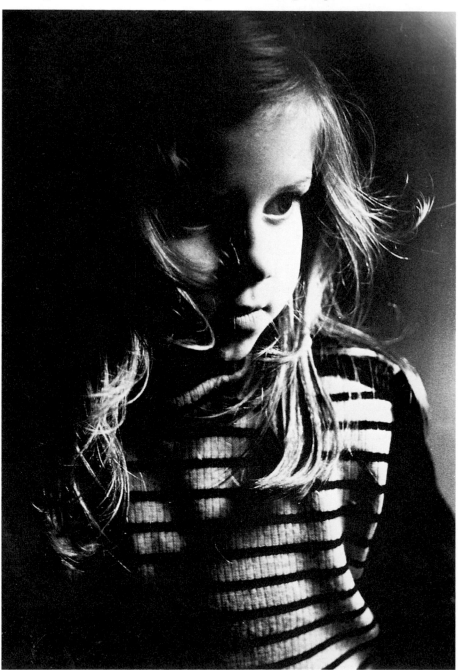

Lighting does not have to be just from one source. These two children were standing under a strong overhead bulb with another more distant normal household light filling in the detail of their faces. The window behind and to the right added the dimensions of backlighting.

With two children, to get natural expressions, it sometimes works to ask them to bump their heads together, though this may result in a look of pain rather than humour.

Low light is an advantage in portraiture because the pupils of the eyes dilate. Brilliant lighting leads to contraction of the pupils and smaller looking eyes.

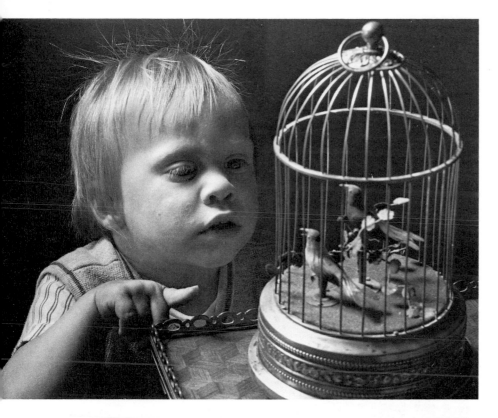

The studio situation makes the portraiture of very young children particularly difficult. To extract the remotest sign of character from a child, the first requirement is to abandon the convention of a chair in a circle of light. A healthy, intelligent toddler is physically incapable of staying happily in one place if bored.

If studio lighting must be used, then everything should be arranged before the subject comes near. A minimum of lights should be ready set up, plus some interesting object to bring the ambulant child to a halt long enough for half a dozen shots. With so small a child, there is no second chance. Once his interest in the proffered object is satisfied, then he will move somewhere else. If the lights were wrong, and you have to try another shot, then a different ruse will have to be rapidly conceived.

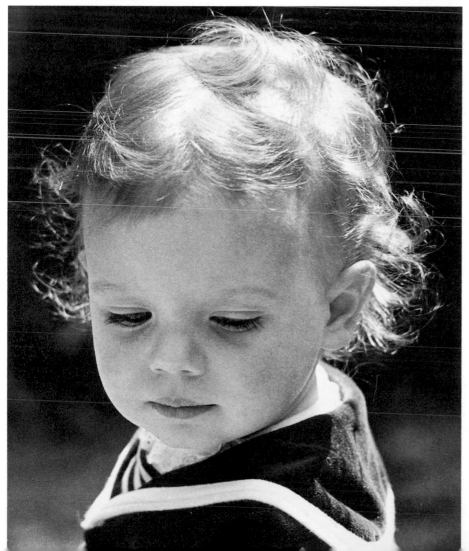

Out of doors, sunlight produces much the same effect as studio backlighting, without the hassle of having to keep the child perfectly still under the spotlight.

Overcoming self-consciousness

The problem in any setting is to spark off the right facial expressions. The degree of self-consciousness varies – often increases – with age. But even the youngest children nowadays seem camera-conditioned. A lens pointed in their direction, and they have been trained to stare straight at it, armed with obnoxious artificial grins. This barrier has to be overcome by sheer cunning.

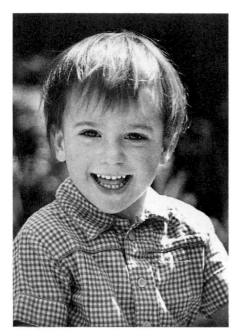

Toddlers and tiny children respond well to the peep-bo technique: hide your face behind the camera, then, at great speed play peep-bo to either side, until the child is laughing: at which point you have to get your shot in a second before the child's smile fades. (Practice is required to avoid camera shake or out-of-focus pictures.)

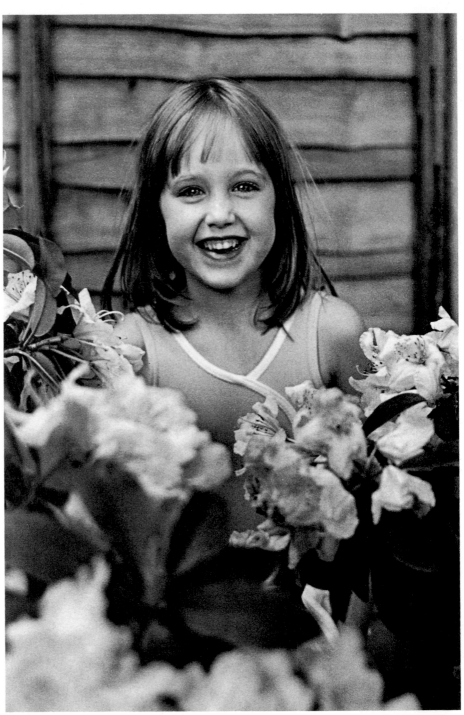

Another peep-bo method is to get the child to hide behind a bush and play the game of leaping up and trying to hide again before a photograph has been taken.

You might succeed in sparking off a fascinated expression by asking if the child can see a little green insect walking over your head.

Yet another effective diversion is to have a second adult or another child making funny faces over your shoulder.

Another of my well-tried inventions is the ghastly-face technique.

Between the ages of seven and nine, the child becomes extremely self-conscious. The falsest of smiles is likely to emerge – and stick – while a camera is around. So the child is encouraged to make more and more ghastly faces until he relaxes into natural laughter. Again, you have only a fraction of a second to obtain the desired shot, and probably will not be given a second chance.

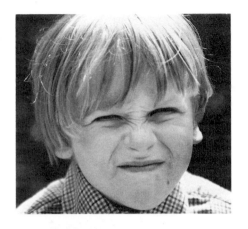

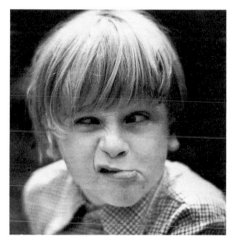

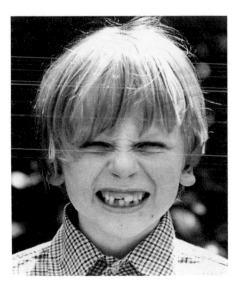

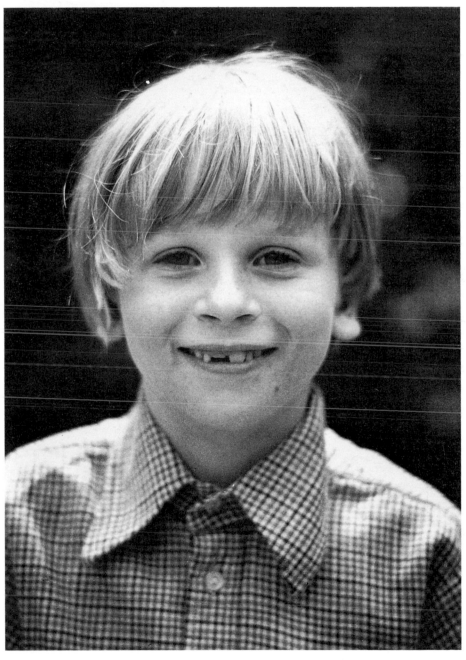

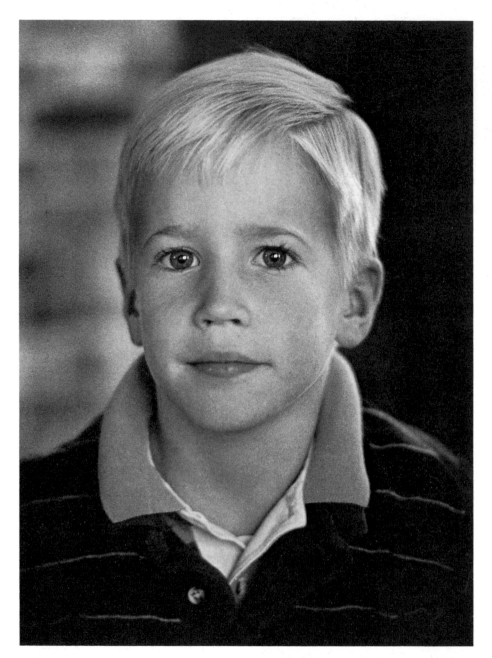

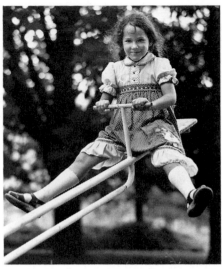

I had been some hours at the home of this little French country girl, Mélie, before I even suggested photographing her. Her mother immediately wanted to tidy her hair, but I dissuaded her. Mélie and I went off on our own together for just ten happy minutes. The light was bright enough for me to use my telephoto zoom so that I could frame each shot without changing lenses as she played about.

If a child really is not in the mood to smile, it is unfair to tease him into it. His sensitivity and seriousness anyway may make a better portrait than an expression imposed on him or dragged out of him by a photographer.

Leica R4 90mm lens f2.8 1/125 sec. Tri-X film, indoor available light

Self-consciousness and camera-shyness are as likely to occur with your own children as with strangers. Sometimes the very closeness of parent and child increases the difficulty.

One way to overcome the problem is to go for a walk together, and to start to snap away as soon as the child takes up a new stance or gets involved with anything she comes across.

Nature often provides the most beautiful backgrounds.

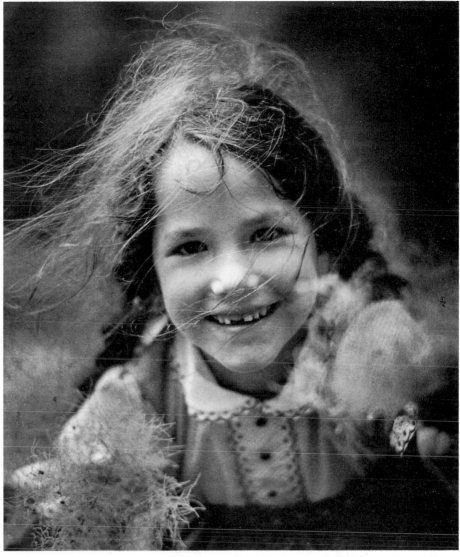

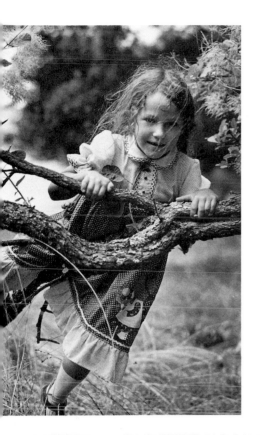

Leica R4 75-200mm zoom lens f4.5
1/250 sec. Plus-X film

I only switched to a wide angle lens
so that I could include the pictur-
esque mediaeval city in focus as well
as the child.

Leica R4 35mm lens f11 1/125 sec.
Plus-X film

If we had gone on for more than
ten minutes, we would have lost the
freshness and fun of our photo-
graphic session.

The key really to successful
portraiture is the enjoyment of
subject and photographer alike.

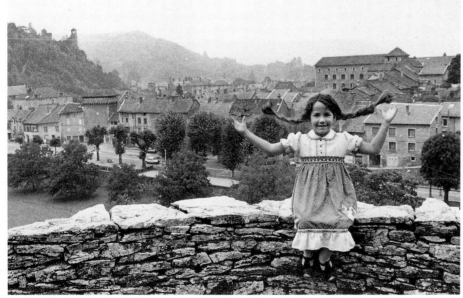

Birth

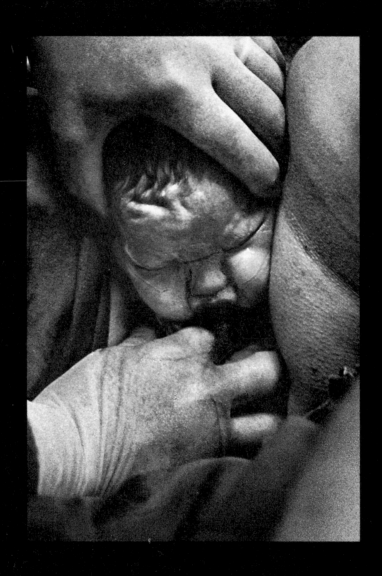

Keeping the lights low

Your first consideration
when photographing child-
birth should not be the
camera, nor the lens, nor
the film. It should be the
amount of light which is
going to strike the baby's
eyes. A baby emerging from
the darkness of the womb
screws up his eyes with
shock, even with the nor-
mally reduced hospital light-
ing. The blast of a flashgun
can only be sheer cruelty.
Without doubt it is worth
sacrificing photographic
clarity and sharpness to
have gentler, softer pictures
taken in the lowest light
possible (p. 45) until the
baby has had plenty of time
to adjust to the glare and
clatter of the outside world.

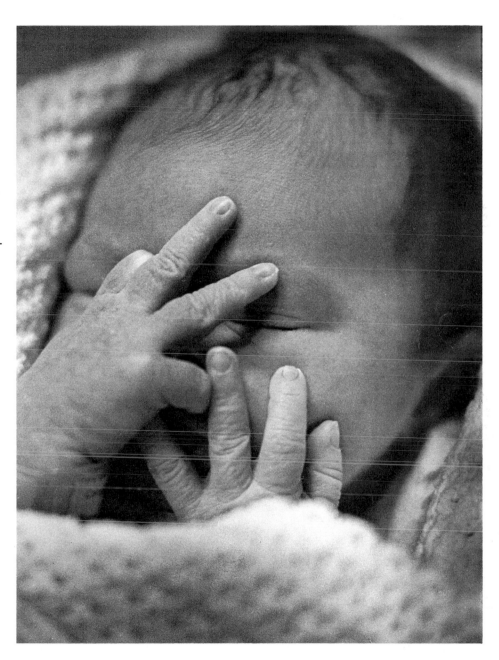

Likely sequence of events

Accepting that the birth will take place in muted lighting, the best lens to have ready on the camera is a 50mm standard lens with a wide aperture, say f2. Though there will probably be hours of waiting around, the actual birth will happen very quickly indeed, and there will be no time to change lenses. The 50mm lens allows you to stand back and get a general view of the scene, as well as coming in quite close for detail. (Not too close: the photographer must always avoid getting in the way of medical staff, otherwise their goodwill will dissolve, the safety of the baby being more important than good photographs.)

A dilemma arises if the photographer happens also to be the father of the

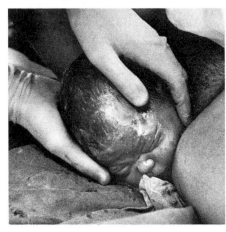

baby. The mother needs her man right by her, holding her hand through the hardest moments. Yet, as the head crowns, the ideal position for photographs is at the end where the baby emerges.

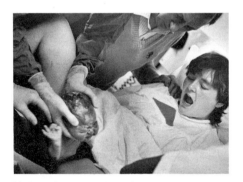

If the photographs of the half-born baby must be sacrificed in order to give support to the labouring

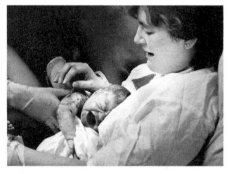

mother, at least the photographer will be well positioned to catch the baby being lifted out, hopefully on to the

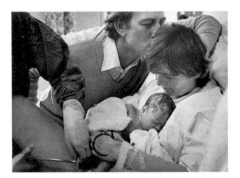

mother's stomach, to be close to her, immediately feeling her love and warmth even before the cord is cut.

Many people anyway will not want clinical looking pictures in their family albums. They may prefer to wait until the next stage, once the baby is safely out, when the intimate and vital bonding process is going on between parent and child.

It is not always an instant love scene. Some babies seem quite disgruntled about their arrival: they need time to get used to breathing for themselves before they can begin to enjoy new sensations and start looking about.

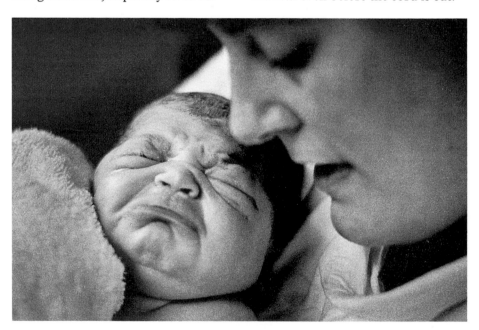

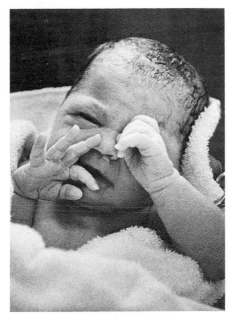

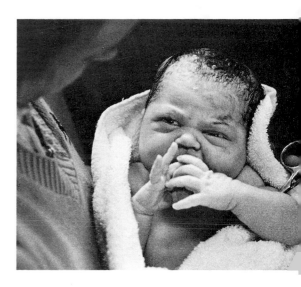

This particular character did not open his eyes for fifteen minutes. Though the curtained daylight was quite soft, it was too bright for his taste. While the nurses attended to the mother, he lay, eyes tight shut, cradled in his father's arms; gradually he started to blink and look around, and to stare fascinated into his father's face.

Then he was rushed away to be measured, weighed and checked over by the medical staff, before being handed back to his mother for a first feed.

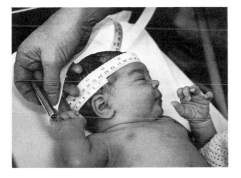

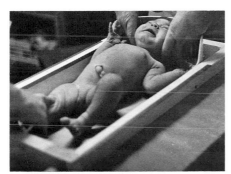

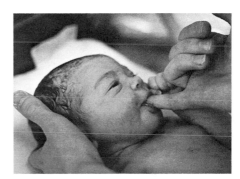

This first feed is an excellent photographic opportunity. Most newborns suck with amazing strength because they have already practised sucking their thumbs in the womb. It is always an emotive moment to see the baby taking hold and getting on with the business of food and survival.

Fed, swaddled and comfortable, though the baby cannot focus his eyes, he is likely to lie awake for a while, staring about at the lights, shapes and movements. Text books indicate that babies do not develop a smile response for the first five to six weeks of their lives, but I have seen many a breast-fed, hour-old baby smile inwardly with contentment.

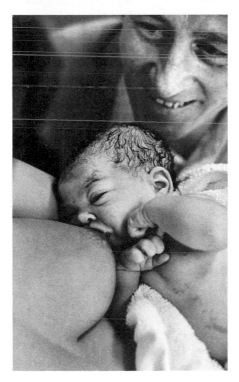

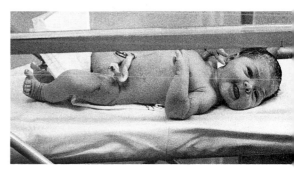

The photography of birth should not be a record of clinical detail, but rather a reflection of the warmth and joy of one of the very greatest human experiences.

All photographs taken on Leica R4
50 and 90mm lenses f 2.8
1/60 sec. Tri-X film

83

Excluding hospital clutter

Hospitals never provide un-cluttered backgrounds, so there is always the problem of how to emphasize the human warmth and drama, while minimizing the crumpled draw sheets, hospital clutter and gadgetry.

It is often worth using a soft edge filter. These are readily available commercially (sometimes called centre spot filters). Otherwise, use an ordinary skylight filter and smear a circle of petroleum jelly round the outer edges.

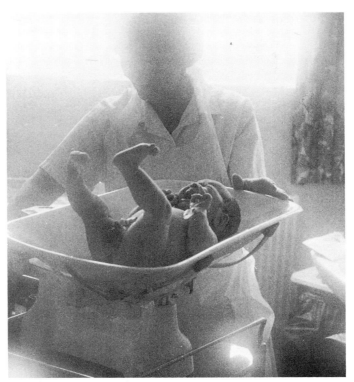

Olympus OM1 50mm lens f 2.8 1/125 sec. Tri-X film pushed 1 stop skylight filter smeared with vaseline

Olympus OM2 50mm lens f 2.8 1/125 sec. Tri-X film pushed 1 stop Hoya centre spot filter

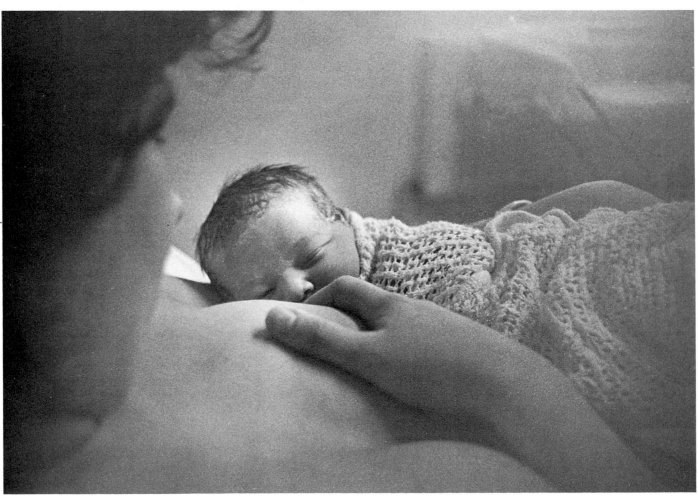

Hospital beds are likely to be high off the ground: for intimate pictures of the baby's first feed, find a chair or something to climb on to get pictures from above.

Olympus OM2 35mm lens f2.8 1/60 sec. Tri-X film exposed at ISO 1600 and developed in Diafine

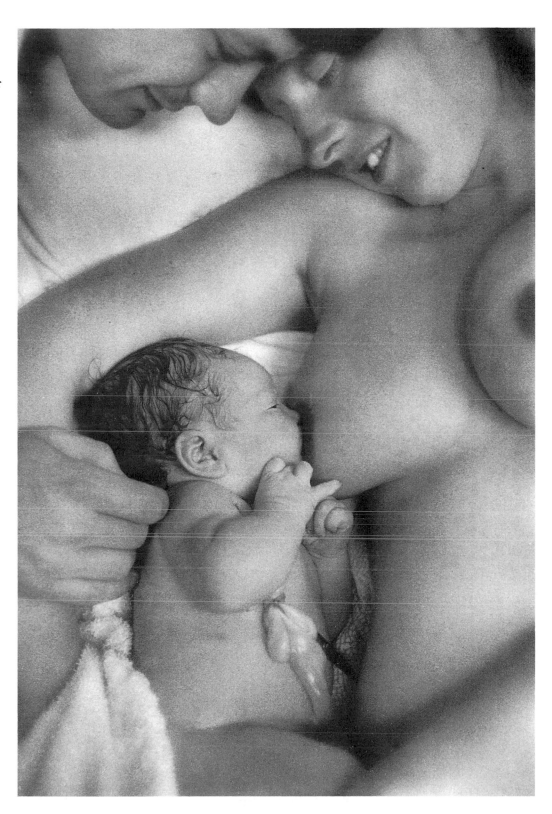

Studies of the newborn

Once the excitement of the birth is over, a first portrait of the baby is called for. The variations in character and mood of different new-born babies are amazing. Much depends on how the birth has gone and the quietness and gentle lights of a sympathetic delivery.

The baby is very small, the wrapping often over-whelming. It is essential to come in very close (p. 91) to fill the frame with the baby's face.

Olympus OM1 100mm lens with Hoya × 1 supplementary close-up lens f 2.8 1/125 sec. Tri-X film pushed 1 stop

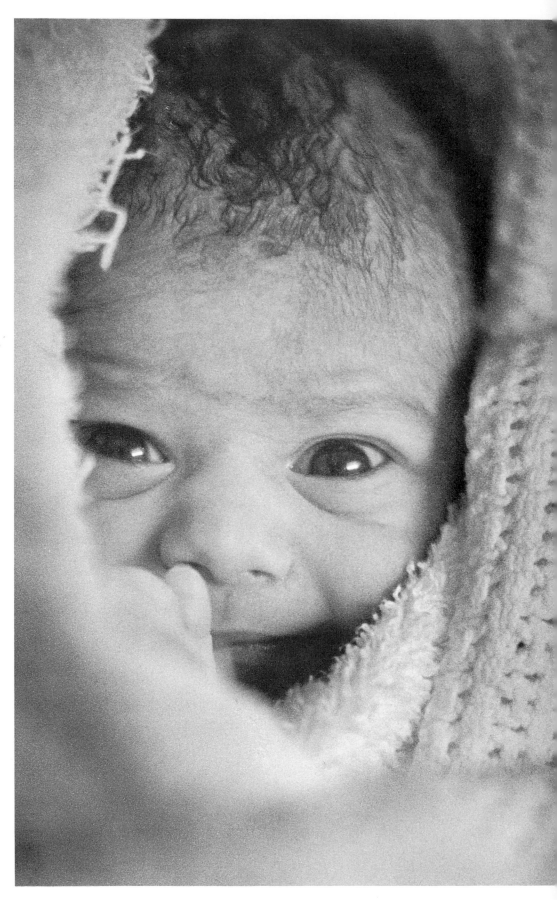

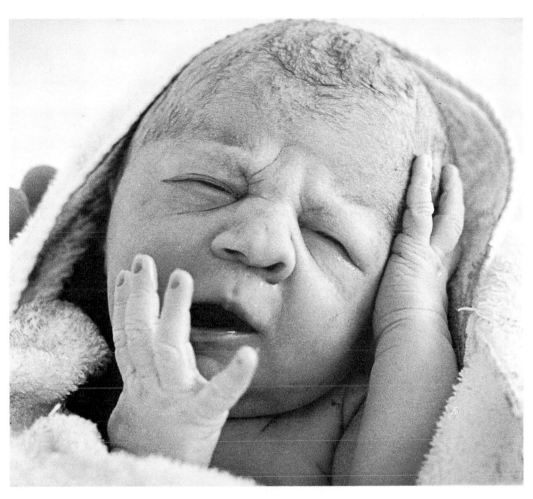

When it comes to the all-enthralling subject of tiny newborn hands and feet, special equipment may be needed (p. 91).

Olympus OM1 100mm lens f 2.8 1/125 sec. Tri-X film pushed 1 stop

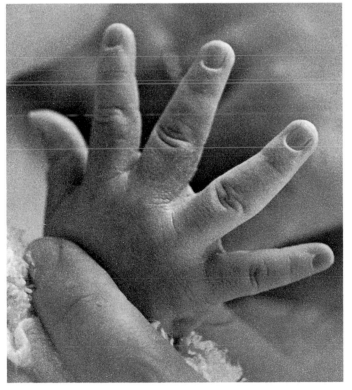

Olympus OM2 50mm macro lens f 3.5 1/60 sec. Tri-X film

OVERLEAF
Olympus OM2 50mm macro lens with Hoya centre spot (soft edge) filter f 3.5 1/60 sec. Tri-X film pushed 2 stops and developed in Diafine

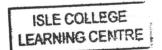

Hospital lighting (colour)

Hospital fluorescent lighting introduces nightmarish shades of ghoulish green into colour film, but it is worth trying to cope with whatever available light is on offer, however unfortunate, in order to avoid the use of flash near the sensitive eyes of a newborn baby.

With six different kinds of fluorescent lighting on the market, each requiring different correcting filters, it is usually practicable only to guess, and take along some sort of magenta filter which should keep the green at bay.

All photographs taken on Ektachrome 200 or 400.

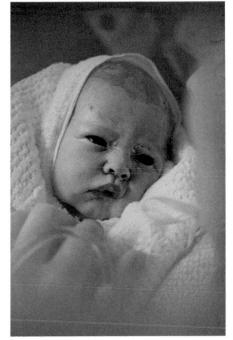

Daylight from window

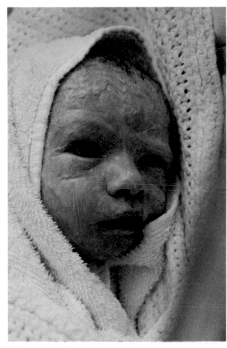

Magenta filter

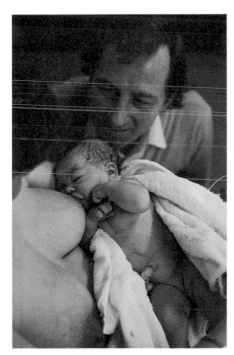

Fluorescent light, no filter

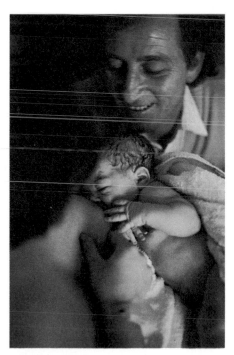

Magenta filter

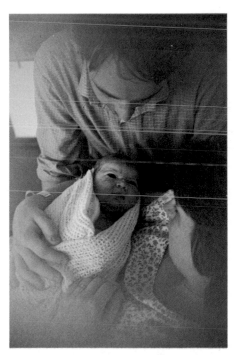

Daylight with centre spot filter

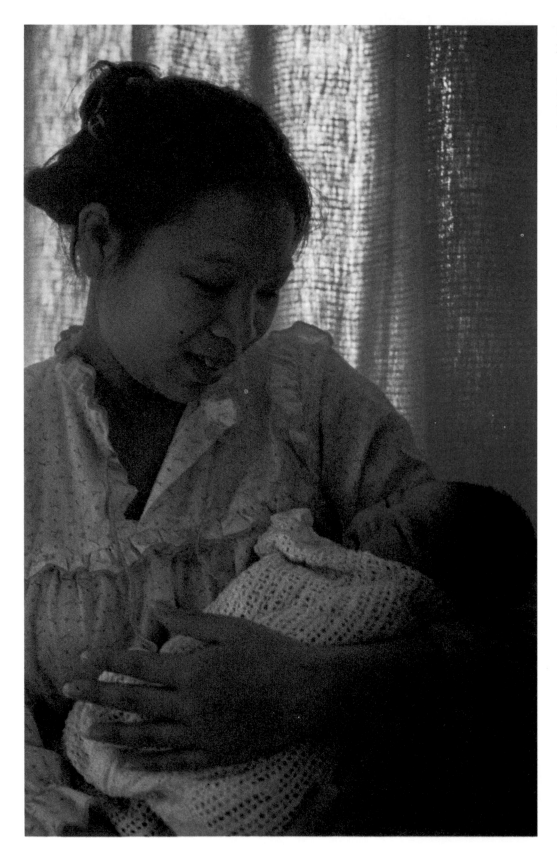

Sunlight, like flash, is painful for new babies.

Muted light through curtains, besides avoiding distress to the baby, can bring warm and exciting colour effects.

Close-ups of the newborn

The newborn baby's feet and hands are touchingly perfect. No ordinary lens can come in close enough to do them justice.

The costly macro lens can be used as a normal lens at greater distances too, but the number of close-ups likely to be required for child photography make it a luxury rather than a necessity.

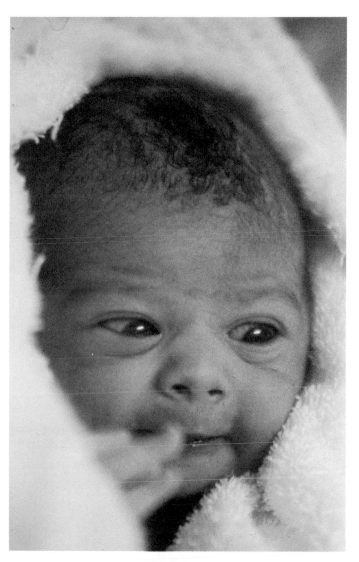

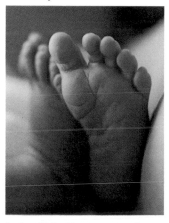

Leica R4 60mm macro lens
f 3.5 1/60 sec.
Ektachrome 64 available
light

A cheaper alternative is a supplementary close-up lens attached to the front of a normal lens. (Extension tubes, normally recommended for close-up photography, result in longer exposures; because they also make focusing more difficult (dimmer viewfinder image), they are impractical for moving targets such as babies' fingers.)

Leica R4 90mm lens f 2.8
1/60 sec. Elpro 3 close-up lens
Ektachrome 400 (daylight
film in fluorescent light)

Olympus OM1 100mm
lens f 2.8 1/60 sec.
Hoya × 1 close-up lens
Ektachrome 400 (daylight
film in fluorescent light)

For flash you could use a special macro ring flash but it is cheaper to use a clip-on macro sensor attached to a normal computer flash.

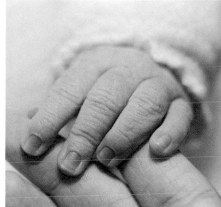

Leica R4 60mm macro lens
f 5.6 Vivitar 4600 flash
with macro sensor on front
of lens

Babies

Photographs of small babies too often consist of a face the size of a pinhead peeping out from swathes of shawl and clothing. Somehow the photographer must overcome the difficulties and discover the person inside the parcel. The first rule is to work in a very warm room, so that it is possible to remove the clutter of garments without chilling the baby.

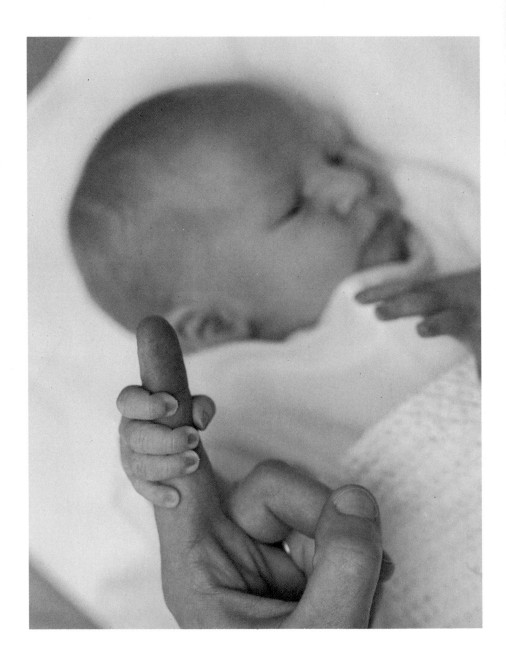

Reflex actions

We tend to think of newborn babies as being totally helpless. But they are born with a number of fascinating reflexes left over from pre-history when our apish ancestors clung tight to their mothers as they swung from tree to tree. The holding reflex which we have inherited from this stage in our evolution makes a fascinating photograph: the grip is so tight that the blood runs from the baby's finger-tips.

A close-up attachment or macro lens will show the fingers with technical clarity (p. 91), but it may be preferable to use a wide angle lens and include the baby's face in contrasting soft focus.

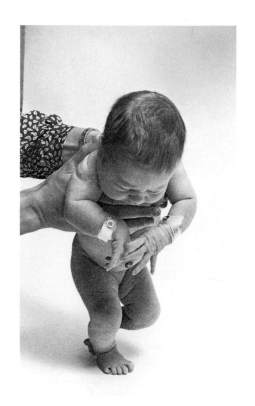

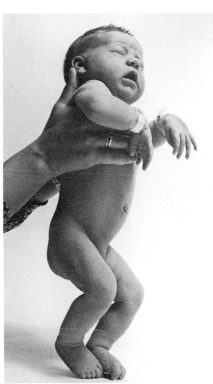

Another particularly photogenic reflex is the walk reflex, where the floppy newborn baby, for at least the first week of her life, will suddenly become galvanized as her feet touch a hard surface: she straightens out and starts to make walking movements, almost a goose-step, one foot in front of the other.

Olympus OM1 50mm lens f 5.6 1/60 sec. one studio flash with umbrella reflector Plus-X film

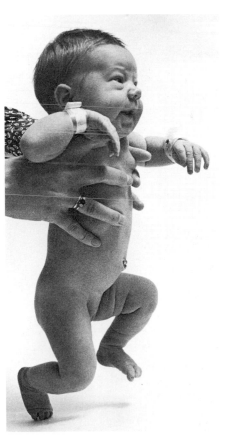

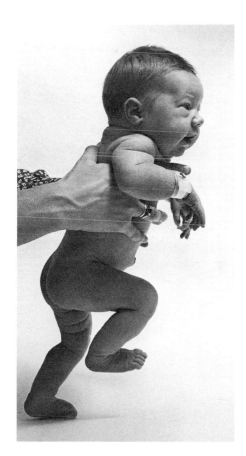

Support for a floppy head

A baby's head is disproportionately large and heavy. Her neck will take some weeks to gain enough muscle to control movement. One of the most endearing characteristics of the newborn is this floppy head, falling like a drunk to one side.

Several ways can be found to support the baby's head without disturbing her peace or comfort.

Photographing her encircled by her mother's arms not only provides support, but gives a sense of her smallness in proportion to an adult.

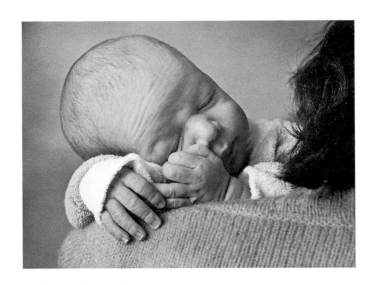

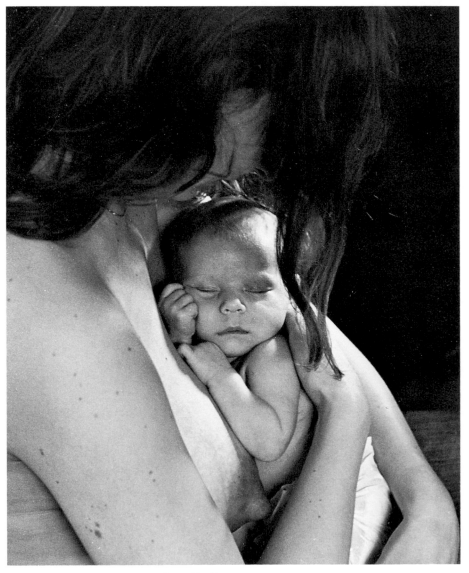

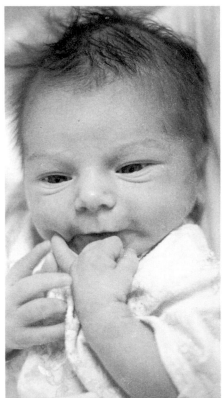

If you are on your own with the baby, you can photograph her lying on her side. The picture can be shown vertically so that her expression is more readily seen.

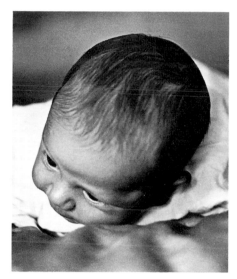

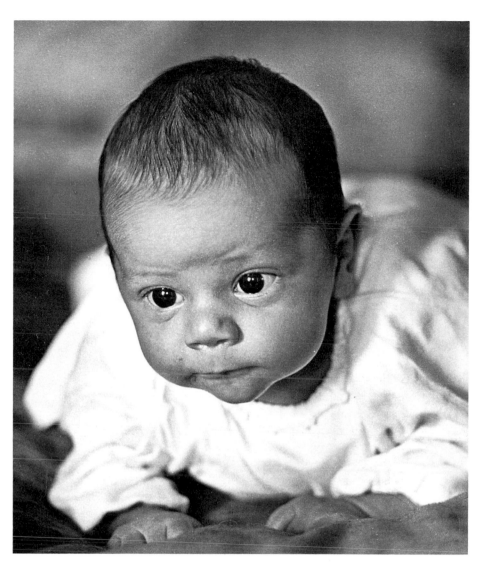

Soon, when lying on her stomach, the baby will start to try to lift her head. You can shoot a sequence illustrating this development by photographing her progress every week.

Once she can hold her head up for a few moments, this may make a first almost formal portrait.

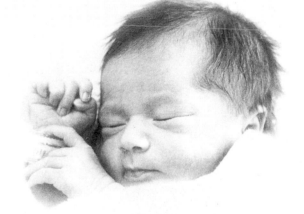

Meanwhile much of the baby's day will be spent sleeping, but this is no bar to sentimental photographs.

95

Breastfeeding

Feed times are the most important moments of each day in the life of a newborn baby. Breastfeeding of course offers more beautiful photographs, with the flesh-to-flesh loving contact of baby and mother.

Various factors such as the age of the baby and the size of the mother's breast in comparison to the baby's head make this subject far trickier than it might initially seem. The lighting is awkward because the mother may cast a shadow on the comparatively miniscule baby. Some backlighting for the sake of modelling is desirable if possible, either from a window or studio lighting.

The mother's clothing is significant in the composition because the baby is so small. A patterned shirt would make him almost invisible. Any restrictive or indecorous underwear should be completely removed: bra straps or visible pieces of elastic look more indecent than natural bare flesh, and elastic tends to cause red marks or unappealing bulges.

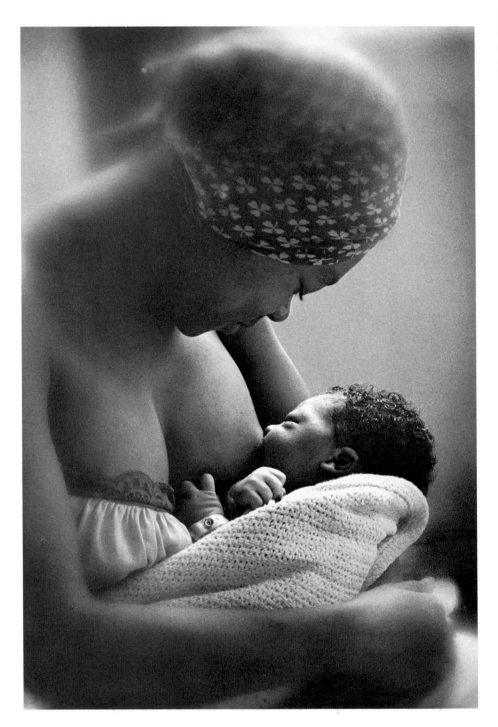

The angle of view is all-important, especially if the tiny baby is to dominate the picture, rather than the more sizeable mother. A camera viewpoint from over the mother's shoulder shows the baby's expression better than the more conventional side-on aspect.

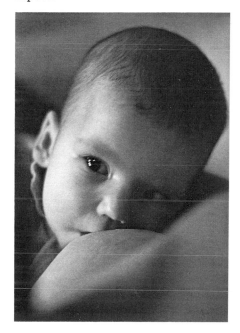

The baby's position is also important. The newborn is too floppy to hold himself upright without support while feeding. Better pictures may be obtained when the baby is three weeks old or more. By then, fascinated by his mother's face, he will stare up at her while feeding, achieving the developmentally significant 'eye-to-eye' contact; the quintessence of the picture will be heightened by the wordless but intense communication and unity between them.

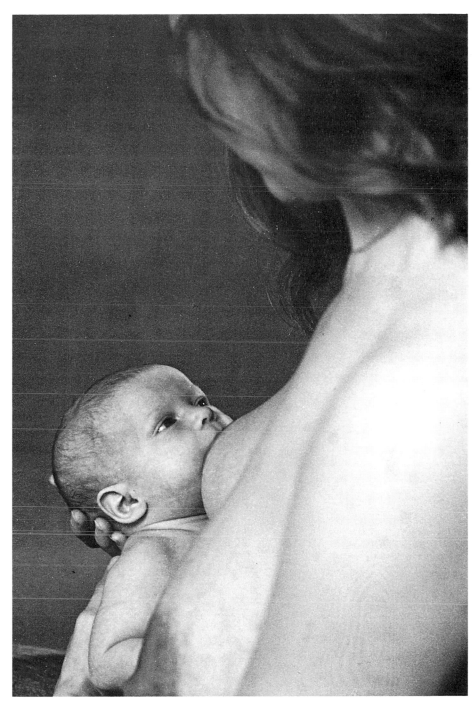

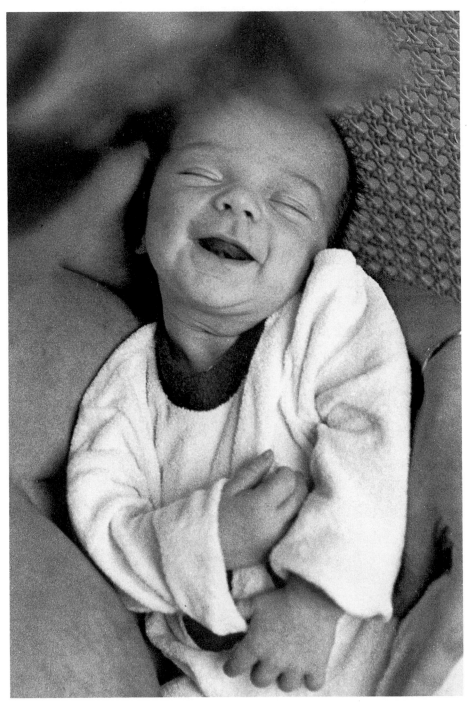

One of the after-feed bonuses in a newborn baby is the so-called 'windy' smile. I am not convinced that this smile is a result of wind. To me it always seems an expression of sheer bliss at having a full stomach and the experience of warmth and loving arms around him during his feed. Perhaps this baby is dreaming that it is all happening over again.

Early smiles

The heartmelting, toothless smile of the baby is his passport to safety and love. Scientific research backs up the obvious emotional judgement. The baby's smile can turn a parent's pent-up rage and exhaustion, even when woken for the fifth time in the night, into instant rebirth of adoration and protectiveness.

The smile response dawns like sunshine between the third and twelfth week of the baby's life. Unlike the comical grin of the sleeping newborn, it is a direct answer to a smile on the face of a human being close to him.

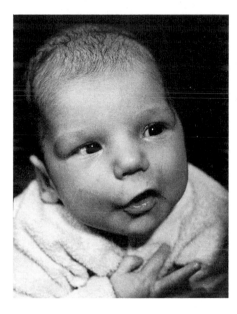

The first sign is a definite twinkling in the eye when the baby's interest is fixed on the attending adult.

Then the mouth develops a quiver.

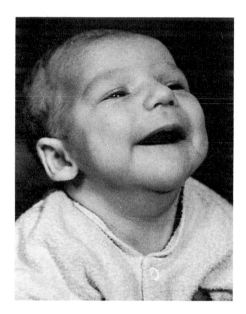

These preliminary signs may go on for days, even weeks, before the true smile dawns. Even then, at first it flickers on and off so fast that you need ultra-rapid reactions to capture it.

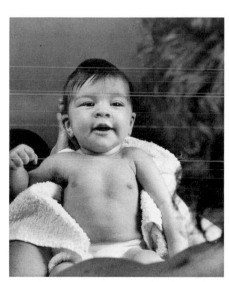

Since the smile is a response reflex, a photograph can seem partially incomplete without at least a hint of the person at whom the baby is smiling, perhaps a wide angle shot over the shoulder of the adult so that the eye is led past the mother straight to the smile.

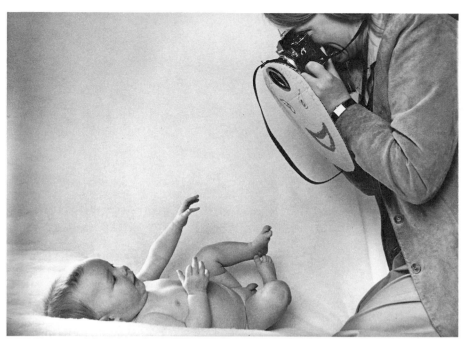

No one, however quick on the trigger, will ever achieve a direct smile at camera without subterfuge. This is because the baby's smile is a reflex, not a conscious action directed by his intelligence. A baby reacts quite as enchantingly to a smiling mask fixed to the camera!

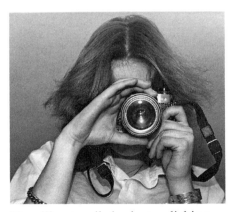

He will not smile back at a clicking mechanical frown.

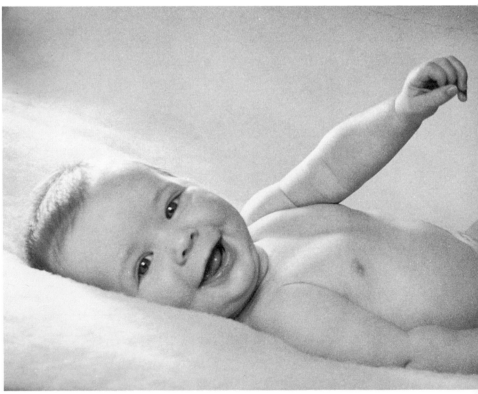

An alternative to a mask fixed to the camera is a second person ear to ear with the photographer.

Bathtime

Bathtime sounds an ideal subject, but has its problems because of the essential supporting adult arm without which the baby would sink.

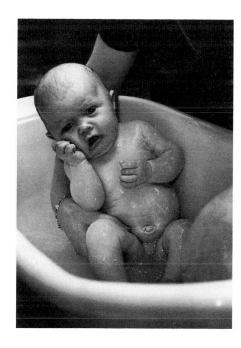

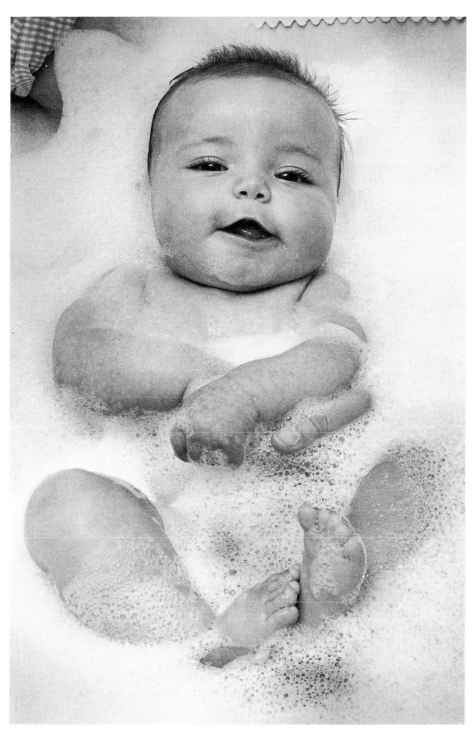

The only way to minimize this is to wear a long-sleeved black sweater or, better still, to use a generous splash of bubble bath (special baby product, because the adult ones often cause allergic rashes in babies).

Watching for developmental stages

The stages of sitting, crawling, standing and walking are obvious milestones: however, much earlier on, an intriguing sequence can be obtained by watching your baby's growing hand-and-eye coordination.

With patience and perseverance, you might catch the moments from when your baby still cannot coordinate his arm at all, through the stage where he can only bash at an object, then at last grasp it at will. Gradually his hand becomes a skilled tool, posting shapes through holes, putting pieces into jigsaw puzzles, transporting food to his mouth, picking tiny, delicate flowers.

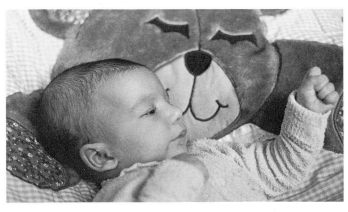

Meanwhile, around three months, discovering his hand as an object, he may spend many minutes a day staring at its constantly changing profile.

The problem in recording such minute movements is the smallness of the baby's hand and the unwanted detail of clothing and household clutter which inevitably intrudes. Because baby clothes tend to visually overwhelm their wearers, it is best to warm the room and photograph the baby naked or wearing a light suit set against a plain background, preferably a soft (washable!) fabric placed on a waterproof base.

Even with a carefully prepared home studio set-up, it is better not to have too strong a preconception of the photograph. Let your happy, comfortable, well-fed, warm baby respond as she wishes, without any sense of pressure. In this relaxed situation she will effortlessly demonstrate what stage she has reached by her reaction to whatever is presented to her. Then, baby book in hand, the developmental stages can be interpreted after the photographs are printed.

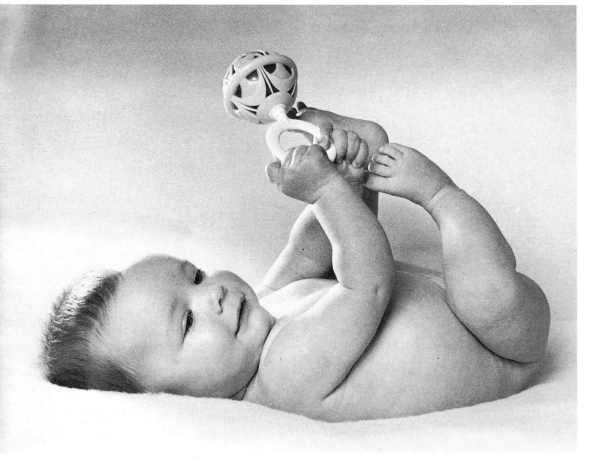

This baby is showing that, at three months old, she is still virtually prehensile. She hardly seems to be able to tell which are feet and which are hands: perhaps she is trying to hold the rattle with both.

Demonstrations of developmental stages cannot be imposed on babies. They will either be at the right stage and respond a certain way or not. Pressure from parent or photographer to produce a reaction is usually counter-productive. Even the smallest baby can sense tension in an adult, and will become tense herself.

Leica R4 50mm lens f 8 two Bowens Monolites (studio flash) Panatomic-X (fine grain) film

When your baby reaches the stage of trying to get something to his mouth, he seems to measure very carefully.

Even then he may miss his goal.

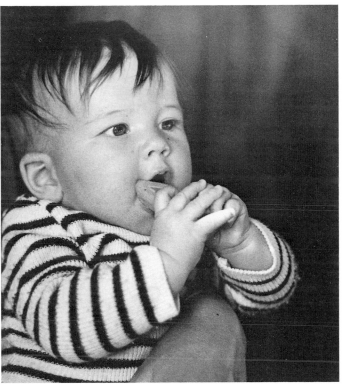

The baby seems to measure the distance . . .

then make a first strike at his mouth . . .

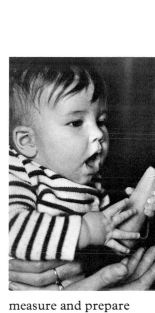

measure and prepare again . . .

crash landing . . .

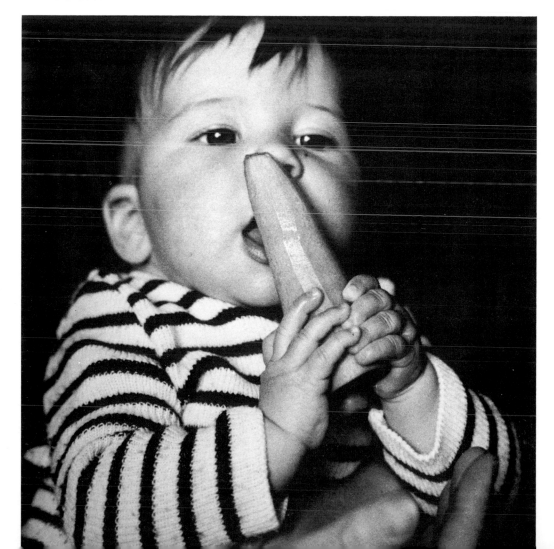

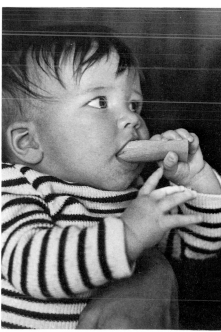

success at last.

103

Exploration and discovery

Now exploration of everything becomes a way of life. Many parents find this stage a nuisance, even while recognizing it as a vital part of learning.

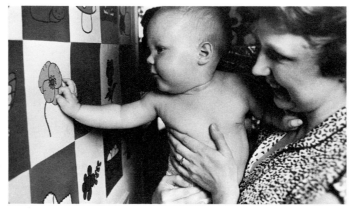

The baby reaches out to try to pick a poppy off a wall chart. Until he is conceptually ready, he cannot see the difference between two- and three-dimensional objects. He will never learn if his parents do not give him the chance to try.

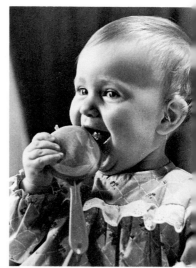

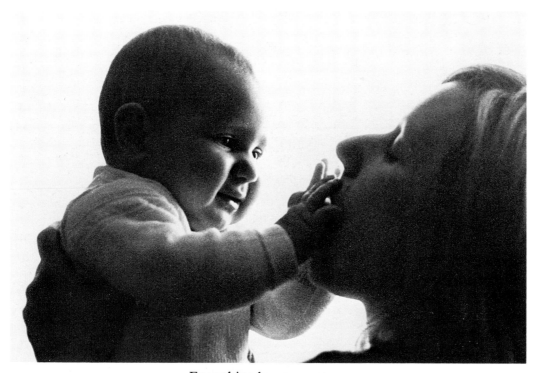

Everything he comes across he instinctively researches. Even mother's face becomes an object of scrutiny, to be studied in minute detail.

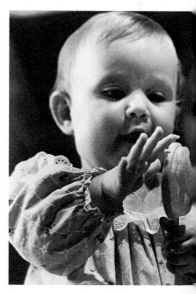

Babies learn as much about texture and the nature of objects with their tongue and the sensitive area of the inner lips as with their fingers.

Even the greatest research physicist had to go through these stages of exploration; his first lesson on whether liquids could be grasped probably took place in the bath.

So much of visual interest is going on, the camera now should always be ready to hand.

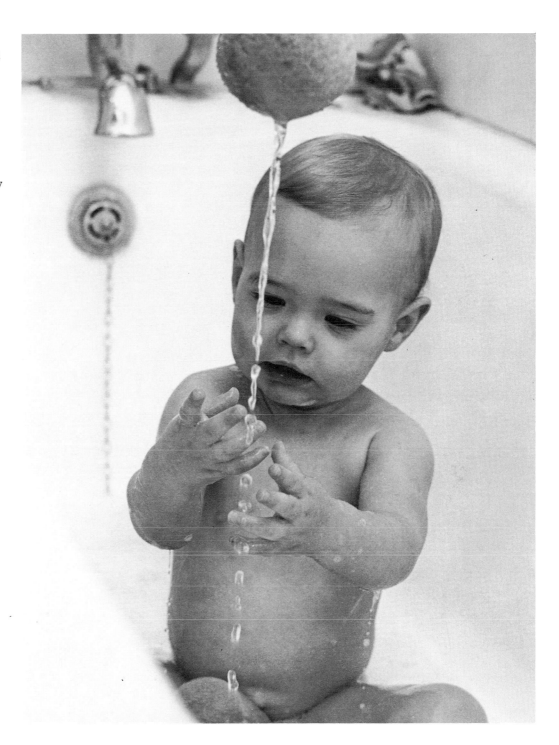

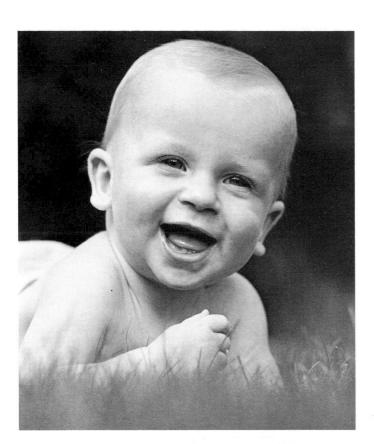

The baby's level

With small babies (and toddlers too) photographs are often better when taken from floor level. A camera bag makes a good cushion.

Lying on the floor is not always dignified or practicable; squatting or kneeling can be passable substitutes. Standing is hopeless: photographs of the tops of babies' heads are disappointing.

For those with bad backs, elementary yoga exercises are the answer: the spine becomes not only stronger but more supple, allowing you to crouch and twist even with two heavy cameras and a flashgun strung about your neck.

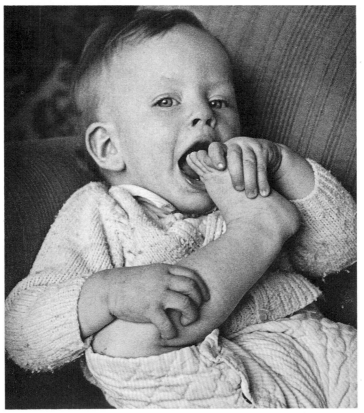

Sometimes it is possible to place the child higher up, but then another adult must be ready to leap if there is any danger of falling.

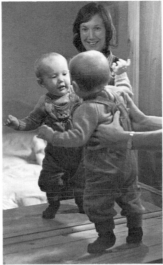

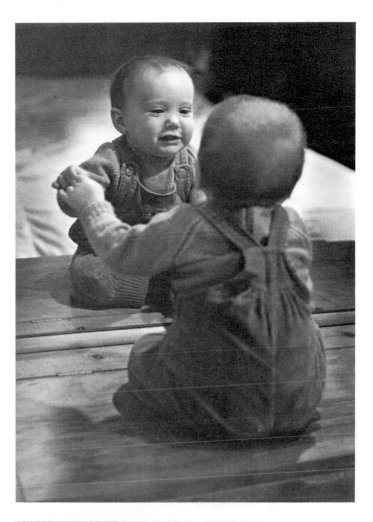

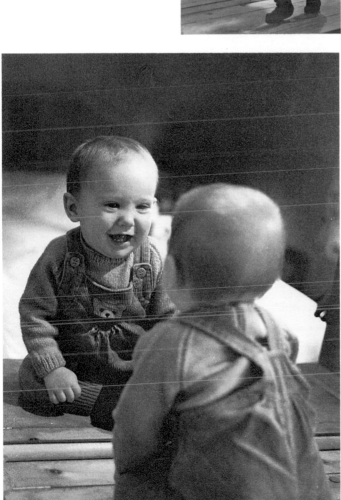

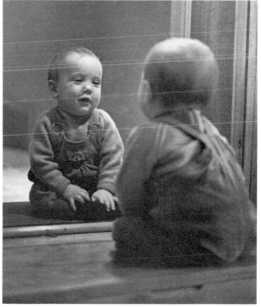

Soon the baby will become self-propelled. Then a second pair of arms will be all the more helpful to entertain and keep him within range of the camera.

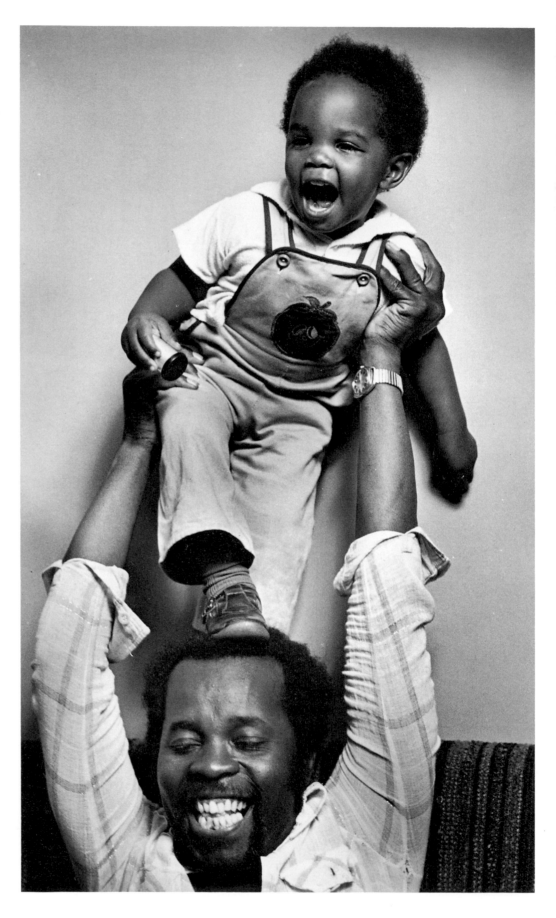

The tender trap

Once the baby learns to crawl, he will stay in one place only so long as his short span of interest is sustained. His driving mission is to move on, to investigate, learn, explore.

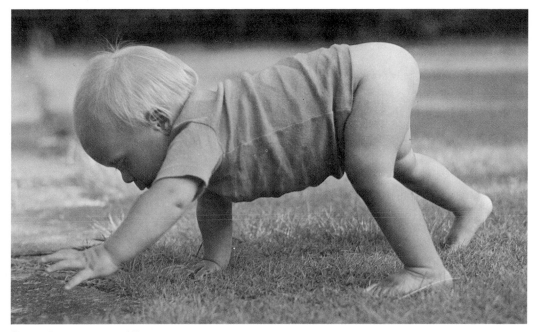

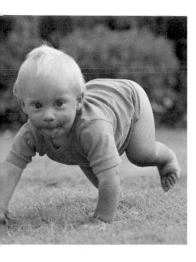

Soon the moment will come when the crawler is ready for high-speed, forward-propelled take off.

From that moment on, the only hope is to think out ways of keeping him in one place. One way is to use house furnishings physically to trap him; the other is to get him trapped by his enjoyment of some special occupation.

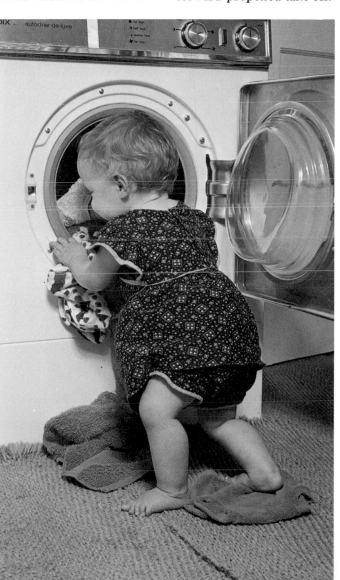

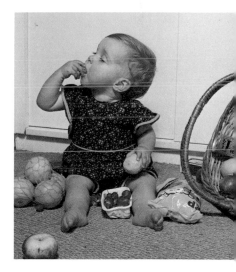

Situations have to be found from which the baby cannot easily escape. The high chair tray can be used for building bricks.

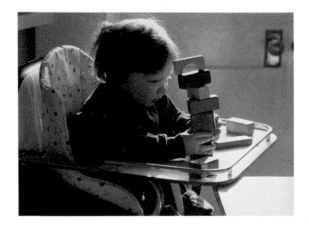

The bath is another obvious trap, with water and bubble play for distraction.

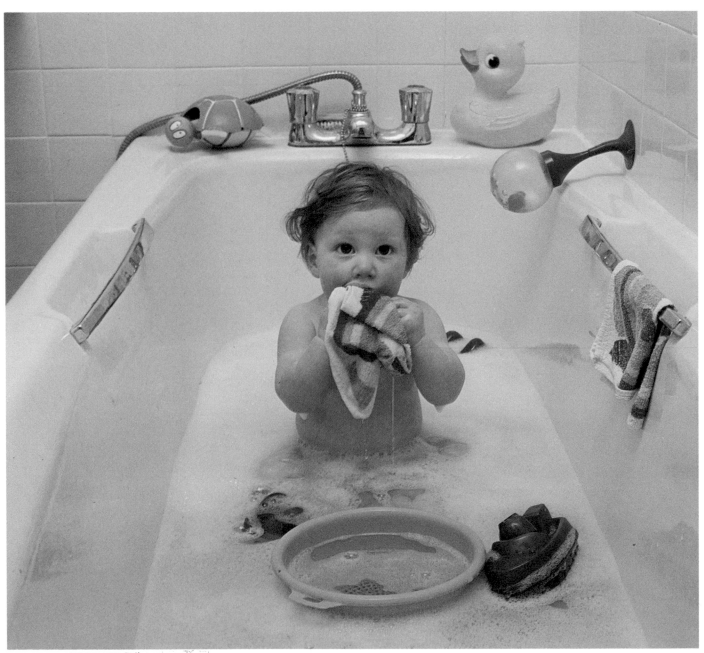

Some babies scream with rage if confined in a cot when it is not their normal sleep time. But photographs of sleeping babies bring back tender memories.

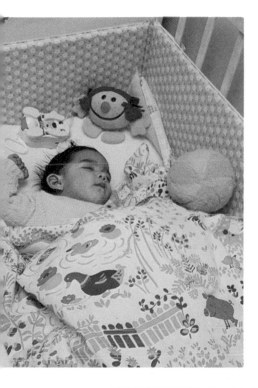

A table, too, can form a trap, ideal for play or teething needs.

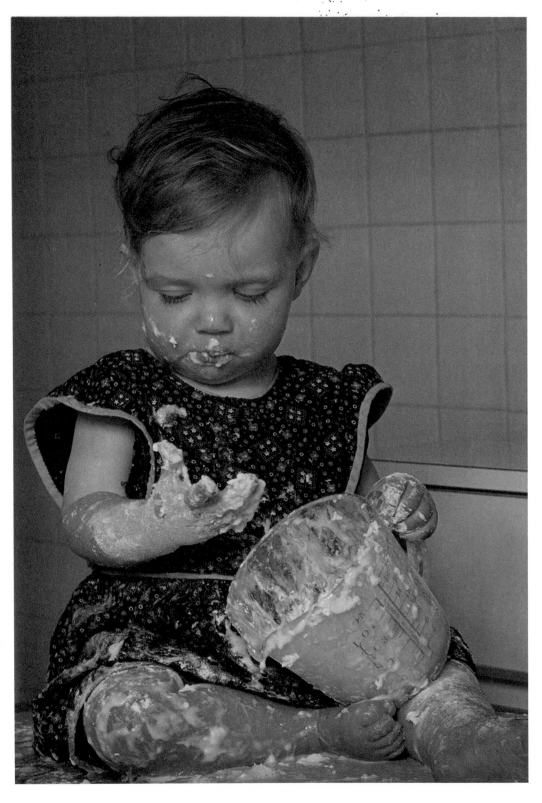

However, the best way to keep a baby still is to provide a pastime so pleasurable that nothing would induce her to move.

Flour and water, easy to wash off afterwards, will keep a child in the same place longer than anything else. Cheaper than any commercial toy on the market, it is probably the best tender trap of all.

Olympus OM1 50mm lens f 11 one studio flash with umbrella reflector

The child's mind

Photography can speak eloquently about far more than the child's face, features, or actions: it can be used to see into the child's imagination and the workings of his mind.

Understanding your subject

It is all too easy to preconceive what will make a satisfactory photograph and try to impose the required action on the child. For example, an obviously charming study would be a child blowing the fluff from a dandelion 'clock'. The photographer might reasonably expect to capture surprise and delight at this perennially successful experiment.

However, with small

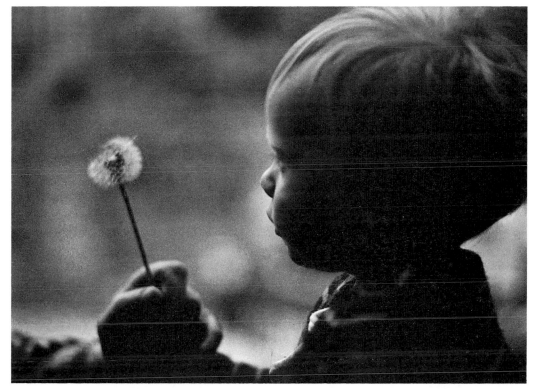

children, plans do not always work out as expected.

Thomas steadfastly refused to blow.

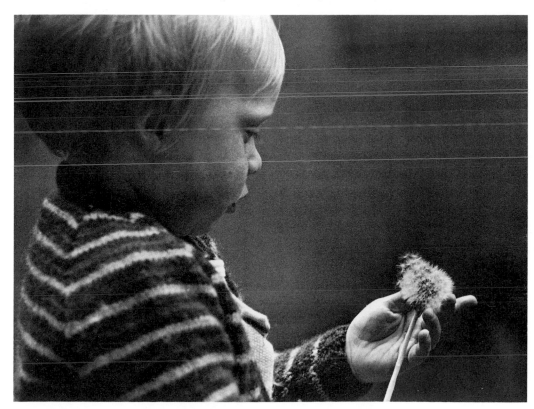

He had one desire only: to touch, to explore with his fingers the magical gossamer. The last thing he wanted was to blow the exquisite stuff away! A future research scientist perhaps, he wanted to sense its consistency, experience its lightness, test how easily it came apart by hand.

It pays not to insist on obvious ideas. It is fair enough to find likely 'props', but what the child does with them can be more interesting than what you expect him to do. We have to keep reminding ourselves that children have unpreconditioned vision, and that they will set the scene themselves for fascinating photographs just because they see objects differently to us who 'know' what they are for.

The child's eye view

The child's eye view is richer than ours. We adults go to art museums to stimulate our jaded visual palettes: we need the eye of an artist to refresh our conventionalized concepts of objects or patterns of light. But the baby peering through the net, the toddler behind the curtain, the four-year-old who re-invents binoculars, all are making their own abstract patterns through what they find, from ordinary household furnishings or seemingly useless scrap from the bin.

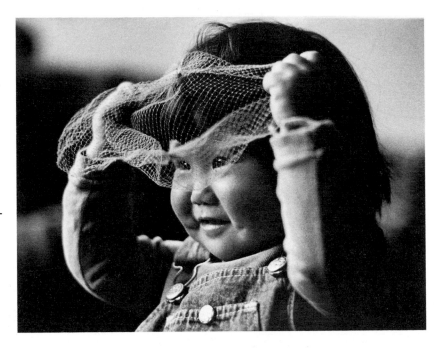

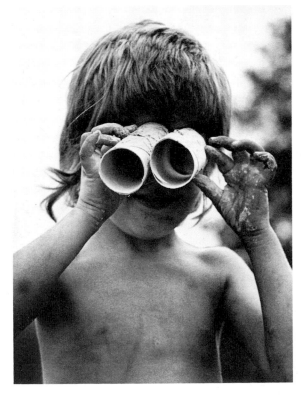

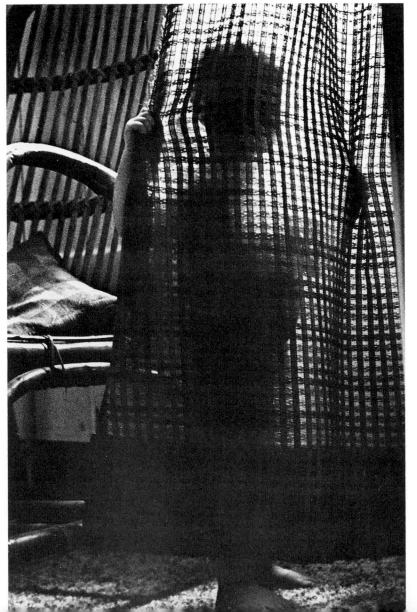

The photographer has much to gain by attempting to diseducate himself, relearning to see the world through the eye of the child. It is worth taking pictures in anticipation that something might happen, even if sometimes no photogenic sequel occurs and a few frames of film are wasted. A certain aura of absorption, a sense that something is cooking in the warmth of the child's imagination, and the camera should quietly and unobtrusively be brought into readiness.

For example, one morning at playschool, Tammy suddenly stopped listening to the story which had previously enthralled him. A glazed expression seemed to indicate that his own thoughts had taken over: he was oblivious of his surroundings.

Leica M5 50mm lens f 2 1/125 sec. Tri-X film

He continued in this daze for ten minutes or more until it was time to take his coat and go outside for play. He brushed aside his companions, raced for the football, and at last was able to try for himself the skills of the performing seal in the book.

Leica M5 90mm lens f 5.6 1/125 sec. Tri-X film

There is no end to the ways in which different children re-create the mystical and apparently important adult world on a level that they can understand.

Sandy's father was a limousine driver, who went off to work each morning resplendent in a smart peaked cap, always carrying a pack of sandwiches.

When the great moment came that Sandy was old enough for playschool, he felt that he, like his father, was also going off to work.

He demanded a sandwich pack, and, every day, as soon as he reached playschool, he would rush to grab the cap from the dressing-up box. Since he considered himself to be at work like his father, he wore the cap whatever he did throughout the morning's activities, and never let go of his sandwich pack for a second, until the great moment when he ritualistically sat himself down, ignoring the pleas of hungry onlookers, and contentedly munched his 'dinner'. A text-book example of father-identification, this photo-sequence also shows how profoundly a child can absorb himself into his own imaginary world while carrying on play with others in his day-to-day life.

Leica M5 90mm lens f 2.8 1/60 sec. Tri-X film pushed one stop

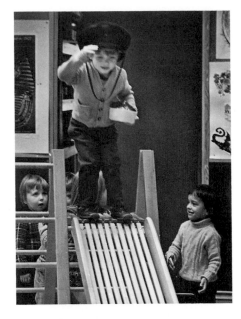

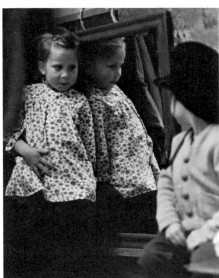

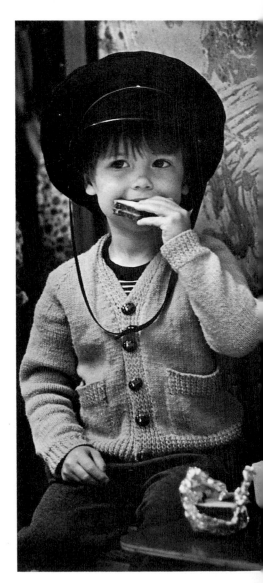

To quietly observe and catch pictures such as these, it is vital to cultivate the techniques of low light photography (p. 45). A flashgun slows down the photographer and distracts the child.

Time and again the action reflects real happenings at home: Mum burning her finger on the stove, or talking on the telephone.

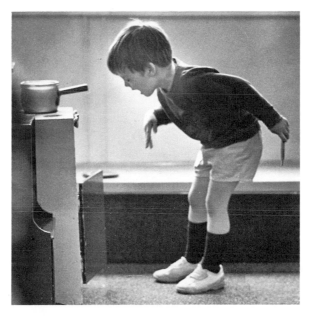

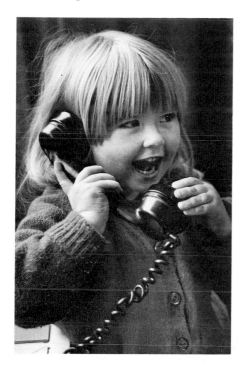

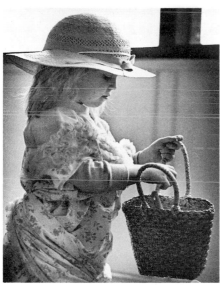

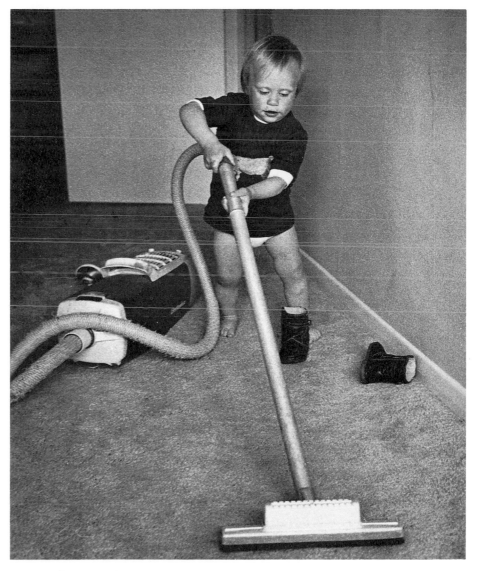

If father uses the vacuum cleaner with such seemingly passionate intensity, from the child's eye view, it must surely be an enjoyable activity: he will want to try for himself.

Expensive toys look good in catalogues, but usually make poor props in photographs of children.

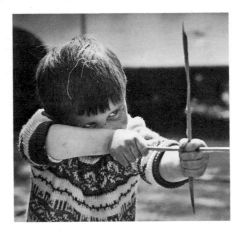

It is interesting to observe what a child will do, say, with an old rubber tyre, or two ordinary sticks from a hedgerow.

Leica M2 90mm lens f4 1/250 sec. Tri-X film

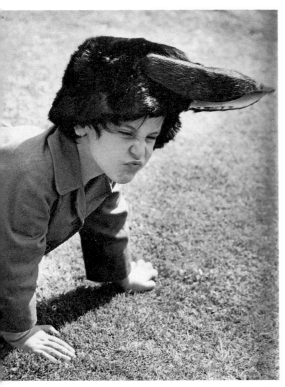

Homemade bits and pieces, a couple of cardboard rabbit ears attached to an old fur hat, are as stimulating to the imagination as any custom made fancy dress.

Leica M2 90mm lens f2.8 1/500 sec. Tri-X film

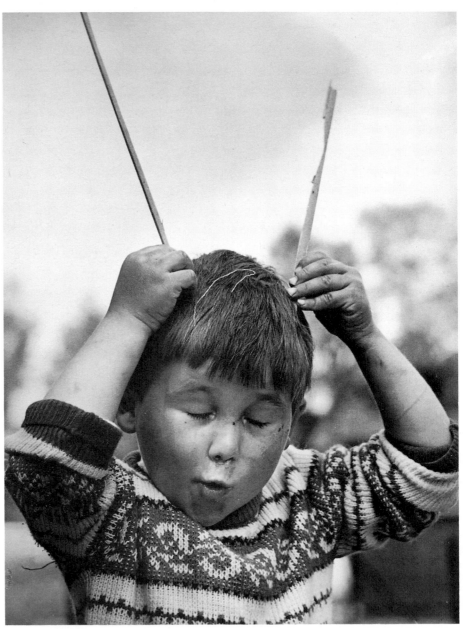

Leica M2 90mm lens f2.8 1/1000 sec. Tri-X film

To portray the workings of the imagination it is not always necessary to show faces. It is sometimes unnecessary to show the child at all.

Abstract workings of the child's mind

Examples of cognitive development not only offer thought-provoking images for the family album, but also provide opportunities for unconventional photographs.

As shown on the previous page, a face is not always essential, even when delving quite deeply into a complex subject such as the child's capacity to conjure up abstract images. A hand can tell a story quite as well as a full picture of the child (though it is pity, perhaps, not to record the cheeky smile as well).

The point this particular pair of hands is proving is that this mischievous toddler has developed beyond the baby stage. For a baby, 'out of sight' means not just out of mind but out of existence: something unseen ceases to exist because the imagination is not yet adequately developed to conjure it back into her memory. This is why babies sometimes cry as if the end of the world has come: because that is what they feel has happened when mother disappears.

The ability to retain a mental image of an object over a longer period is a comparatively mature skill, which James has now triumphantly mastered: each time he visits his aunt's house, even after a gap of a month, his visual memory takes him straight to the shelf with the sweet jar!

A book on child development will lay out many other visually and psychologically fascinating stages to watch for and photograph.

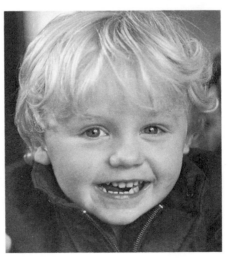

All photographs taken on Leica R4 60mm macro lens f2.8 1/60 sec. Tri-X film

Abstract concepts are learnt, not inborn.

The three-year-old playing hide-and-seek believes he has made himself invisible because he cannot see the person looking for him.

Leica R4 90mm f 5.6
1/125 sec.
Ektachrome 64 film

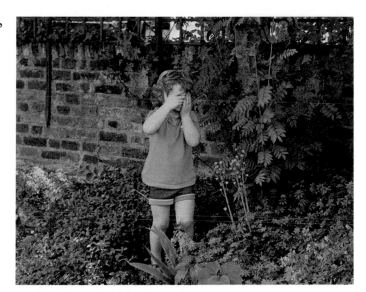

The tide encroaches on this child's beach pool; she frantically bales it out; she has not yet developed the concept that it is impossible to beat back the sea.

Leica CL 90mm lens f 5.6
1/125 sec.
Kodachrome 64 daylight film

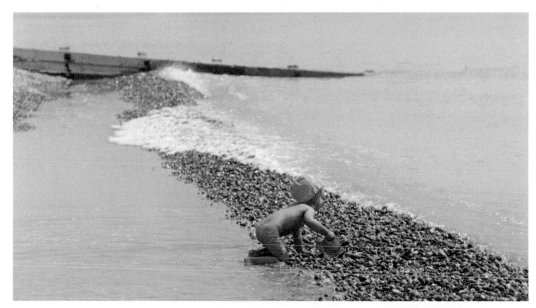

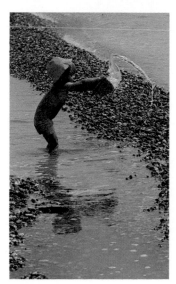 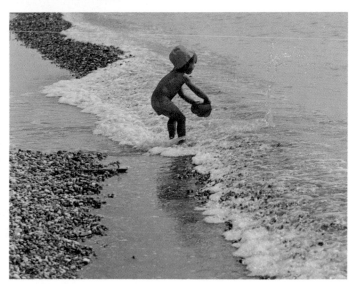

Playing out anger and fear

Though parents buy bricks or jigsaws to help develop their children's motor skills, they tend generally to write off play as a way of keeping the family busy and quiet. But play is children's work.

Balancing along a log they are developing coordination and self-confidence. Playing at shops and shoppers they are exercising their imaginations and learning to channel them usefully. Most important for their own peace of mind, and for the peace of their parents, they can safely 'play out' any rage, frustration or fear and, through imaginary games, come to terms with the world around them.

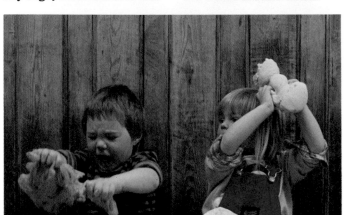

John is wracked with jealousy caused by the arrival at home of a new baby. The dough presents him with a safe way to bash out his injured feelings. His little friend looks on amazed, and tries to copy him, but, as she does not share his deep feelings, her efforts are comically less intense.

*Leica R4 50mm lens
f5.6 two Vivitar 4600 flash-
guns bounced off umbrellas
Ektachrome 64 film*

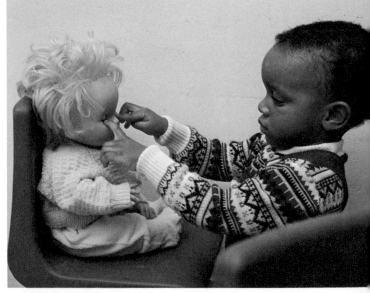

Children can be photographed playing out their fears of medical treatment, operations, injections. They may find it helpful at a suitable later moment to look at the photographs and talk through with their parents what they were feeling at the time. It can be useful for parents too, to learn, through children's play about fears which might never be put into words.

*Olympus OM1 50mm lens
f5.6 Braun 910 flashgun
bounced off ceiling
Kodachrome 64 film*

Sometimes, however, it can be tempting to read too much into apparently aggressive play. Scientific interest in mechanics could be the reason for this boy's action: or it could be a combination of curiosity and animosity that prompts him to poke at the doll's eyes. This child turned out to be a gentle, well-balanced, much-loved youngest—no question of jealousy of a new baby or anyone else. Snap judgements can be dangerous!

*Leica R4 90mm lens f2.8
Vivitar 4600 bounced off
ceiling Ektachrome 64 film*

The child's expanding world

A baby or toddler is the centre of his own universe. The world seems to him to revolve outwards from his own needs and desires. Only gradually over several years does he start to comprehend how small a segment he is in a huge pattern.

At first the child's world expands with parental help. The optician's son, taken to see his father's workplace, reverses roles; and learns more about what it feels like to be his father.

A budding relationship with an unborn sibling: the first experience of feeling the baby kick is a photographic cinch.

These photographs catch the glow of pride and sheer happiness of children sharing real experiences with their parents, rather than just being lined up in front of the camera for the conventional parent and child snap.

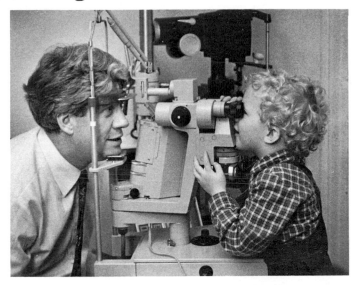

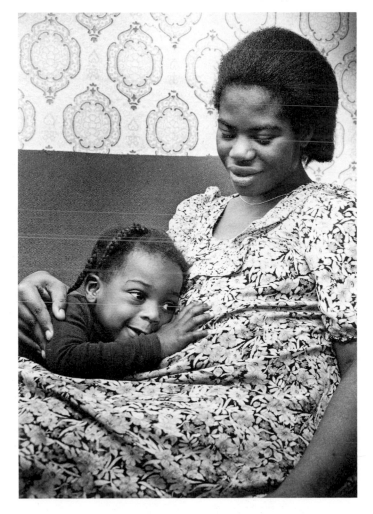

Watching developing relationships

Relationships between people, angry as well as loving, can be an endless source of fascinating photographs, especially with small children, who, on their adventurous early paths of learning, have to fit in with more and more complex human situations.

Early on, children do not consciously cooperate in play, but they play 'parallel', sometimes subconsciously arriving at almost dance-like unison in their movements. Even though they do not communicate much, they plainly enjoy each other's presence.

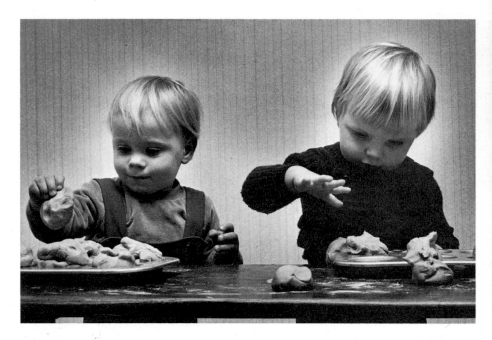

Learning to play together success-fully – even harder, managing to share toys – is a social skill not easily acquired.

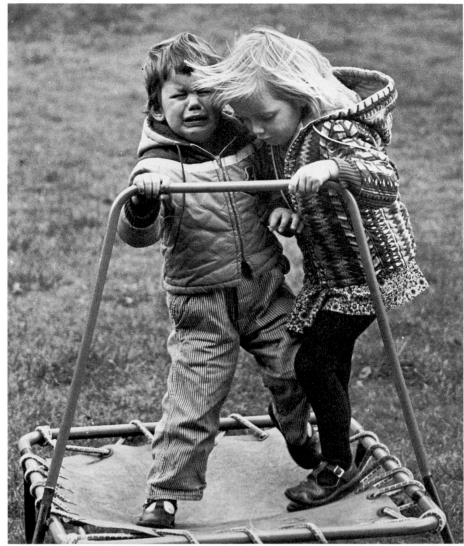

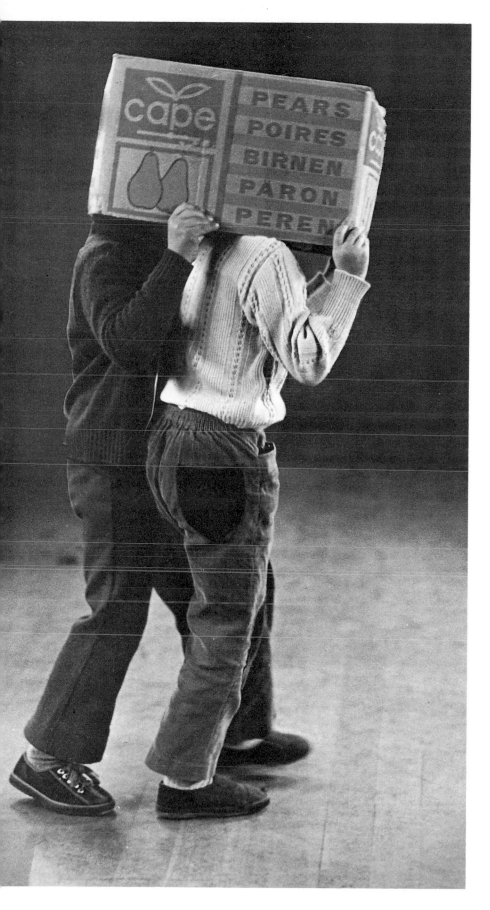

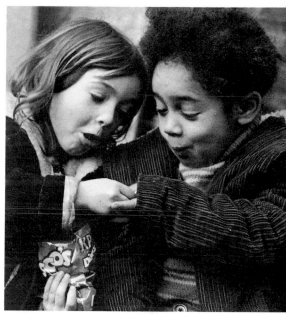

As they work out their new skills in cooperation or discover the pleasure of a first steady friend, all sorts of dramatic opportunities await the near-invisible photographer.

Outdoors, telephoto lenses are ideal for silent, unobtrusive observations. Indoors it is not possible to work from the distance. However, as the children become absorbed in their activities, your presence will quickly be forgotten, especially if attention is not attracted towards the camera by blinding flashes, noisily changed film or other distractions.

As children get older, more self-conscious, and only too glad to be distracted from schoolwork, you have to use will-power over your subjects, somehow erecting around you a screen of invisibility – a knack demanding stillness and tact.

Natural photographs in the classroom cannot be achieved without some degree of conscious co-operation by all the children involved. By this age, the Western child has a conditioned reflex to grin straight into the camera. What is more, everyone wants to be in the picture, and, however much they are prevailed upon to try to ignore the camera, every third minute one of the group will weaken and look up to see if the lens is pointing his way.

The only solution is to appeal to each individual's vanity and desire to be the centre of attention, and say that no photograph will be taken of anyone looking at the camera.

To maintain this concentration so precariously won, it is advisable to avoid the use of flash (see pp. 36–45). Most classrooms are well lit, and the bonus in emphasis to be gained by use of natural light sources frequently compensates for the loss of the (admittedly safer) brightness of flash.

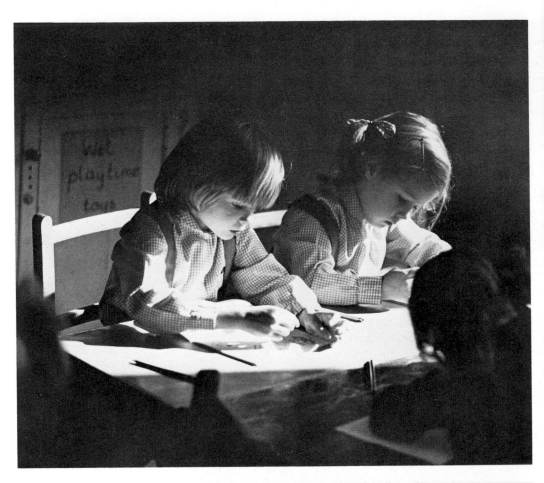

Sunlight from the window may offer a special contrast and sparkle.

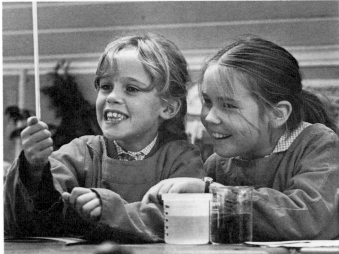

A softer directional window light just catches the glass tube and highlights the experiment.

The flare from a bunsen burner flame is reflected in the eager, interested faces.

The child's ideas

The less interference from the photographer, the more chance of the resourcefulness and wit of the individual child coming into full play, with ideas that the adult would never have dreamed of.

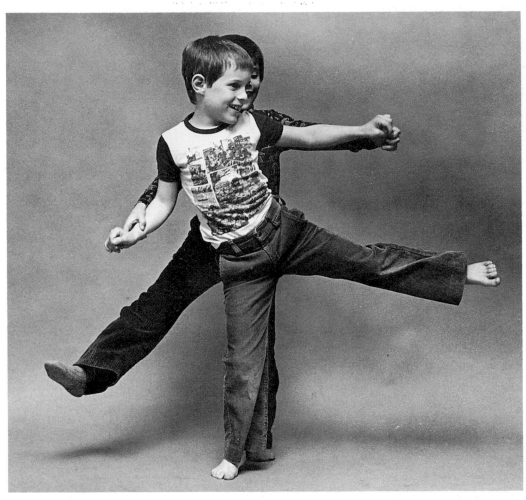

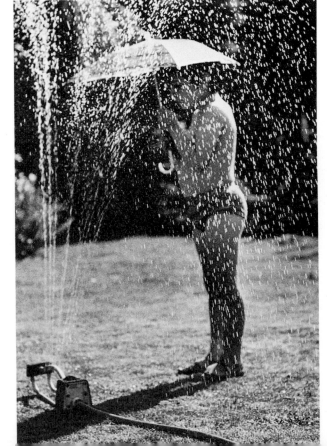

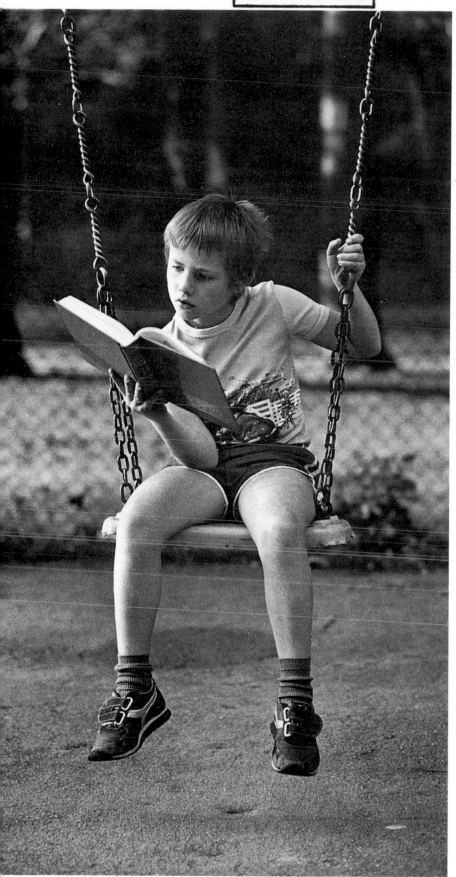

Stage photography

Lighting problems tend to wreck photographs of stage performances but, with care, most of the difficulties can be overcome. With luck, the light will be bright enough to photograph without flash. For colour with available stage light, use tungsten film (p. 32).

For black and white, the usual ISO 400/27° film will be suitable, probably pushed one or two stops (pp. 45 and 143).

Avoid flash if possible. It is unfairly distracting for young performers to put up with flashes popping all over the hall, when perhaps they are already slightly thrown by a combination of stage-fright and the extra excitement of having an audience.

Besides disturbing the cast and irritating the rest of the audience, the results are likely to be disappointing. The distance from audience to stage is often too great for the capacity of most amateur flashguns, so the light will not reach the intended subject.

If more than the odd happy snap of a production is required, it is preferable to attend the dress rehearsal. There will be more time, and more

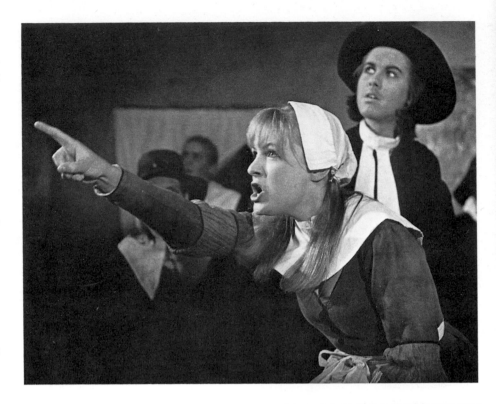

space to manoeuvre. You can quietly work while the children are still rehearsing, still concentrating on getting the performance right, rather than showing off to parents and friends in the audience.

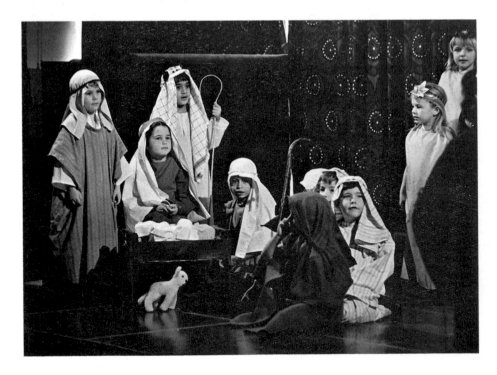

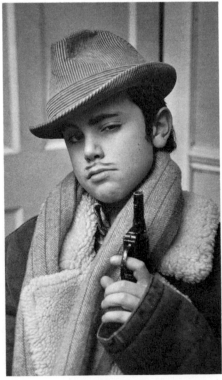

Because of lighting difficulties on stage, it is worth taking a close-up of your child in his costume at home.

130

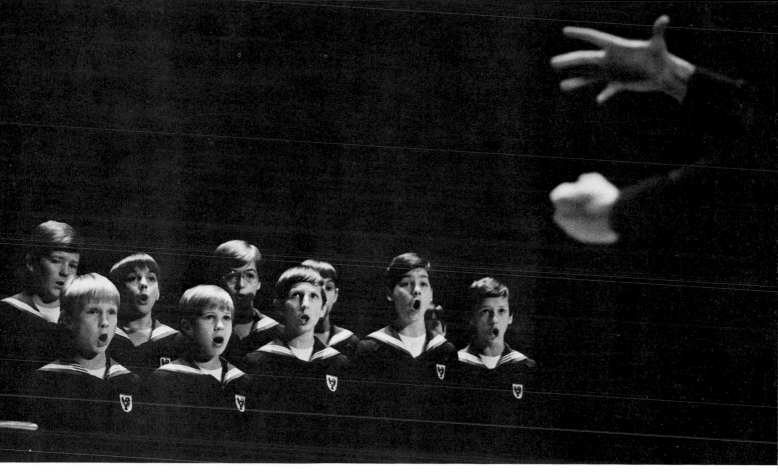

Stage lights can be disastrous with fully automatic cameras. An automatic camera takes a reading for the whole area covered by the viewfinder, and it will choose an exposure based on the average all-over light. In this concert hall situation, where the light is beamed down from above, the background is unlit, and the Vienna Boys' Choir are wearing a navy blue uniform.

An automatic camera would choose an exposure to bring out detail in the dark areas and would grossly overexpose the boys' faces, leaving them like white moons.

This is a situation where the non-automatic camera wins. To get facial expressions, a close-up light reading should be taken directly off the boys' faces, and the camera should be manually set.

Leica M5 90mm lens f2.8
1/60 sec. Tri-X film pushed 1 stop

With an automatic camera under such conditions, the only way to avoid over exposure of the boys' faces is to 'cheat' the light meter by setting the film speed much faster than it actually is. If the automatic camera has film settings up to ISO 1000, then ISO 400/27° film could be set at 1000 and it would probably come out right.

All too often a school hall does not have enough light even for pushed film: here the stage lights were virtually non-existent. To portray the Caribbean and Anglo-Saxon girls desperately trying to match the grace of their Indian schoolfriends, a powerful professional flashgun was used to bounce light off the high ceiling. However, this was the dress rehearsal, not the performance, so the use of flash was not too distracting.

Olympus OM1 50mm lens f4
1/60 sec. bounce flash, Braun
F910 Professional flashgun

The less lucky children

Because all children should be happy, well fed and well occupied, it is tempting to avert the camera eye from those who are not. But their miseries, their hunger should be recorded on film too: the shanty-town sisters in Argentina . . .

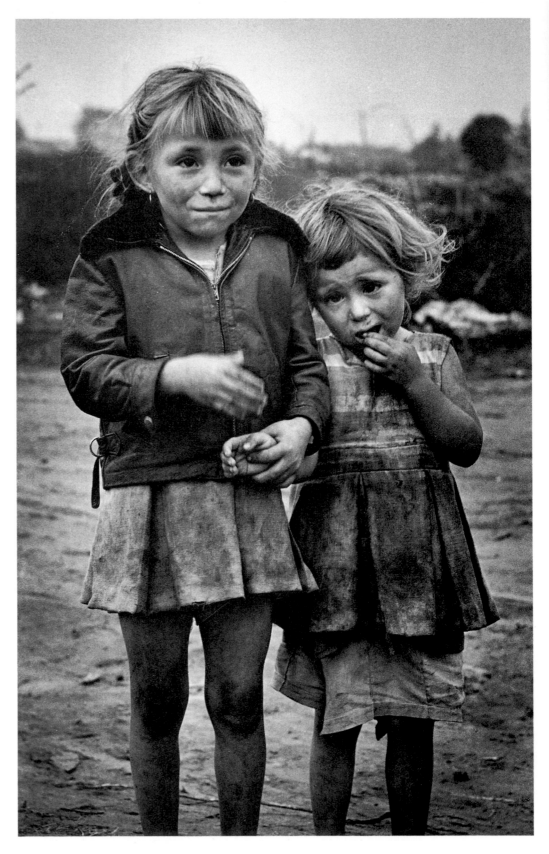

the sick, hungry baby in
Uganda . . .

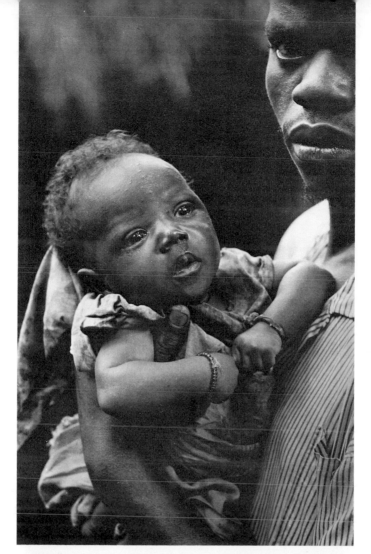

Children who need our
help are not only to be
found in such far-flung
places. Sadness and stress
are all around us.

This Vietnamese boat boy
was photographed near my
own home, but his tears, his
rootlessness were as real as
the fear he must have felt in
his earlier traumatic voyage.

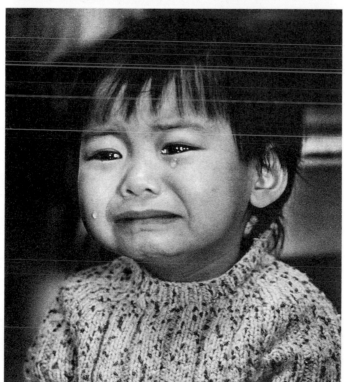

Photographs with messages

The photographer can help to fight discrimination against disabled children by showing them successfully integrated in to the community (pp. 20 and 138), children like any others, with a similar love of life and games, even if they do not have the use of their legs.

The trapped internal world of the autistic child is more easily explained with a photograph than a thousand words.

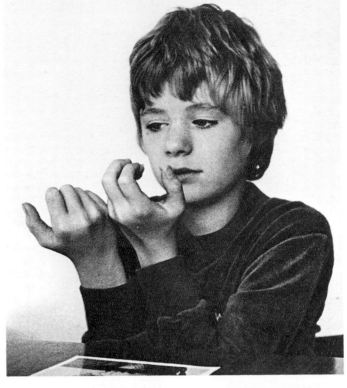

That children can be crippled by arthritis yet struggle on to lead a full and busy life is also more swiftly conveyed by a picture.

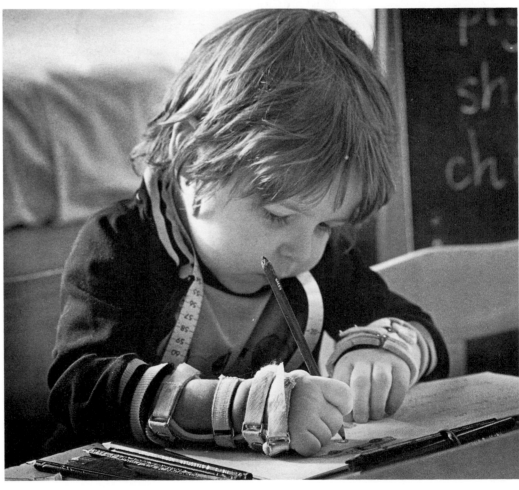

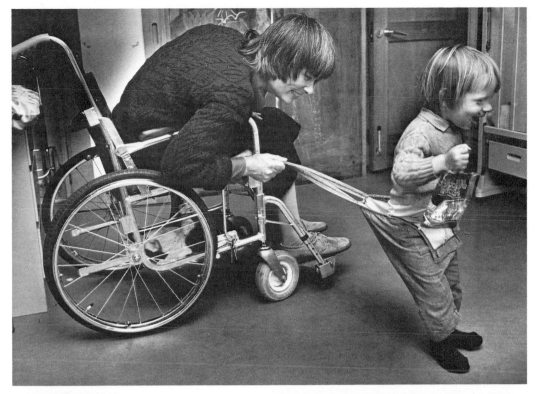

Photography is the most potent way of giving immediate messages.

Both these pictures have been used world-wide, one to fight prejudice against the disabled, the other in the battle to overcome racial prejudice, these four-year-olds showing clearly that racist attitudes are not in-born.

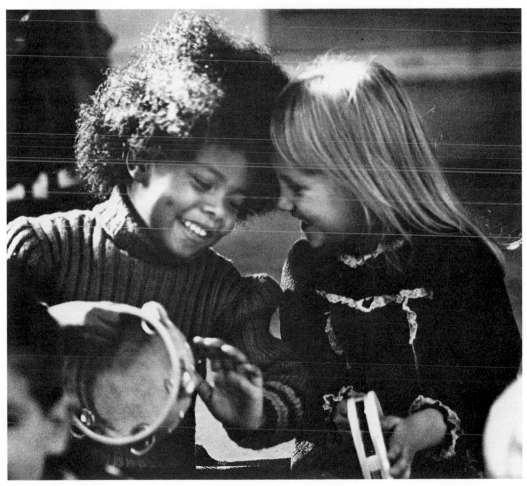

Holiday time

Some of the best family photographs are taken on holiday, not just because of fresh surroundings, but because the rat race is left behind. Relaxing with the children, parents may find more time to get behind the camera and think about what is in the viewfinder. Some of the best, most natural character studies are likely to be achieved, because no-one is under pressure or in a hurry.

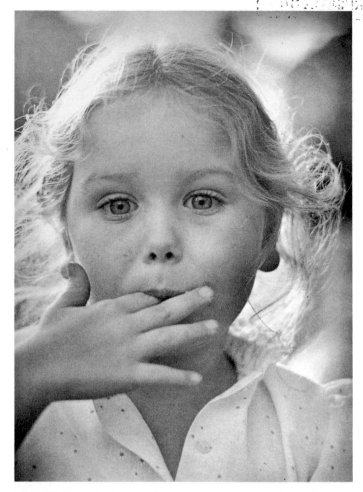

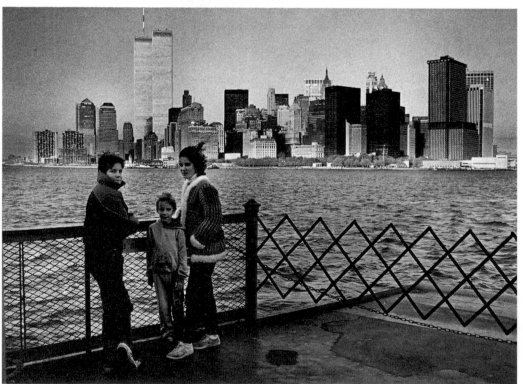

Faces and places

On holiday or on a trip, people usually want to record where they have been. It is a pity to waste film on famous views or buildings as such: postcards are cheaper, and the post-card photographer has got out of bed at 5 am to obtain early morning light with minimal passing cars and no tourists around. An interesting place visited can be stamped as a more personal memory if it is brought to life by members of the family.

Other tourists, bad light or busy backgrounds often ruin a shot. Usually it is impossible to return when the light is better, when everyone else has gone. Some sort of photograph is better than none. A pair of scissors or darkroom magic can always be applied later.

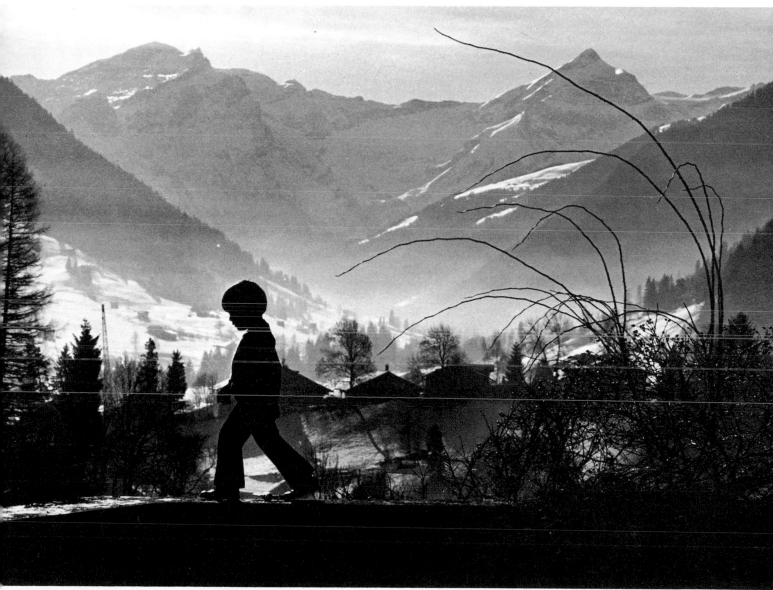

However superb a view, to me it is always enriched by a live presence. The smallness of the boy accentuates the magnificence of the Swiss valley, and yet serves as a comment on childhood: his total oblivion to the view, the relative importance in his mind of balancing along a snowy wall.

Sun, sea, snow and silhouettes

Sea and snow present similar problems photographically. The sparkle and reflections fool the light meters of cameras, which take their readings from the extra light reflected off the snow or off the sun washed, sea drenched sand. The non-reflective surfaces of human flesh, especially against the sun, therefore come out as underexposed, black silhouettes.

Whether on colour film or black and white, the silhouette can often be more dramatic and beautiful than the front-lit fleshed-out infant. However, silhouettes could become monotonous, so the photographer on holiday must adjust the camera to achieve chosen results.

With manually controlled cameras under bright snow or sea conditions, the aperture will probably need to be opened up 1 or 1½ stops. (An element of guesswork is inevitable, though experience will help.)

Some automatic cameras have a light meter override switch, which opens the aperture 1½ stops. Otherwise the light meter can be 'cheated' by adjusting the film speed: for one extra stop, halve the film's ISO number. For example, if ISO 100 film is in the camera, switch the dial on the camera to ISO 50. The camera will then think it needs more light for the slower film, and will open up its aperture one stop.

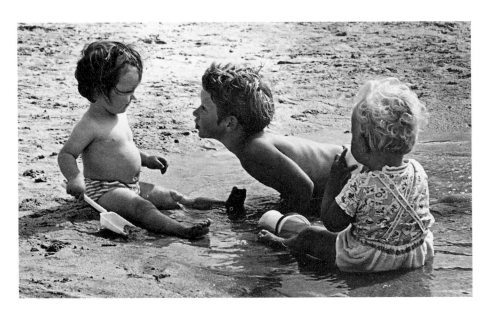

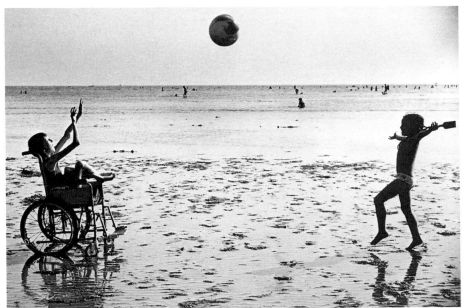

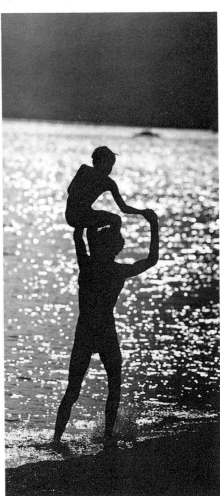

Filters are essential on the beach. They protect the delicate lens surface from scratchy sand or a splash of salty sea. A yellow filter brings out detail in sky, beach and sea yet hardly darkens the subject (*above*). Orange renders people as silhouettes but also interestingly darkens the sky and brings out a glorious sparkle from the water (*right*).

With snow in colour, even more care has to be taken over precise exposure than with black and white. If the light meter is left to its own devices, it will take a reading which is correct for the texture of the snow itself, and anything else will again be very dark, probably black, an advantage against the stark beauty of a frozen Icelandic lake.

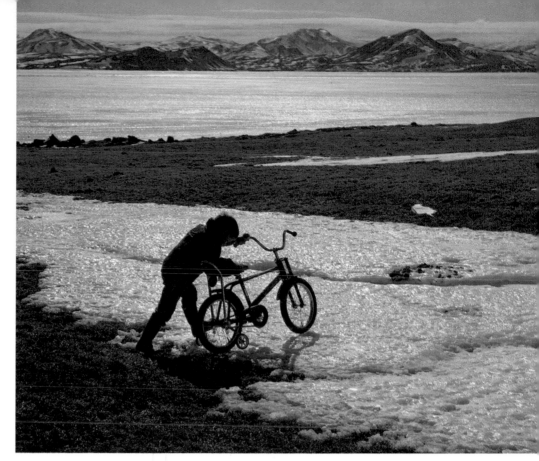

With the aperture opened up 1½ stops, the young skier is portrayed as a person rather than a cipher in a landscape: the colour of his clothing shows up, but the snow is a flat, bleached-out white surface.

'Right' exposure, according to the light meter in the camera: every ripple of the sea's surface is clear but the swimmer is totally silhouetted.

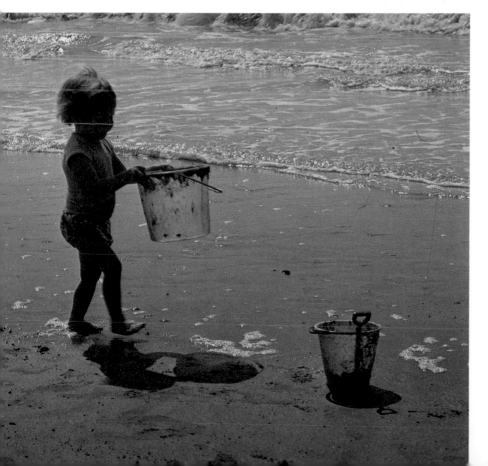

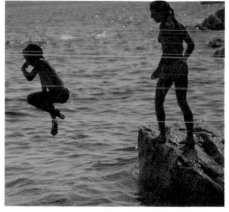

The aperture opened up one stop, and the sea colour is more pleasing, the bucket glows with light and colour. Though the toddler is still partially silhouetted, enough detail is there to make her contentment readily apparent.

139

Stories in stills

However glorious a holiday, children, especially teenagers, have moments of boredom. A sure way to amuse everyone is to get them inventing a story to act under the camera. All the generations can join in.

Filters may add fantasy to the family dramatizations.

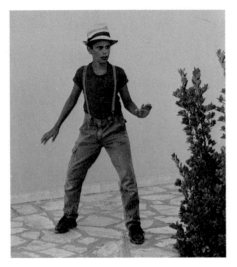

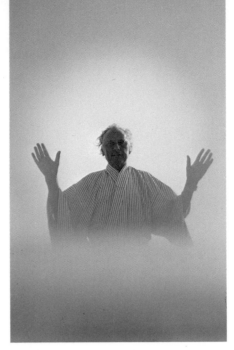

Detective Gordon Gordon is summoned by a wizard, flying in the sky by courtesy of a mirror attachment (Cokin no. 220) plus a centre spot (Cokin no. 061) on a 35mm wide angle lens.

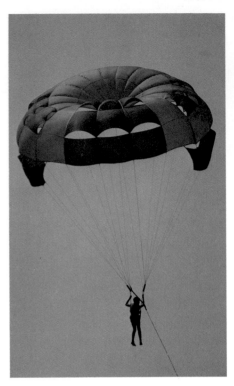

As Gordon Gordon 'lands' in Corfu (by paraglider), the distance haze is cut out by a polarizing filter (Leitz Polarizer).

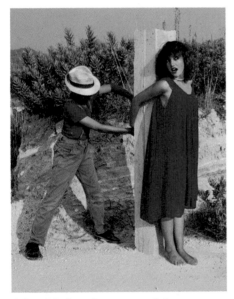

After his heroic rescue of the princess and the battle with her captor, a headless monster, the princess cruelly ignores him and flies away with the wizard.

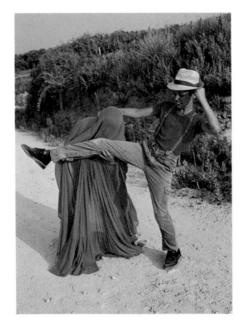

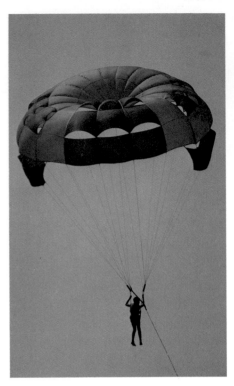

Gordon Gordon wanders off with only whisky to console him (sunset effect from Cokin pastel filter no. 022 plus orange filter no. 030).

140

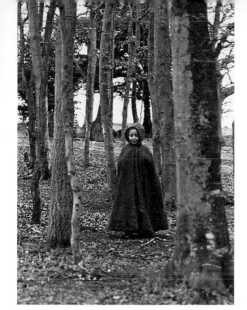

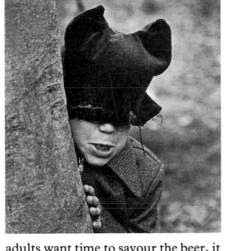

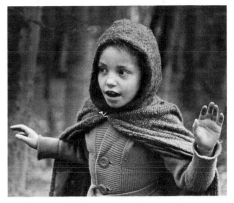

No need to go to exotic places for story acting in front of the camera.

On a picnic in the woods, if the adults want time to savour the beer, it is worth taking along a few dressing-up clothes. One minute the boy is Batman, the next the two children are acting out *Beauty and the Beast*. Because the children are happy and absorbed, all self-consciousness dissolves, and their natural characters emerge in the pictures. Story play keeps everyone happy for an extra half hour as well as making an unusual page for the family album.

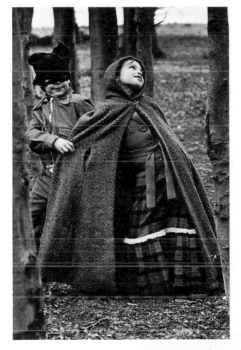

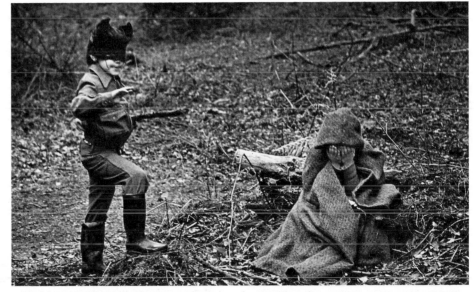

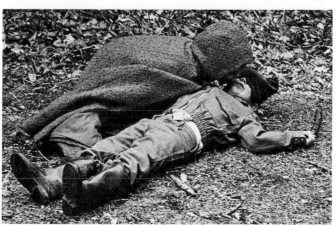

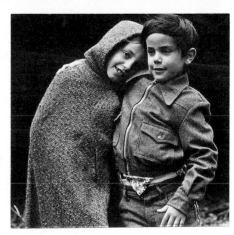

Developing and printing

Finding a good laboratory

The difference between well and poorly processed photographs can be startling. Often photographers blame their cameras or themselves for unsatisfactory prints when the fault is actually with the laboratory.

Colour prints from negatives usually are machine-made, though the more expensive hand-prints are worthwhile when possible. Different types of equipment in different laboratories produce alarming variations in results. There are no miracles. Cheap prints may mean that costs have been cut by use of old-fashioned printing machines, stale chemicals, the poorest papers.

For black and white or colour, it is wise to look out for a first class lab which has professionals as well as amateurs among its clientele, so that pressure is constantly exerted to keep standards high. Such a lab will be successful enough to have the most up-to-date machinery, yet able to offer reasonably competitive prices due to the large number of satisfied customers.

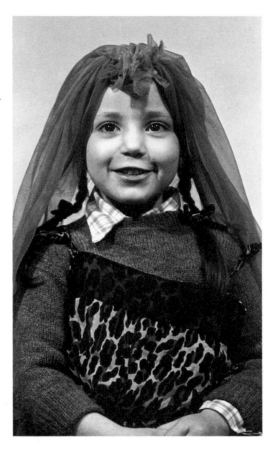

Photograph printed in my own darkroom.

Same negative sent out to cheap printers.

The white marks on the right-hand print are from inevitable flecks of dust and hair on the negative which a lazy darkroom assistant failed to blow away. The lack of black and white contrast is the result of careless or mechanical printing.

The difference in printing is bad enough. If the lab had also developed the film, the negatives would probably have scratches and dust irremovably dried into the emulsion. Care of negatives, especially at the development stage is essential for print quality.

Sometimes it is possible to find a small lab or a photographer who is short of business, who will take on printing with individual care for an enthusiastic photographer. Then it is important to know what is required from a particular negative, what can be done to improve composition and impact by darkroom manipulation.

Developing film at home

For beginners, it is advisable to find an experienced photographer willing to demonstrate basic darkroom techniques: alternatively buy a step-by-step picture manual.

There are some tricks of the trade which are particularly useful in printing baby and child photographs, and make it well worthwhile setting up your own darkroom. Black and white is straightforward; accessories for colour are more expensive and the work is considerably more complicated.

Darkrooms do not have to take up much space. They can be set up in broom cupboards. My first darkroom was my tiny bathroom, the window lightproofed, a hinged table built over the bath, which could be hooked up on to the wall when the work was finished. Good photographic shops sell all necessary gadgetry, not only enlarger and safelights, but also special syphon fittings so that prints can be washed in bath or kitchen sink.

Remember that a cheap enlarger lens will produce poor quality prints even if the camera was superb (and vice versa).

Development of film can be achieved without a darkroom, by loading the film into a lightproof developing tank inside a light-tight changing bag (which is worth owning anyway, in case a film gets jammed in the camera). Place the film, the reel on to which the film is to be wound and the developing tank all inside the black bag. Open the film cassette, taking care not to scratch the emulsion of the film, and wind it on to the reel. Place the reel inside the developing tank and close the lid firmly.

Once the film is loaded into the tank, the developing process can be carried out in daylight. Follow the manufacturer's instructions carefully; processing times, temperatures of solutions (you will need a thermometer) and instructions for agitating the tank are best carried out exactly as recommended until you know your chemicals well enough to experiment. Beginners should try out chemicals on test films. Film ruined during development has gone for ever.

Pushing film

It is a great advantage to be able to develop film which needs 'pushing' at home, rather than leaving it to the mercy of a disinterested laboratory assistant.

Only tests and experience will show how much extra time a given film in a given chemical will need in order to make up for 'pushing' the ISO number higher than advised by the film manufacturers. As an initial test, try an extra 20% for I stop extra with your usual developer. If using an accelerating developer, such as Diafine or Acuspeed, make a first test precisely according to the makers' instructions, and only 'push' or 'stew' the film even further if essential. The more it is pushed, the grainier it becomes and the more the black and white contrast is emphasized, at the expense of intermediate tones.

When in doubt, it is always worth exposing a few frames of spare film in exactly the same lighting conditions, and developing them first as a test strip.

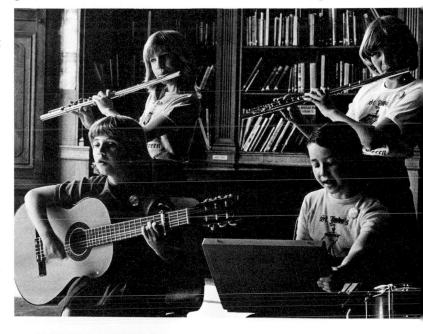

Tri-X film pushed 1 stop, developed in Aculux for three minutes more than manufacturer's recommendation

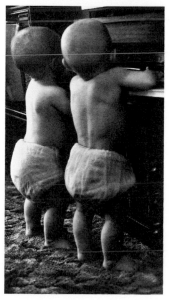

Tri-X film pushed 2½ stops, developed in Diafine

143

Making the most of the picture

There is no one right way
to print any negative. It is
always worth spending
time trying out different
degrees of enlargement,
different framings of a face.

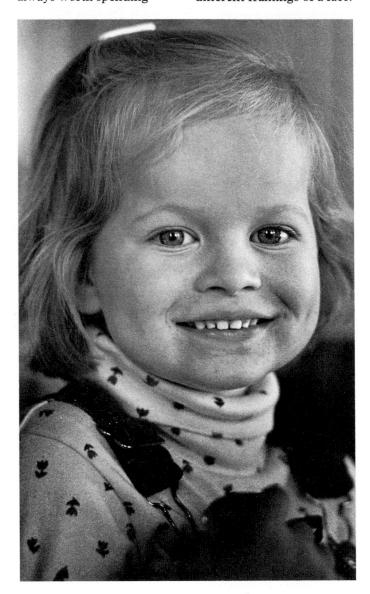

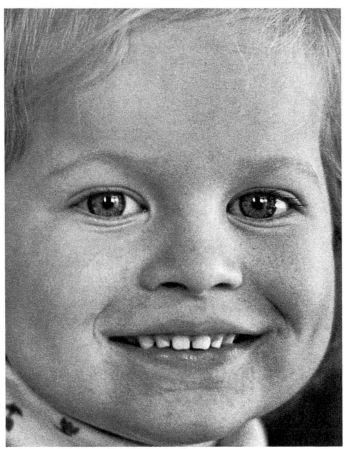

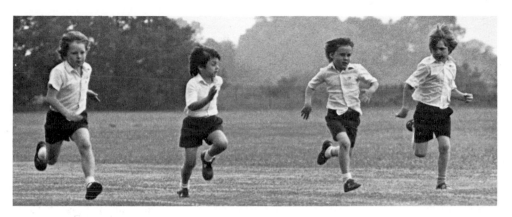

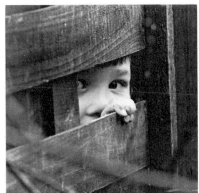

According to convention, photographs are almost always printed as plumpish rectangles (p. 48), but they can just as well be ovals, circles or squares; tall and thin; or narrow horizontal strips.

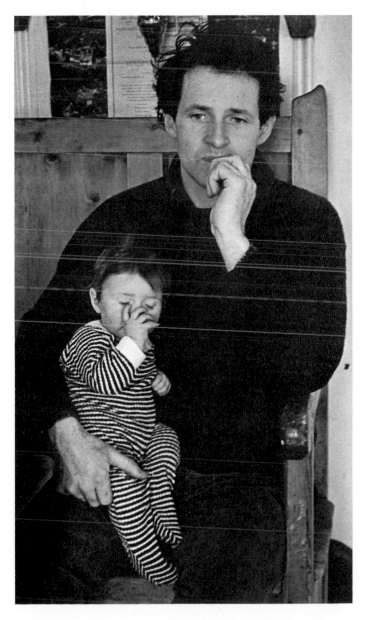

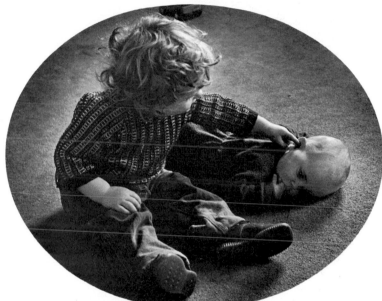

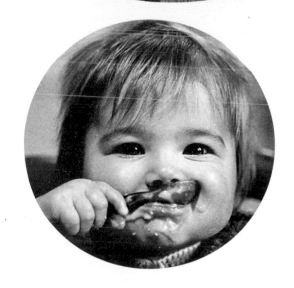

Individual composition and content should rule, not the proportion as dictated by the manufacturer of the photographic paper.

Grades of photographic paper

Different grades of paper alter black and white contrast. With a negative of average density:

Grade 1 is 'soft' with no extremes of black and white.

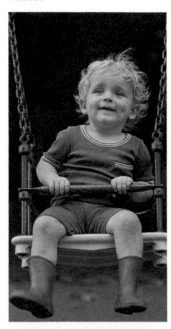

Grade 2 produces warm skin tones but reasonable contrast.

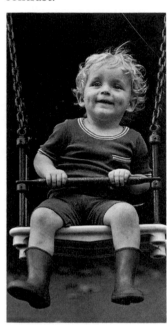

Grade 3 increases contrast sometimes at a cost to detail.

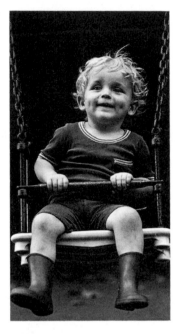

Grade 4 is usually too contrasty for averagely exposed photographs. It dramatically emphasizes the grain inherent in greater enlargements.

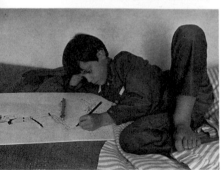

With grade 2, an under-exposed 'thin' negative produces a murky print.

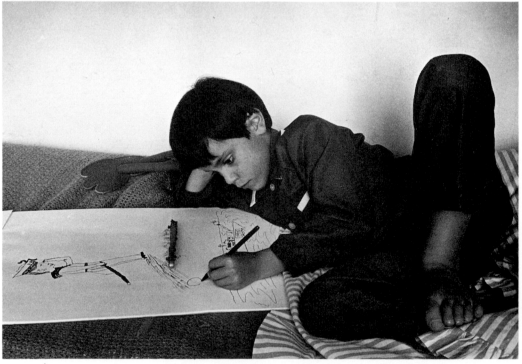

Grades 4 and 5 are indispensable for 'thin' negatives.

Burning in and holding back

However much care is taken over lighting, most photographs can be improved under the enlarger, by burning in dense areas of the negative which would otherwise print too pale, and holding back thin parts of the negative, which would come out too dark.

Burning in is accomplished by making shapes with the hands under the enlarger, allowing just a narrow trickle of light through on to any area which needs extra exposure: in this photograph the baby's face, clothing and the bottle. Before risking ruining expensive paper, beginners should first practise making hand shapes and letting light through on to the correct areas.

Burning in is also used to obscure fussy, distracting areas of a picture: here the irritating detail of the buttoned chair.

Holding back (dodging) is achieved with a hand or finger, or with a blob of cotton wool on the end of a thin piece of wire; used here to hold back the face of the elder brother. It is sometimes more practical to cut out a cardboard mask if the area to be held back is round the edges.

Tests should be made to check what reduction of the exposure time is needed to arrive at a balanced print.

Whether burning in or holding back, the hands or the cotton wool dodger should be kept gently but continuously on the move, so that ugly hard edges will not spoil the effect.

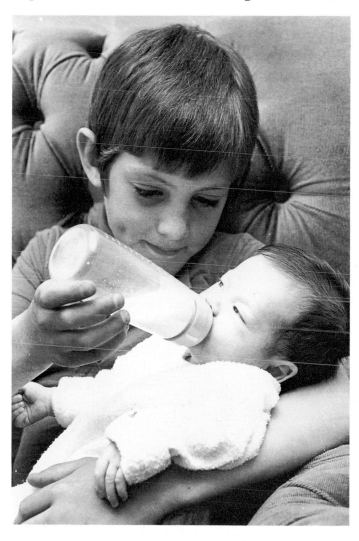

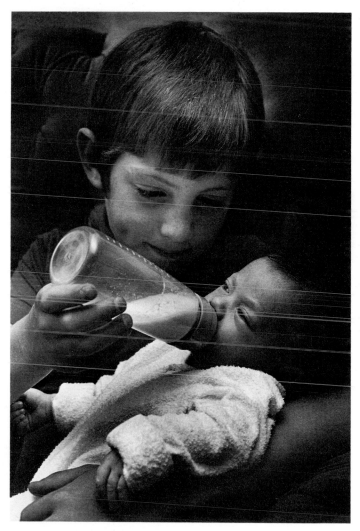

Vignetting

Nineteenth-century portrait photographers greatly favoured the romantic softness of vignetted photographs.

Vignettes are easier if the background is already pale. Then the edges can easily be softened and excluded by using the hands as a funnel.

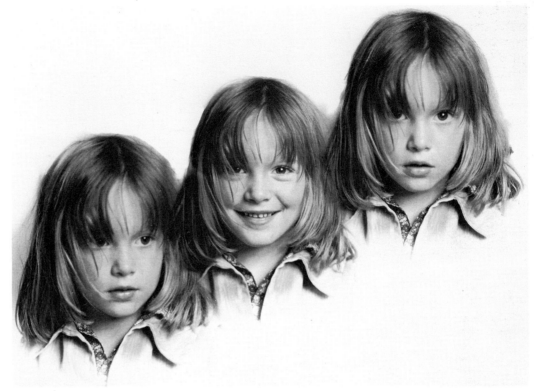

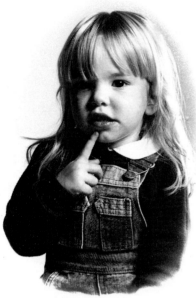

For a multiple vignette, work out the positions for each image by sketching round them under the enlarger on a plain sheet of paper. Then expose the first image as marked on to the sensitized photographic paper. Hold a red filter over the lens while putting the second negative in the position sketched on plain paper (without moving the photographic paper beneath). After the second exposure, repeat the process as many times as required. A family of ten could all appear in one picture.

To vignette photographs with dark or messy backgrounds, cut an oval or circle in a stiff card and hold back the light with this frame, keeping it constantly on the move during exposure to avoid a hard-edge.

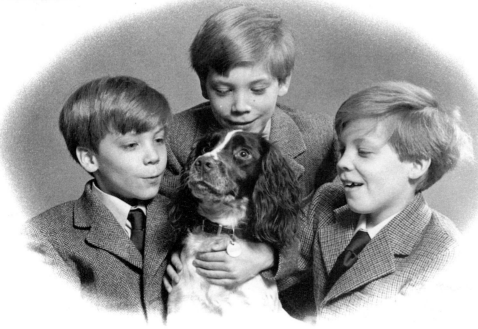

Sepia colouring

The old photographs were often sepia-coloured rather than black and white. This effect can be achieved on modern paper with special chemicals.

A contrasty black and white print, already well fixed and washed, is dipped into photographic bleach until the image has almost disappeared.

A second chemical (sulphide or selenium sepia toner) is used to reform the image in a sepia colour on the bleached out paper. The photograph is then fixed, washed and dried as normal.

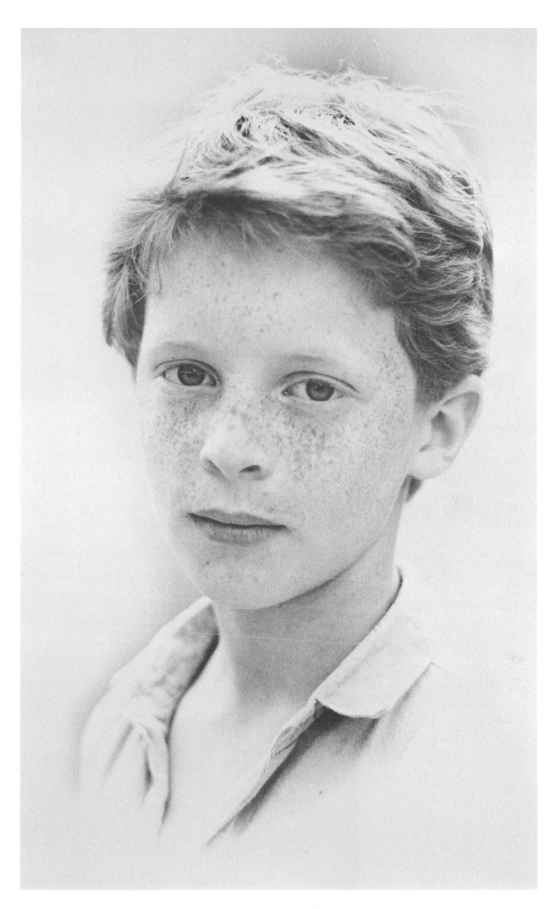

Special techniques

More filters

Filters can make photography more fun. You can use them to create a world of fantasy, turning normal mortals into magicians (p. 140), or to improve or exaggerate colour. They may help you to discover unimagined hues in bleak situations, say a silhouette of a boy in black against a sheet of ice.

*Cokin prism filter 219
Leica R4 90mm lens f5.6
1/125 sec.
Ektachrome 64 film*

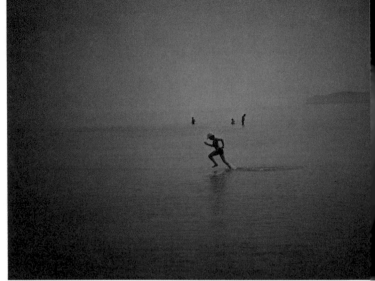

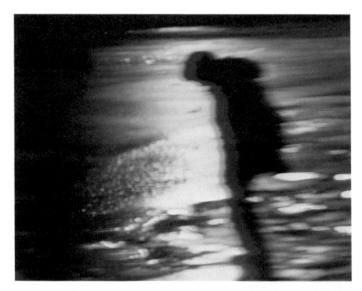

Predominantly neutral colours are not always a disadvantage (p. 11). However, the use of coloured filters can emphatically alter the character of a drab, mud-coloured beach, or white ice on a grey day.

*Cokin orange filter 030
plus orange centre-spot 066
Olympus OM2 50 mm lens
f4 1/250 sec.
Kodachrome 64 film*

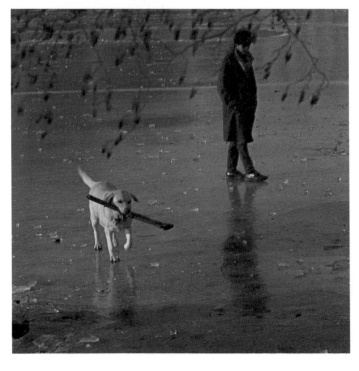

*Cokin blue filter 20 Leica R4
50 mm lens f2.8 1/125 sec.
Ektachrome 64 film*

A neutral polarizing filter cuts out surface reflections from the sea so that the underwater swimmer may be clearly seen, provided that the tidal movements are not stirring up sand. (It is useful too for counteracting undersirable reflections in glass, and it may darken sky areas, thus emphasizing the foreground.)

Cokin neutral polarizer filter 160 Leica R4 35 mm lens f8 1/125 sec. Kodachrome 64 film

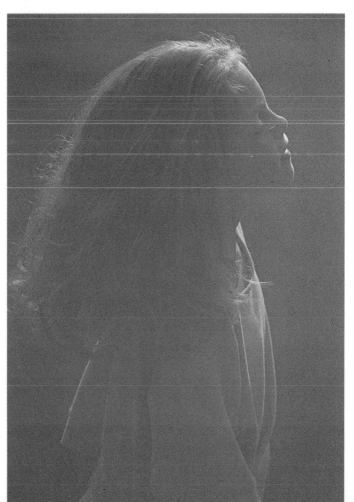

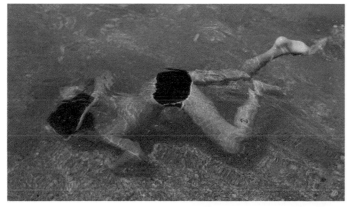

Star filters add sparkle to bright spots in a picture. They are overused for corny candlelight advertisements and by photographers hooked on street and theatre lights. However, they can add considerable glamour to background scenery for action shots of children (only if the effect is subtle enough to seem natural).

Cokin star filter 057 Olympus 0M2 100 mm lens f11 1/125 sec. Kodachrome 64 film

Soft focus diffusing filters are often recommended for portraiture. They usefully minimize wrinkles in aging subjects, and may cast a romantic glow over otherwise unexciting human specimens. However, children's skin and hair are usually more beautiful without extra softening effects.

If romanticization of a subject is requested, I prefer to use pastel filters, often in combination with a supplementary colour.

Cokin pastel filter 087 plus Cokin sepia filter 005 Leica R4 90 mm lens f2.8 1/125 sec. (2 extra stops allowed to soften and lighten effect)

Some filters are too limiting and obviously gimmicky. If used more than once or twice, the repetition becomes boring. However the multi-image filters allow intriguing variations and experiments.

Cokin multi-image filter 202 Olympus OM2 100 mm lens f4 1/250 sec. Kodachrome 64 film

While you may not normally seek to take horror pictures of your child, he may enjoy posing for them, and will probably appreciate them more than your most flattering portrait. He will show all his friends proudly and is likely to be more cooperative at future photographic sessions after stardom as a science fiction character.

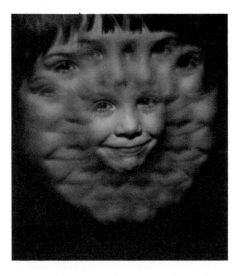

Cokin multi-image filter 203
Leica R4 50 mm lens f2.8

All three pictures taken with Vivitar 4600 flashgun with reflector attachment and Ektachrome 64 film

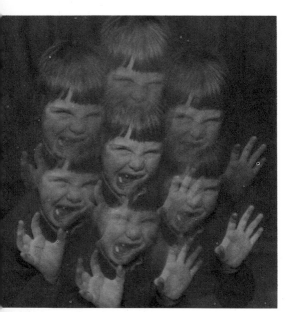

Cokin multi-image filter 204
plus Cokin red filter 003 Leica R4
35 mm lens f2.8

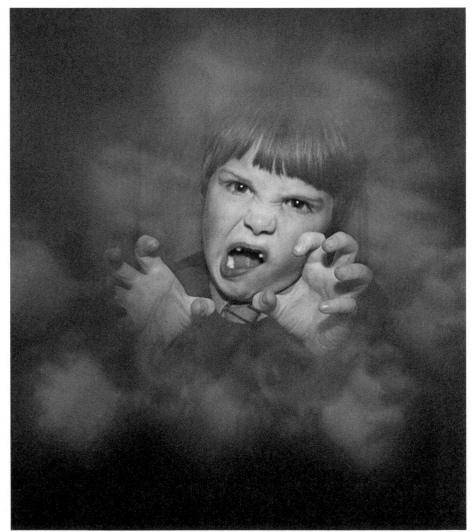

Cokin multi-image filter 204
plus Cokin green centre-spot filter 065
Leica R4 35 mm lens f2.8

Double exposures

Double exposures can be used for spooky pictures. Again, cooperation is likely to be forthcoming from any child who likes playing at ghosts.

Two exposures on one frame.
Leica R4 50 mm lens f8 1/125 sec.

To avoid movement, the camera must be placed firmly on a tripod, and the shutter fired by a cable release. The first shot is taken with the child/ghost in place: the second of the background only.

The hardest part of the trick is to cheat the camera into not winding on the film until after the second exposure is made. Some expensive cameras have multiple-exposure switches on their autowinders: but to take a double exposure on most

cameras, the winding-on process must be carefully overridden. Autowinders or motors without multiple exposure switches must be removed. (Double exposures are impossible on so-called foolproof cameras with built-in autowinders.)

Before taking the first exposure, without pressing the film rewind button, turn the film rewind crank until the film is taut. Then make the first exposure. Wind on as usual but simultaneously hold down the rewind button. The film will stay where it is, but the shutter will be cocked ready to fire again and the

second exposure can be made. For correct exposure, underexpose by one stop both times the shutter is opened.

A double exposure mask can be used to create ghostly or surreal effects. With available light take the exposure reading before placing the mask on the front of the lens.

Cokin double exposure mask 346
Leica R4 35 mm lens f4 1/30 sec.
on tripod available tungsten light
Tri-X film

153

346

Double exposure masks can be used for other tricks.

A lonely schoolgirl, stuck at home with an essay to write, wishes she had a twin to keep her company. It will cheer up her evening to create one for her.

The double exposure mask takes half a picture at a time, but with an overlap which allows a perfect join. Sarah was able to move from one seat to the other while the camera was prepared for the second exposure. Extra exposure is not required: it is only essential to remember to stop down the lens to f5.6 or f8, and adjust the speed accordingly. (A camera with manual settings makes this easier.)

Cokin double exposure mask 346 Leica R4 with multiple exposure setting 35 mm lens f5.6 Tri-X film Vivitar 4600 flash bounced off ceiling normal exposure

A double exposure without a mask is also effective with a brightly lit subject against a neutral black background. This young dancer was able to demonstrate in one picture the beginning and the completion of his pirouette.

Mamiya C3, the quarter-century-old model which allows multiple exposures (by mistake as well as on purpose!) Tungsten studio lighting Tri-X film

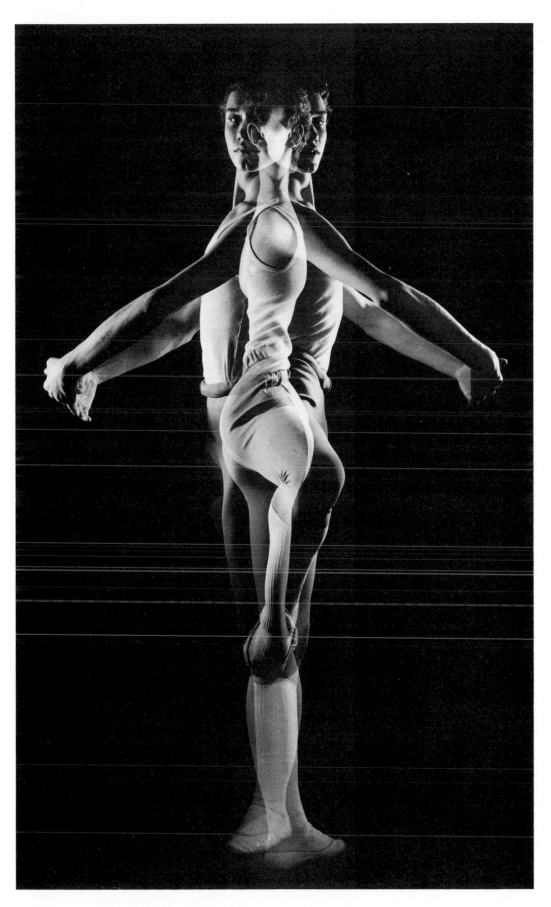

Montage with prints

A montage can be made in the darkroom by carefully masking out areas under the enlarger, then printing from two or more negatives on to one piece of paper. A more straightforward method is to glue separate pictures together, then rephotograph the whole. Sometimes joins have to be inked or retouched, and a black background makes this easier.

Montage allows limitless opportunities for surrealism and humour and is not at all difficult, especially if you have your own darkroom and can make prints to any size.

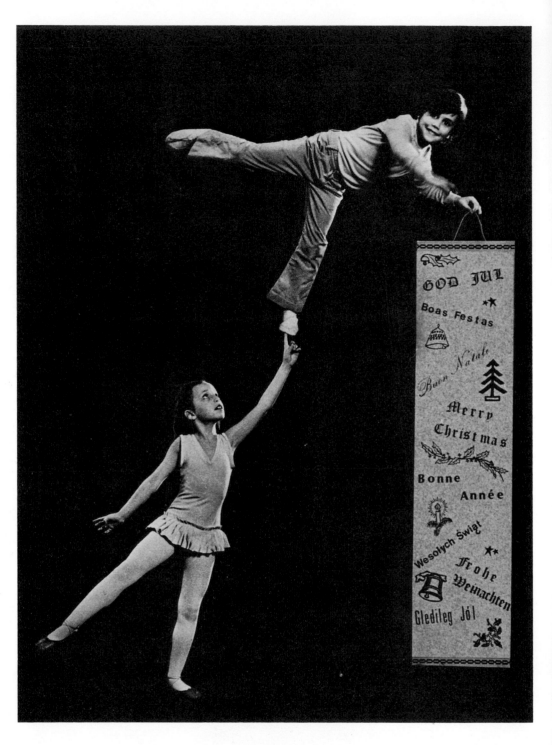

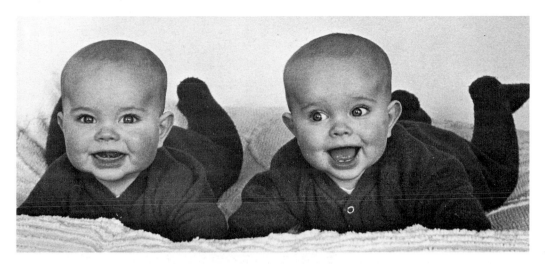

But creative trickery should not overshadow what I believe to be the true purpose of child photography: the search for the soul, the personality of the subject; a celebration of the warmth, wit and originality of each and every child.

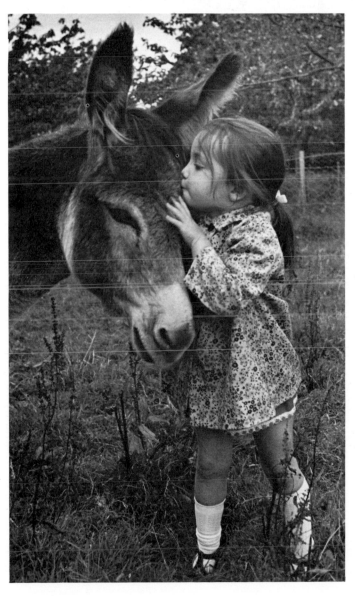

Index

*Flashgun with twisting, tilting
head for bounce flash*

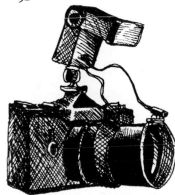

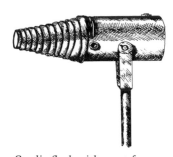
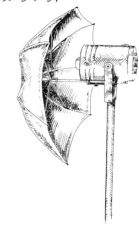

Acknowledgements

My warmest thanks go to all the children in this book and their parents; old friends and new friends found through photography over many years in many parts of the world. I am deeply grateful to my husband for his warm support and tolerance, and to my children for their longterm involvement. I also want to thank all the schools, hospitals, playgroups and play projects who welcomed me in to take photographs, particularly the West Middlesex Hospital for the birth pictures, and the Royal Ballet School.

My gratitude to Save the Children Fund, Action for the Crippled Child, Christian Aid, the National Society for Autistic Children, the Arthritis and Rheumatism Council for Research and the National Association for the Welfare of Children in Hospital for allowing me to include photographs first taken for their use.

Also I am indebted to Messrs Dorling and Kindersley, Michael Joseph, and Penguin Books, London, and Alfred A. Knopf, New York, for allowing me to use some of my photographs published in (YOUR) BABY AND CHILD by Penelope Leach and (THE COMPLETE BOOK OF) PREGNANCY AND CHILD-BIRTH by Sheila Kitzinger: I am equally indebted to Methuen Children's Books for allowing me to use my photographs from MARK'S WHEELCHAIR ADVENTURES, MOV-ING HOUSE, GOING TO PLAY-GROUP, LIFE AT THE ROYAL BAL-LET SCHOOL (Methuen, NY) and THE JOY OF BIRTH (Hillside Books, E.P. Dutton, NY).

My deepest thanks of all to my editor, the patient, wise and ever-supportive Erica Hunningher, who made the impossible possible for me at each stage of the work. And warmest gratitude to the designer, Pauline Harrison, whose tremendous talent and sensitive concern made her also a joy to work with throughout. My special thanks to Jeff Griffin, C.Eng., M.I.Mech.E, Technical Consultant of E. Leitz Instruments Ltd, UK, for invaluable advice and encouragement; to Diana Lecore, Dip.Lib., Registered Indexer, for her excellent indexing; to my son, Jeremy Panufnik, who, at the age of 15, supplied the technical drawings; and above all, to David and Brenda Herbert of the Herbert Press for their enthusiasm and encouragement.

Other books with text and photographs by Camilla Jessel

LIFE AT THE ROYAL BALLET SCHOOL
THE JOY OF BIRTH
MARK'S WHEELCHAIR ADVENTURES (with a research grant from the Nuffield Foundation)
THE PUPPY BOOK
LEARNER BIRD
PAUL IN HOSPITAL
MANUELA LIVES IN PORTUGAL

THE CHATTERBOOK SERIES for children under five:
THE NEW BABY
MOVING HOUSE
AWAY FOR THE NIGHT
GOING TO THE DOCTOR
GOING TO HOSPITAL
AT PLAYGROUP
THE BABY SITTER
LOST AND FOUND

The BABY DAYS SERIES for babies:
BABY'S DAY
BABY'S TOYS
BABY'S CLOTHES
BABY'S BEDTIME
OUT AND ABOUT
BABY'S FOOD

Books with photographs only by Camilla Jessel

BABY AND CHILD by Penelope Leach
PREGNANCY AND CHILDBIRTH by Sheila Kitzinger
50-PLUS LIFE GUIDE by Miriam Stoppard
MULTI-CULTURAL BRITAIN by David Moore
BABY LOVE by Esther Rantzen and Desmond Wilcox
COMPLETE METHOD FOR THE HARP by David Watkins
PLAY IN HOSPITAL by Susan Harvey
THE TOWER OF LONDON by Dorothy Shuttlesworth

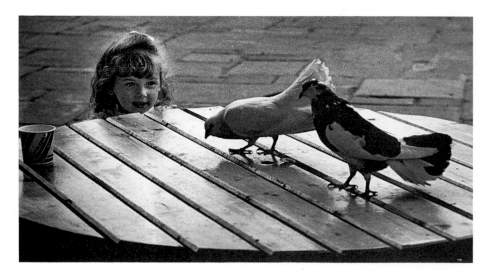